ART AND SOCIETY

The New Art Movement
in Vienna, 1897-1914

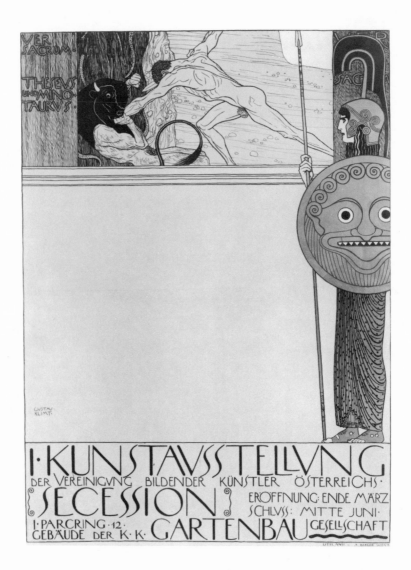

Gustav Klimt: "Poster of First Exhibition of the Secession" (1898)—
uncensored original.

ART AND SOCIETY

The New Art Movement
in Vienna, 1897-1914

BY JAMES SHEDEL

Department of History, Georgetown University

The Society for the Promotion of Science
and Scholarship, Inc. (a nonprofit corporation)
4139 El Camino Way, Palo Alto, CA 94306 USA

 The Society for the Promotion of Science
and Scholarship, Inc. Palo Alto, California, USA

ABOUT THE PUBLISHER The Society for the Promotion of
Science and Scholarship, Inc. seeks to promote through
its publications selected works of high scholarship in
science and the humanities. The Trustees of the Society
invite inquiries regarding the publication of books of
appropriate quality and educational value. A list of
current and forthcoming publications can be found at the
back of this volume.

International Standard Book Number: 0-930664-04-3
Library of Congress Catalog Card Number: 81-52836

PRINTED AND BOUND IN THE UNITED STATES OF AMERICA

TO THE MEMORY OF

MY GRANDPARENTS

CONTENTS

List of Illustrations

Acknowledgments

I should like to take this opportunity to express my gratitude for the help I have received during the preparation of this study.

I wish to acknowledge the material assistance extended to me by the University of Rochester and, in particular, that provided by the Austrian Fulbright Commission without which I could not have done my research in Vienna. I feel also a debt of gratitude to the Department of History of Stanford University for providing me with a Teaching-Research Fellowship that proved to be intellectually as well as financially supportive. Thanks too are owed to Georgetown University and the staff of its Department of History for their generous aid in the preparation of my manuscript.

My debts to the above institutions, however, are only a fraction of that which I owe individuals. A sizeable portion of this obligation must go to Professor William J. McGrath for his advice and guidance during the original formation of my work. To Professor A. William Salomone who always encouraged my scholarly interests and who with Mrs. Salomone showed me many personal kindnesses I owe a very special debt. During my stay at Stanford and since, I have also become indebted to Professor Peter Paret for his friendship and always helpful interest in my work.

In expressing thanks I would be indeed remiss if I did not include as well my mother, father, and family as a whole, among whom my aunt, Mrs. Elizabeth Koppenhaver, deserves particular mention for transforming my original handwriting into legible typescript. For the final form that writing has taken, equal recognition must be given to the typing skills of Mrs. Mary Dyer, to Robert Kramer for his help in preparing the Index, and to the valuable assistance rendered by the editorial and production staff of SPOSS, Inc.

James Shedel
Washington DC, March 1981

Introduction

At the Paris Exposition of 1900, the art dealer Samuel Bing used the term "art nouveau" to describe what had by then become the most popular and widespread style in Europe. Although the words that he chose have since become the accepted name for the style and the movement it represented, by 1900 art nouveau had already been called by various other names, such as *Jugendstil, Stile floreale,* and *Secessionstil.* Beginning in the early 1890s when it first appeared in France and Belgium, the style had spread quickly to other parts of Europe, merged with local tendencies in the arts, and been named appropriately. In Germany *Jugendstil* described the style's close identification with the magazine *Jugend* and its youthful quality; in Italy *Stile floreale* expressed the flowing, organic nature of its sinuous line; while in Austria *Secessionstil* referred to both an act of rebellion and the artistic movement it brought into being.

The founding of the Vienna Secession in 1897 marked the entrance of Austria into the ranks of the European avant-garde. For Vienna, which was already becoming a reluctant center for musical and intellectual modernity, it meant assuming the unaccustomed role of patroness to modern art. Unlike the creations of Mahler and the discoveries of Freud, however, Vienna treated the works of her new artists with more indulgence. Neither before nor after the early years of the Secession did Vienna and Austria enjoy such an international reputation in the visual arts. The paintings of Gustav

Klimt and the buildings of Otto Wagner, as did the works
of so many artists of the Secession, received high praise both
at home and abroad. Yet, they could not entirely escape the
fate of the innovations in other fields, and with the praise
was mixed a significant amount of hostility.

The opposition encountered by artists of the Secession
was the same encountered historically in Austria by almost
all who broke new ground in a society that was traditionally
more intent on preservation than innovation. Anything that
altered the status quo was open to criticism and the art
created by the Secession was not meant simply to please, but
to inspire with a new image of what art could be to the
individual and society. In this aspiration, however, it was
not alone for, both stylistically and conceptually, the Seces-
sion was a European as well as an Austrian phenomenon
that reflected the broad thrust of art nouveau in general.

The Pre-Raphaelite Brotherhood, the English arts and
crafts movement, and the Symbolists all provided important
elements in the development of art nouveau and, thereby,
to the Secession. The spirit of revolt against established
artistic canons and interest in a purer aesthetic past that had
motivated the Pre-Raphaelite Brotherhood found its echo in
Ruskin, Morris, and the arts and crafts movement. From
these sources came an ethic of high craftsmanship and de-
sign, the equality of all art, and the fundamental belief that
art was an integral part of life. From England this message
found a receptive audience on the continent, especially
among the rising artistic generation of the late 1880s and
early 1890s, which also found appealing the eroticism and
representational traits of the Symbolists. Out of these influ-
ences a new creative amalgam was formed.

Art nouveau grew out of this combination by accepting
these various strains and synthesizing them into its own
more vigorous style, but behind the linear and organic forms
of the new movement stood also a supporting body of ideas.
Art nouveau preached the necessity of a modern art, yet
respected what it felt was valid in the artistic past; it hon-

ored "honest" artistic impulse and rejected the "dishonest"; it added artistry to mundane objects to make them useable things of beauty; it championed the equality of the fine and applied arts and sought their unification in the total work of art; and it celebrated the organicism of life and art's intrinsic link to it. When the artists of the Secession broke with their historicist past and identified with the new artistic future, they had already come largely to accept this conceptual outlook.

What followed was the application and adaptation of these general ideals to the specific Austrian context. The reality of the Dual Monarchy's difficulties in dealing with the type of disruptive change represented by growing class divisions and the demands of emerging and declining national groups was in sharp contrast to the optimistic visions of modern life offered by its most advanced artists. The Secession felt a distinct artistic and social obligation to the society out of which it grew and in which it existed. It took on a missionary aspect as the public's tutor in the new art and its benefits. They were benefits that were spiritual as well as aesthetic and held out the possibility of an harmonious and unified environment through art's application to the physical world of the everyday. If the efforts of art could lead to unity and harmony in its sphere perhaps society would follow.

As the Secessionist architect Otto Wagner maintained, art should correspond to the needs and aspirations of "modern life." This was a sentiment shared by other theorists of the new art, such as the Belgian artist, Henry van de Velde, who expressed this sense of social concern on the part of art even more directly when remarking that he sought an art "representative of daily life, yet adapted to the social changes of its times" (1). Placed in the broader context of art nouveau as a whole, these viewpoints reflect what at least one art historian has called the basic artistic question of the period, namely "What is culture and what finally and absolutely does it have to do with life in our time?" (2).

In the case of the Secession the answer to that question asserted the validity of art's value to man's well-being and its ability to have a therapeutic influence upon the ills of society. This required a socially engaged art and the Secession sought to play such a role, at first with great promise, but ultimately with scant success. In the pages that follow, the efforts and experiences of the Secession in the years between 1897 and 1914 are examined as those of an art movement aware of its European context, but acting in response to the circumstances of its own society in an attempt to make of art a force for social as well as cultural intervention.

What this study will not attempt to do, however, is provide a thorough art historical approach to either the Secession or the artists involved with it. There are now in print several excellent works in this vein and the interested reader is referred to those mentioned in the bibliography of this book. The role of the state in Austrian art is also touched upon here only as it is directly related to events connected with the Secession. A deeper exploration of that subject requires a major history of its own. The concern here is the impact of the Secession upon the popular, official, and cultural environment of which it was a part. The movement's expectation that a "sacred Spring" (*Ver Sacrum*) would blossom with its founding was meant to be a symbol of revitalization for the world beyond as well as within the artist's studio. The question at issue here is that which the Secession itself posed—its ability to transform the ideal into the real.

Chapter Notes

1. Quoted in Henry F. Lenning, *The Art Nouveau* (The Hague: Martinus Nijhoff, 1951), p. 27.
2. Rudolf G. Kohler, "Programmatische Künstlerschriften" in Helmut Selig (ed.), *Jugendstil, Der Weg ins 20. Jahrhundert* (Heidelberg: Keysersche Verlagsbuchhandlung, 1959), p. 404.

Chapter I
The Philosophy of the Secession

Now the *Künstlerhaus*[1] is a market hall, a bazaar where the merchants like to display their wares" (1). These remarks were made by Hermann Bahr in 1896 at the height of what was then still only an internal squabble between the progressive (*Jungen*)[2] and conservative (*Alten*)[2] wings of the *Künstlergenossenschaft*.[3] About one year later, in December 1897, after the argument between the *Jungen* and the *Alten* had resulted in the creation of the Secession,[4] he justified that recent event with some further remarks:

> Business or art, that is the question of our Secession. Should Viennese painters remain manufacturers or should it be allowed them to become artists? Whoever is of the opinion that pictures are the same as stockings and cigars will remain in the *"Genossenschaft."* Whoever by painting or drawing wants to reveal the forms of his soul will go to the *"Vereinigung"* (2).

[1]Artists' House (the headquarters of the *Künstlergenossenschaft*).

[2]The words *Jungen* and *Alten* may be translated as the "young" and the "old" (ones).

[3]*Künstlergenossenschaft* can be translated in a variety of ways depending on how one understands the word *Genossenschaft* in this context. In my opinion, because of the relatively closed and monopolistic nature of the organization before 1897 as well as its own self-image, a suitable translation would be "Artists' Guild."

[4]The Secession was officially known as the *Vereinigung der bildender Künstler Österreichs* (Association of Austrian Artists).

At the turn of the century and in the years before the first world war, Bahr (Figure 1) was considered one of the leading literary figures in Vienna. He was both a novelist and playwright as well as being a journalist, drama critic, and self-appointed adjudicator of the arts. In the 1890s Bahr led an avant-garde group of writers known as *Jung-Wien* (Young Vienna), the aim of which was to revitalize Austrian literature, and with the advent of the Secession he attached himself to what he considered a similar movement in the fine

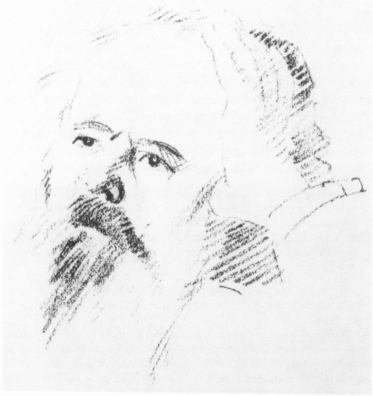

Figure 1 Kolomon Moser: "Hermann Bahr " (c. 1900?).

arts. As a staunch friend of the Secession and many of its artists, including the founder, Gustav Klimt, Bahr acted as an unofficial propagandist for the movement, and, as the two passages above indicate, he was enthusiastic in his support.

Bahr saw the Secession as the new hope of art in Austria. In a collection of essays published in 1900 and entitled *Secession*, he gave his version of how the Secession had come about. He emphasized that, unlike the Secessions's counterparts in Paris and Munich, the conflict within the *Künstlergenossenschaft* was not a mere disagreement over style between men of the old and new schools who, however, equally loved art. On the contrary, in Vienna, according to Bahr, it was a basic struggle between art and business that was involved, with young and old present on both sides, being distinguished from one another only by their dedication to true art or lack of it.

The foe against whom the future members of the Secession, then known as the *Jungen*, had had to struggle were, in their eyes, those "artists" who felt that reproducing safe pictures in past styles and with conventional themes, but with an assured market value, was better than risking innovation, and thereby financial loss. The *Jungen* had attempted to correct this situation from within, but were prevented from doing so by the intransigence of their opposition. When in 1896 that same opposition, led by a painter referred to by Bahr as Herr Felix,[5] captured the *Genossenschaft*'s governing committee, a crisis was precipitated leading to the departure of the *Jungen* and the founding of the Secession. Unable to expel the money changers from the old temple,

[5]The painter, Eugen Felix, was a mediocre artist, a skilled intriguer, and a representative of the most conservative faction within the *Künstlergenossenschaft*. His election to the presidency of that organization in 1896 made conditions intolerable for the *Jungen*.

they built a new one of their own and opened the doors to all who were dedicated to true and honest art.

For Bahr, the events that caused the split in the *Künstlergenossenschaft* and the founding of the Secession were part of a critical struggle between good and evil in Austrian art. The members of the Secession, like true prophets, were persecuted by their colleagues and finally cast out for preaching the truth. Bahr, of course, had a rather partisan view of events, yet the emphasis he places on the struggle between art and commercialism accurately reflects what was perceived by the *Jungen* to be an arch sin of their opponents;[6] however, a strong element of stylistic conflict was also in-

[6]The truth of the accusations of commercialism that the Secession hurled at the *Genossenschaft* are difficult to verify since information concerning the prices paid for specific works of art is very difficult to come by. Still, from what evidence is available, it seems likely that the Secession's opponents were at least well off, if not actually venal.

The "Makart style" had made historicism extremely popular in Austria-Hungary and its creator lived in a lavish style as reflected in Rudolf von Alt's painting of Hans Makart's extremely well appointed studio. What lesser practitioners of the style earned can only be guessed at, but the income of the *Künstlerhaus* where members of the *Genossenschaft* exhibited suggests that it was probably respectable.

The *Künstlerhaus* was owned by the *Genossenschaft* and was the only large scale hall designed specifically for art exhibitions in the city, and before the construction of the *Secessionsgebäude* (Secession building) the *Genossenschaft* had a virtual monopoly on exhibit space. Yet, even after the appearance of the Secession as a rival the income of the *Künstlerhaus* for the years 1898, 1899, and 1900 was 182,914 Kronen, 135,512 Kronen, and 218,081 Kronen, respectively (see Jelusich, Mirko; *Geschichte um das Wiener Künstlerhaus* [Wien: Verlag Kremayr & Scheriau, 1965], p. 22). The sum of 4.80 Kronen equalled one dollar. This was an income based on commissions paid the house on each work sold. The Secession followed the same practice, levelling a 10 percent charge which, however, never brought in that large an income. Assuming that the *Künstlerhaus* charged about the same amount, it must have had a considerable volume of sales to earn that much money, which seems to indicate that a fair number of artists were making healthy if not immense incomes as members of the *Genossenschaft*.

volved. The *Jungen* were definitely, though not exclusively, partisans of the art nouveau style then prominent in the rest of Europe, and their opponents not only seemed unwilling to relinquish their profits, but also were loath to give way to the new art.

The character of the *Jungen* prior to 1897 was that of the stylistically avant-garde faction within the *Künstlergenossenschaft*.[7] Those who counted themselves among the *Jungen*, whether of the older generation like Theodor von Hörmann (Figure 2) or of the younger like Josef Engelhart (Figure 3), felt their works to be representative of what was both honest and progressive in art. The opposition that they met from their more conservative colleagues came initially from a stylistic antagonism not unlike that occurring in other parts of Europe at the same time. This clash of styles, however, also involved a latent clash of philosophies that came increasingly to the fore. The dual nature of this conflict can be seen in the cases of Hörmann and Engelhart.

[7]Before the creation of the Secession the restaurant "Zum Blauen Freihaus" and the Cafe Sperl were the seats of two informal organizations of artists known as the *Haagengesellschaft* (named after the friendly owner of the "Zum Blauen Freihaus") and the *Siebenerclub*. The *Haagengesellschaft* was the older group, having been founded in 1876, with the *Siebenerclub* not appearing until 1895. Their memberships were primarily made up of artists from the *Künstlergenossenschaft* and, though they produced some art work and even publications under their own names, both organizations were mainly social in nature, providing a convivial venue for younger artists to discuss artistic issues of the day. Several future Secessionists were to be found in both groups. Rudolf Bacher, Josef Eugelhart, and Johann Viktor Krämer belonged to the Haagengesellschaft, while Josef Hoffman, Koloman Moser, Josef Olbrich, and Krämer, as well, were to be found in the *Siebenerclub*. After 1897 the *Haagengesellschaft* became gradually less active and the Siebenerclub lost its members to the Secession, but it seems to have been in these two groups that the ideas of the *Jungen* germinated. (See Ankwicz von Kleehoven, "Die Anfange der Wiener Secession", in *Alte und Moderne Kunst* 5. Jahrgang (Juni/Juli, 1960) pp. 6–10. Von Kleehoven bases his account on the recollections of the Secessionists Sigmund Walter Hempel, Josef Hoffmann Josef Edgar Kleinart, Johann Viktor Krämer, and Carl Moll.)

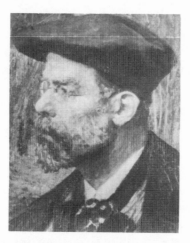

Figure 2 Johann Viktor Krämer: "Theodor von Hörmann" (c. 1895).

Theodor von Hörmann died in 1895, two years before the founding of the Secession, but was always considered by that group as a pioneer of the modern movement because of his struggle against the dominance of the historicist-Makart style in Austrian painting (Figure 4). Hörmann painted scenes from nature in a bold impressionist manner, which gained him nothing but isolation within the *Künstlergenossenschaft* until the advent of the *Jungen* faction. Though he managed to exhibit some of his works in Paris, he was constantly refused an exhibition at the *Künstlerhaus* for lack of artistic fitness, and was strongly ridiculed by critic and public alike for his unorthodox use of color. Only once was he allowed a collective exhibition in Vienna, but even then only as part of a Christmas show in which he was allotted sufficient space for just over half his works.

Hermann Bahr in his book on the Secession relates how he once asked Hörmann what he had done to be so hated in the *Genossenschaft*. Hörmann (3) gave the following reply:

> Done? I to them? Haha! I simply would like to be an artist—yes, I am so insolent! And that they never excuse anyone. For that they loose all the dogs on one!

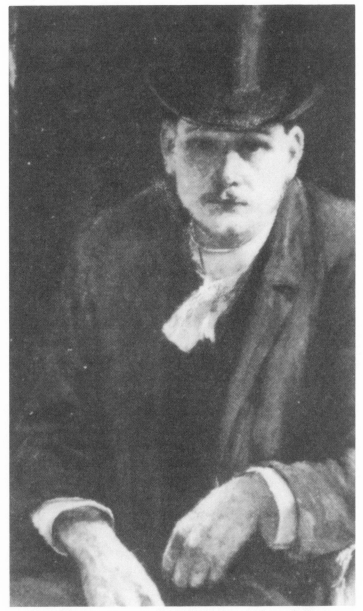

Figure 3 Josef Engelhart: "Self-Portrait with Top Hat".

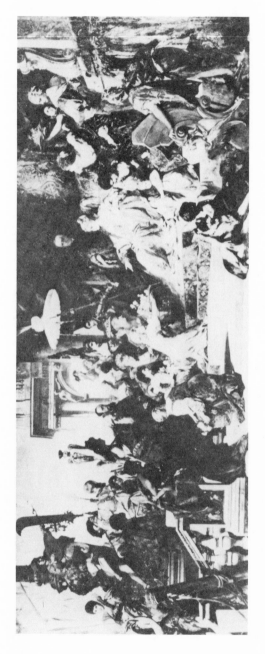

Figure 4 Hans Makart: "Venice Honors Caterina Cornaro" (1872–1873). This painting by the Chief Viennese practitioner of historicism illustrates the style's eclecticism. Makart has taken a Rubenesque theme, borrowed the master's technique of composition, and peopled his canvas with late 19th century Viennese.

Indeed, recognition came to Hörmann only after his death (4), but his difficulties at the hands of his conservative colleagues illustrate the opposition faced by the *Jungen*. A basically impressionist style, drawing heavily on nature themes, was considered enough beyond the pale by its opponents to justify letting "loose the dogs on one." Hörmann had merely wanted to be an artist, which for him meant painting things honestly as he saw and felt them (5), yet it was essentially on these grounds that he felt himself to have been persecuted. Such a persecution by its very intensity seemed to go beyond a simple stylistic disagreement and into the realm of basically opposed outlooks on art. How basic this schism between the two camps was can be further illustrated by the example of Josef Engelhart.

Engelhart, too, suffered at the hands of the opposition, but unlike Hörmann he became a symbol rather than a martyr for the new art. The affair over his painting, the "Woman Picking Cherries" ("*Kirschenpflückerin*"), in 1893 served as a rallying point for other like-minded artists, and according to Engelhart, himself (6), sparked the formation of the *Jungen* faction within the *Genossenschaft*. His painting of a nude girl picking cherries was done in the impressionistic style Engelhart had studied in Paris. Though it was rejected for exhibition on the grounds of immodesty, Engelhart recognized this as a rejection of his style, pointing out that nude studies were often publicly exhibited at the painting academy and that a work by the French artist Georges Rochegrosse called "The Death of Babylon," which contained an orgy, had just recently been exhibited (7). In answer, the head of the *Künstlergenossenschaft*, Professor Josef Trenkwald,[8] replied that it was bad for the public to see a work like Engelhart's because

[8]Professor Josef Trenkwald was a former director of the Prague Art Academy and in 1893 was the rector of the Imperial and Royal Academy of Art as well as being a member of its faculty as a specialist in historical painting, a post he held until his retirement in 1895.

of the current tendency to use "unbeautiful" models who were "without that transfiguring shimmer of poetry which inspired every picture of the antique and Renaissance periods" (8). Again, a painter was being discriminated against because of his unorthodox style.

Engelhart was not silenced by this, however, and in the course of the debate over his painting he went on to point out to Trenkwald that the changing times were creating differences between artistic generations (9) and that what was modern in art could hardly be held back much longer (10):

> The new strivings, the modern views which encompass not only painting, but rather all of art, have diffused themselves over the entire civilized world and have finally fastened roots here, also. Do you believe that the struggle of those men, who for this have staked their existence, has passed by without a trace? No! It stemmed from a need and, therefore, it is only a question of time as to when it will have succeeded here, as well.

Besides being a stirring profession of faith in the ultimate triumph of the modern movement in art, Engelhart's words were also a rebuttal to his conservative opponents.

In his effort to defend the artistic value of his painting, Engelhart found it necessary to justify the value of the modern movement in art as well, for his work was an intimate part of that movement. Trenkwald's statements made it clear that Engelhart was being condemned for his lack of adherence to past styles, the same styles that his opponents in their historicist works were still imitating. The actual worth of his artistic expression was not being judged on its own merits, but rather on the fact that it was identifiably unorthodox, and therefore modern. Hörmann had recognized that this was an attack upon art created by honest impulse, and Engelhart, in turn, saw it as an assault upon all that was new in art, all that was coming from men "who had staked their existence" on the value of what they were expressing. By their opposition, the opponents of the *Jungen*

seemed to be attacking the most vitally creative forces in art, and under such circumstances the *Jungen* quickly came to see themselves as true artists struggling against unimaginative hacks.

The black and white division between the *Jungen* and their opponents was further strengthened by what appeared to be the blatantly mercenary character of that opposition. The conservatives, because they held most positions of authority in the *Künstlerhaus,* were able to organize exhibitions that favored their own side and that were admittedly lucrative events. The historicist style had long been established in Vienna and had a ready market with the public. Although the Secession's own exhibitions would later prove highly lucrative themselves, for the moment, the opposition was also guilty of the sin of greed.

The differences between the *Jungen* and the *Alten* grew more pronounced in the wake of Engelhart's confrontation with Trenkwald and resulted in an open struggle within the *Genossenschaft* that noticeably increased after 1895. The critical events of April and May, 1897 that would lead to the founding of the Secession were preceded by almost two years of political manuevers between the *Jungen* and the *Alten;* the former to push for administrative and exhibition reforms favorable to their views and the latter to preserve the status quo and their position.

Shortly after the incident over Engelhart's painting, a pamphlet appeared censoring those responsible for excluding it. The pamphlet was obviously inspired by Engelhart and succeeded in holding his opposition up to public ridicule. In what Walther Maria Neuwirth implies was a result of popular reaction to the pamphlet, the *Jungen* succeeded in having two of their number, the painters Carl Moll and Josef Mayreder, elected to the steering committee of the *Genossenschaft* (11). This, however, was a small victory and the conservative *Alten* who had come to power in the elections of 1893 under Trenkwald and Felix still held most positions of influence.

Yet, despite the dominance of the *Alten* the appeal of a fresh approach in the arts was not without its effect among the rank and file of the *Genossenschaft*. This was revealed in 1894 when the opposition of the *Allgemeine deutsche Kunst-genossenschaft* (General German Art Guild) prevented the recently founded Munich Secession and an independent Düsseldorf group from participating in the *Genossenschaft's* Third International Exhibition. Reacting to what was perceived as an injustice and from an interest in the new art, the majority of the *Genossenschaft* voted to offer their colleagues an exhibition of their own at the *Künstlerhaus*. It took place in December and was received with great excitement by the public (12). Although Munich represented a relatively conservative avant-garde, art in the manner of symbolism, impressionism, and the developing art nouveau style had, nevertheless, been a success in Vienna. This emboldened the *Jungen* to press their views more vigorously.

Inspired by the success of the Munich exhibition, Theodor von Hörmann called for the creation of an "Austrian Gallery" in which the development of impressionism would be displayed. Typically, his call went unheeded, but he was not discouraged. In 1895 he went on to advocate controversial reforms in commercial and exhibition policy, and the composition of committees (13). In the elections of that year, however, a more moderate president succeeded Trenkwald, the architect Julius Deininger, and 1895 saw the first major "political" successes of the *Jungen* within the *Genossenschaft*. These successes can, in part, be explained by the favorable aftereffects of the Munich exhibition, which probably gained sympathizers for the *Jungen,* and by the temporary weakening of the conservative's hold on the *Genossenschaft* signaled by Deininger's election; but it was not until one of their number had scored an undeniable major artistic success that the *Jungen* were able to mount a serious challenge to the *Alten*.

In 1895 a painting by Gustav Klimt entitled "The Auditorium of the Schloss Esterhazy in Totis" won the Grand

Prix at Antwerp (14). The impact of this triumph raised the prestige of the *Jungen* to the point where Engelhart, Klimt, and the architect Otto Wagner, among others, were able to win positions on important committees (15). In a letter to the *Jungen*, Rudolf von Alt, Austria's leading painter, expressed his indirect criticism of their opponents by exhorting them to "Preserve your warm hearts and praise the fate that made you true artists" (16). Their self-image was clearly becoming heroic, and with Hörmann's death in July they acquired a fallen hero in whose name they could struggle. In the following year, 1896, the *Jungen* were able to make further gains when their momentum carried them into more committees, onto juries, and for the first time to the garnering of significant medals at *Künstlerhaus* exhibitions. The climate had seemed to change so radically in their favor that they decided to put up their own candidate for president of the *Künstlergenossenschaft*.

The *Jungen* ran the sculptor, Edmund Hellmer, but their hope to capture the leadership and thereby secure a strong and lasting position for themselves and their views proved illusory. On November 30 in a highly charged election during which fears were expressed about the effects of partisanship on the unity of the *Genossenschaft* (17), the *Alten* still had enough strength to defeat Hellmer in a vote of 99 to 115 for Eugen Felix (18). It was clear from the vote that the *Jungen* had many supporters among their colleagues; but 99 out of a total membership of over 300 (19) were not enough, and their defeat was followed by the appointment of *Alten* to key positions in the *Genossenshaft*.

The electoral victory of the *Alten* did nothing to reconcile the two camps, and in April of 1897 it was felt among the *Jungen* that they must have at least an autonomous organization of their own within the *Künstlergenossenschaft*. They chose as their leader Gustav Klimt (Figure 5). The son of a goldsmith, Klimt had made a name for himself as a decorator of theaters and public buildings, most notably the Art History Museum (*Kunsthistorisches Museum*) and the Burg-

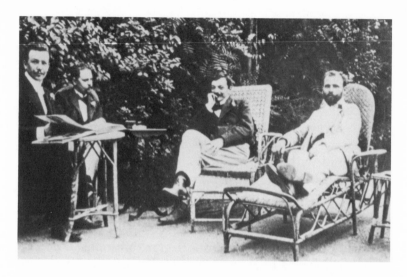

Figure 5 Photograph (c. 1898) showing from right to left Gustav Klimt, Koloman Moser, an unidentified man, and Joseph Olbrich.

theater.[9] He was also an established portraitist with a penchant for the dreamily erotic, but despite his ties to the artistic establishment, he sympathized strongly with the desire to break with the dominant style and as early as 1896 was identified as a leading "radical" among a group consisting of the architects Otto Wagner (Figure 6), Josef Olbrich (Figure 5), the graphic artist Koloman Moser (Figure 5), the journalist Berta Zuckerkandl, and Bahr.

As the chosen leader of the *Jungen* faction Klimt notified the *Genossenschaft's* governing committee on April 3 of this decision (20) and that it had been taken

> in order to bring Viennese artistic life into a livelier relationship with the progressive development of art abroad and to place the nature of exhibitions on a pure artistic basis free of any market character.

[9]The former imperial court theater now essentially the national theater of Austria, but called by the same name.

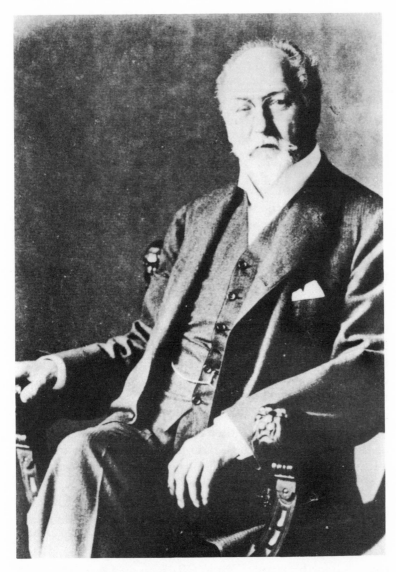

Figure 6 Photograph of Otto Wagner possibly around 1910.

One month later, the intransigence of Felix and his conservative supporters over the new group's exhibiting rights led to the walkout of the *Jungen,* and the founding of the Secession as a completely independent entity.

Perhaps thinking that their electoral victory would allow them to render the *Jungen* impotent, Felix and his supporters struck at their opposition through what amounted to a denial of their right to exhibit. This was the weapon that had been used against Engelhart and Hörmann, and access to exhibitions with the recognition and remuneration it brought was at the center of the political and philosophical dispute between the two factions. If the *Alten* could effectively control the exhibitions connected with the *Genossenschaft* they could go a long way toward nullifying the recent gains of the *Jungen* and thereby reestablish their own dominance.

The tactic employed by Felix was to withhold from the *Jungen* the official invitations to foreign exhibitions sent to his office. They would be delivered eventually, but too late for participation. Following such an incident concerning an invitation to a Dresden exhibition and its repetition with one to the major Munich *Genossenschaftsausstellung* the *Jungen* took matters into their own hands and sent works to the parallel exhibition of the Munich Secession. They did so without first submitting them to a jury of the *Genossenschaft* as they were obliged to do and this allowed Felix to bring a formal charge of misconduct against them and to present it at the general meeting of May 22, 1897 (21).

This set the stage for the final battle between the two factions. The meeting resulted in a tumultuous session during which the painter Johann Viktor Krämer called the charge of misconduct a libel (22); but the real explosion came when the painter Rudolf Ritter von Ottenfeld, who had just resigned from the *Genossenschaft*'s steering committee, revealed that at a meeting dealing with the Dresden invitation Felix had said that the *Jungen* should be kept away

from it even if one had "to raise the dead" to do so (23). In an attempt to end the ensuing uproar Felix offered to withdraw his charge, but in the ongoing exchange members of the *Alten*, directing their remarks at the *Jungen*, referred to the "hostile attitude of the opposition" (24). On hearing that remark, Klimt and eight other *Jungen* silently left the hall in protest. In reaction there was a call for their immediate expulsion, and the charge of misconduct was passed with only four votes against it. On May 24 Klimt formally notified the *Künstlergenossenschaft* that because of the misconduct vote he and 12 others were leaving the organization. By May 28 twenty-four members had gone over, with more to follow,[10] to what would soon be called the Secession (25), and on July 21 it held its first official meeting.

With the founding of the Secession, the demarcation between the former *Jungen* and their opposition became definite to the point that the differing stylistic positions of each side could be identified with philosophical ones as well. In the eyes of the *Jungen* the conservatives had resisted all that was new, honest, and vital in art and had done so, at least partially, out of materialistic motives. While in all likelihood the *Alten* felt themselves faithful to their own brand of artistic idealism, it seemed to the *Jungen* as if art in their hands had come to be a form of expression that was a mere servitor of past styles. In their own day these styles had been vital expressions of the circumstances and strivings of that period; in their own day they had been modern. By imitating these styles the painters of the historicist school were only

[10]One of the Jungen's most prominent supporters who chose not to join the initial exodus from the *Künstlergenossenschaft* was Otto Wagner. Among the allies of the Secession only Rudolf von Alt enjoyed more professional prestige. Wagner held the honorific title of *Oberbaurat* and taught at the Imperial and Royal Academy. Although he worked closely with the new group, he remained at the *Künstlerhaus* for two more years in hopes of a possible reconciliation. When this proved impossible he finally left on October 11, 1899.

perpetuating something that was already dead. There was nothing vital or honest in what they were accomplishing; they were not creators of art, but vendors of secondhand goods that, because of the sanctification of time, happened to sell well. Their philosophy of art was based on the principles of imitation and profitability. The *Jungen* were opposed to all of this, and their opposition helped to define their own philosophy.

To the *Jungen* the meaning of art lay in its vitality as an expression of its own time. As one of their supporters, Otto Wagner, had observed, "art and artists always represent their epoch" (26). What was important for an artist was that he express himself in as honest a manner as possible and that what he creates not be aimed at pandering to any taste alien to his inspiration. Moreover, there was something intrinsically valuable and noble in the very act of creating a work of art, and the *Jungen* were determined not to lose sight of that principle as their opponents had. The motto that they placed in 1898 above the entrance to the Secession reflected the essence of their attitude: "To the time its art, to art its freedom" (*Der Zeit ihre Kunst, der Kunst ihre Freiheit*).

The enshrinement of these words in the very fabric of the building that was the Secession's home was symbolic of the idealism to which both the building and its occupants were dedicated. Out of the struggle in the *Künstlergenossenschaft* the Secession emerged as the representative of idealism in Austrian art. Its call for purity and honesty were the elements of that idealism and the basis of the Secession's philosophy.

The substance of this philosophy was expanded, however, by the fact that the Secession was clearly not an exclusively Austrian phenomenon. To be sure, its idealism had developed in response to a supposed lack of it in Austria's artistic establishment, but from the very beginning, first as the *Jungen* faction and now as the Secession, it had always been aware of the artistic developments in Europe generally

and felt itself to be a part of those developments. Moreover, as the cases of Hörmann and Engelhart illustrate, the Secession's identity was linked with that of the new art in Austria, and this identity carried with it a consciousness of being both an Austrian and a European phenomenon. Because of this, influences from both contexts were significant in Secessionist thought. Its stated goals soon revealed its Austro-European character and ideas stemming from this duality enabled the Secession to reach through art to society.

As a formal organization of artists separate from the *Künstlergenossenschaft,* the Secession had to establish its own rules and regulations. These took the form of a series of statutes, the first of which dealt with the group's goals and defined them as the following (27):

1. The purpose of the Association is the furtherance of artistic interest and, above all, the elevation of artistic consciousness in Austria.
2. Toward the attainment of this serves:
 (*a*) the association of Austrian artists living in the Austrian hereditary lands and abroad;
 (*b*) contact with prominent foreign artists;
 (*c*) the arrangement of exhibitions in Vienna, the larger cities of the monarchy and abroad, in order to further Austrian art and its appreciation;
 (*d*) the introduction of the most important art trends of foreign lands for the stimulation of the Austrian public over the course of the general development of art.

These goals, besides being high minded and public spirited, also reflected the dual nature of the Secession as both an Austrian and a European phenomenon.

It is obvious from the above that the main goal of the Secession was concerned with improving the state of art in Austria. A key tool in accomplishing that goal, however, was close contact with foreign artists who were representative of those art trends from abroad with which the Secession hoped to stimulate the Austrian public. The vehicle for carrying out this process would be the Secession's own exhibi-

tions, which, in this context, were to serve a didactic purpose. Of course, Austrian artists and their works would occupy a prominent place in these exhibitions, but because the new Austrian art was closely related to that of the rest of Europe, it was necessary that the latter be present in order to explain the former. The furtherance of Austrian art and taste could not be carried out without furthering the general European cause of art as well, and, in the process, the Secession was obliged to show its European side to the Austrian public. This it did promptly in its first major undertaking— the publication of its journal, *Ver Sacrum.*

The appearance of *Ver Sacrum* in January 1898 preceded both the Secession's inaugural exhibition and the construction of its *Friedrichstrasse* home. It was the first concrete manifestation of the new group's spirit and was heralded as a harbinger of better days for Austrian art. In token of this feeling, the then director of the Burgtheater, Max Burckhard, expressed the feeling (28) that this new journal possessed

> ... the spirit of youth, through which the present is always becoming "modern," whose driving force is for artistic creations, and which as a symbol of this shall give the name of Ver Sacrum to these pages.

He further noted that *Ver Sacrum* meant "the sacred Spring of consecration" (29), and indeed its pages were consecrated to the flowering of the Secession and its art, but in a cosmopolitan context.

While the Secession may not have used *The Studio* as a model for *Ver Sacrum,* it was certainly following a trend of artistic journalism that had been inspired by this English prototype.[11] Since its appearance in 1893, this magazine had

[11]In his recent work on the journal *Ver Sacrum*, Christian Nebehay maintains that *The Studio* was too conservative a publication to have served as a model for the Secession. He feels that *Ver Sacrum* was basically original both in its format and content. (See Nebehay, Christian M., *Ver Sacrum 1980–1903*, New York: Rizzoli, 1975.)

been acclaimed not only in Austria, but all over Europe as the ideal publication devoted to art. As the official organ of the Secession, *Ver Sacrum* aimed at reproducing the cosmopolitan quality of *The Studio,* and to that end its standard of format and content was set very high. Not only did *Ver Sacrum* carry art work per se, but its contributors both in art and literature were often of international stature, and even though it received only limited circulation abroad, it ranked as one of the most significant journals of art nouveau (30). With *Ver Sacrum,* the Secession was able fully to integrate its Austro-European character.

The pages of *Ver Sacrum* served much the same purpose as the Secession's formal exhibitions. Within each issue one could see the best art of Austria set alongside that of the rest of Europe, usually accompanied by thoughtfully written articles, which, like the introductions of exhibit catalogues, amplified the didactic value of the illustrations. *Ver Sacrum,* like its parent organization, was meant to stimulate the Austrian public's interest in art. It professed essentially the same principles as the Secession, but in a somewhat more ecumenical tone.

The open policy that was to prevail in *Ver Sacrum*'s pages was expressed by its editorial committee in the first issue. They stated that "... to all who strive towards the same goals, even if also by different paths, we joyfully extend the hand of association" (31). The purpose of that association, though initially to attract foreign art to Vienna, was to be (32) not only for the benefit of

> artists, scholars, and collectors alone, but in order to educate the great mass of artistically responsive men, and thereby awaken the slumbering impulse toward beauty and freedom of thought and feeling that lies in every human breast.

It was to awaken all men and not just connoisseurs to the expanded and significant role art could play in their lives. Moreover, the reference to freedom of thought suggested that art could liberate as well as beautify life.

Through *Ver Sacrum* the Secession hoped to reach a fairly wide and potentially persuadable audience. Here, more obviously stated than it had been in the statutes, was the Secession's desire to make art accessible to a broad stratum of the population. The struggle within the *Künstlergenossenschaft* had not been for the benefit of artists only, but for all of art and those who appreciate it. Furthermore, just as there was to be no difference between social classes in the appreciation of art, the Secession also announced in *Ver Sacrum* that there was no longer to be any differentiation between the so-called major and minor arts: "We recognize no difference between 'high art' and 'low art,' between art for the rich and art for the poor. All art is good" (33). This equalization of art at all levels led into the Secession's idea of the *Künstlerschaft*—a concept key to its philosophy.

Ostensibly, the word *Künstlerschaft* meant simply "a community of artists." In true German fashion, however, the concept for which the word stood went well beyond its simple meaning. The art historian, Werner Hofmann, indicates its broader significance by pointing to its link with the Secession's general view of art. He notes (34) that:

> It is equally immaterial to the Secessionist's definition of art whether it is an artist, an artisan, or a 'lay artist' who designs a chair or paints a picture. All the arts have equal rank and 'consumers' and 'creators' together form that ideal community, the *Künstlerschaft*.

The *Künstlerschaft*, then, was meant to be an "ideal community" of "consumers and creators."

The explanation for this link between the equalization of art and the concept of the *Künstlerschaft* leads back to the Secession's basic view of art. The definition of art that appears in the passage from Hofmann was not unique to the Secession, but was current in art nouveau circles, generally. In the Secession's case, however, this definition fit in very well with its idealistic attitude toward art for, if what was important in art was the purity and honesty of the creative

impulse behind it, then it was an easy step to accept the proposition that all art was of equal value so long as it met this basic criterion. Thus, the distinction between major and minor arts was without meaning. Painting and sculpture would no longer be more intrinsically works of art than the creation of a jeweler or the handiwork of a village craftsman —all were works of art and all had equally the potential of being masterpieces in their own right.

The destruction of the barriers between the former divisions within art meant that art was not only being equalized, but was also being defined by a common denominator—the creative impulse. The concept of the *Künstlerschaft* was an extension of this process to the relationship between the artist (the creator) and the public (the consumer). Under the *Künstlergenossenschaft* this relationship had been an essentially commercial one, with the artist existing apart from his public and the one link between them, the work of art itself, playing the stagnant role of a mere commodity; but now, as in the case of the Secession, art was being consciously produced to relate to both the aesthetic and day-to-day needs of the public. Thus, the Secession was at great pains to insure the integrity of the art it produced and exhibited, while the exhibitions themselves, with their strong didactic leanings, were meant to educate and inspire the public in their appreciation of art.

The new situation produced by the Secession allowed a work of art, because of the integrity of the creative impulse behind it, to become a genuine link between the artist and the public. Such a work of art was, in the Secession's view, on a high artistic level, and its appreciation or acquisition by a member of the public was a means of coming closer to an understanding of art and what it had to offer. To be sure, the artist had created the art that the public "consumed," but they were both bound together by the common denominator of interest in and concern for art. This bond united them in the "ideal" community of the *Künstlerschaft* no matter at which end of the creative process they found themselves.

The community envisaged in the concept of the *Künstler-schaft,* however, was more than just a uniting of "consumers" and "creators" through the medium of art. In an even broader sense it was an effort to bring about a closer relationship between art and life. Obviously, for the artist his art was his life, but for the public, art was merely an adornment of life and not life itself. The *Künstlerschaft* could not, of course, transform "consumers" into "creators," but the public's appreciation and understanding of art's importance in life was certainly to be deepened beyond its former superficial level.

An article that appeared in the January 1899 issue of *Ver Sacrum* entitled "Art Enthusiasm" pointed out the need for such a change. According to the author, the so-called art lover of the day was often just a superficial aesthete spouting borrowed criticisms and without any proper appreciation of art. For his own good and the good of art, it was necessary that this situation be changed. The "art lover" had to be freed from the dicta of mere critical opinion so that his inner senses would allow him to appreciate truly a genuine work of art (35). Placed in the context of the *Künstlerschaft,* such an appreciation was to lead to the recognition of art's importance in life.

In a city such as Vienna, where the formal appreciation of art had traditionally played a prominent role in the lives of at least the upper classes, the transition from art as adornment to art as an intense life experience fits into this tradition very well, but the Secession aimed at a more all-encompassing extension of both concepts. To be sure, the concept of the *Künstlerschaft* involved a community of "consumers" and "creators" linked together by art, but so long as exposure to that art was limited to what was available in the pages of *Ver Sacrum* and the exhibitions of the Secession, that community was likely to remain a rather select group drawn from those classes already interested in art. If the relationship between art and life was to become

more integral and the *Künstlerschaft* include more than an elite segment of "the great mass of artistically responsive men," then something more was necessary. The potential for that something more was available in the concept of the *Gesamtkunstwerk*, which, indeed, was the capstone of the Secession's philosophy.

The term *Gesamtkunstwerk* literally means "a total work of art," that is, a work in which all the arts are joined together in one unified creation. Ideally, a *Gesamtkunstwerk* was to have included music, drama, the fine arts, and architecture, but historically such a combination came close to being attained only in the elaborate theatrical productions of the Baroque period. In the nineteenth century the idea of the *Gesamtkunstwerk* was revived by Richard Wagner, who theorized about its nature and attempted to produce his operas as total works of art. The resultant productions, however, were actually combinations of music, drama, and the fine arts without a true architectural element, for sets and backdrops were only sham architecture at best. With the advent of art nouveau in the 1890s the meaning of the *Gesamtkunstwerk* underwent a further transformation, and its musical and dramatic elements moved into the background in favor of the fine arts, architecture, and a new addition, the crafts. In the context of art nouveau and the Secession, it was the combination of these elements in a unified design that constituted a *Gesamtkunstwerk*.

The apotheosis of art and the *Gesamtkunstwerk* became virtually synonymous and the task of the artist in relation to it became altered accordingly. As Joseph Lux, an art critic and friend of the Secession, pointed out (36), the artist ought no longer to simply paint a picture,

> but rather should create carpeting to go with that picture and furniture to go with the carpeting and finally, the entire living establishment [including] perhaps even the house itself so that everything would come out of a single design. . . .

To live up to this ideal the artist had to be a virtuoso capable of combining his traditional talents with those of both a craftsman and an architect. The assumption of the craftsman's role was well in keeping with the concept of the equalization of the arts, for the applied arts were now on a common level with those of painting and sculpture, but beyond the equalization theory a knowledge of the applied arts was also something associated with the role of an architect and this the artist had to incorporate if he were to create a total work of art. The necessity of having a house or other structure as one of its elements made it clear that a *Gesamtkunstwerk* could not exist outside the framework of architecture.

This integral relationship between architecture and the realization of the *Gesamtkunstwerk* called for an artist-architect not unlike those who had flowered in the Renaissance. Though no men with the stature of Michelangelo or da Vinci appeared, there were, however, those capable of filling this dual role. In Belgium there was Henry van de Velde, in France Hector Guimard, and in Scotland Rennie Mackintosh, to name only a few, while in Austria it was Otto Wagner and his students, Josef Olbrich and Josef Hoffmann (Figure 7), who possessed this necessary virtuosity.

The need to reunite art and architecture had already been felt in Austria prior to the Secession. As early as 1895, Otto Wagner, a prominent architect and professor at the Imperial and Royal Academy of Art in Vienna and an early supporter of the *Jungen* faction in the *Genossenschaft,* had pointed out the desirability of such a reunification in his book, *Moderne Architektur.* He deplored the then current practice of separating art and architecture into distinct compartments, thereby producing architects who were primarily mere engineers devoid of aesthetic feeling (37). The physical results of this practice were the numerous buildings done in the historicist style that dominated the Viennese city-scape (Figure

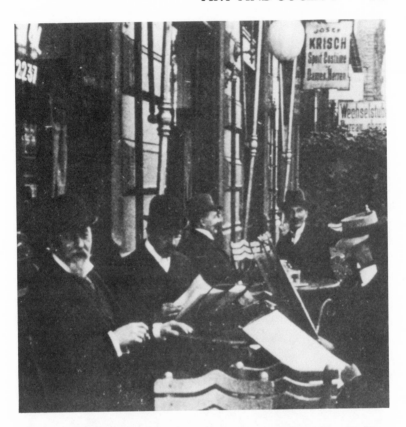

Figure 7 Photograph taken at a sidewalk cafe around 1912 showing Otto
Wagner on the far left with Josef Hoffmann seated next to him reading.

8). As a means of accomplishing this reform he felt that
prospective architects must be screened for artistic sensibil-
ity, this sensibility refined, and all mediocrities and place
seekers discouraged from entering the profession (38).

In addition to re-emphasizing the artistic nature of archi-
tecture, Wagner also proposed a new canon for judging the
success or failure of every design—functionalism (39).
Though originally himself a practitioner of the historicist
architectural style, he had come to deplore it and found the
outright copying of past styles upon which it was based a

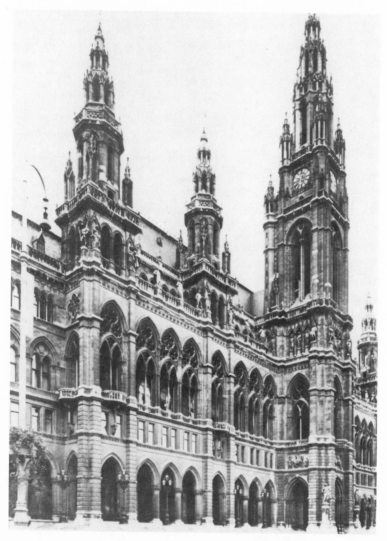

Figure 8 Photograph of the Vienna Rathaus. Designed by Friedrich von Schmidt, it was built between 1872–1883 and is one of the main examples of historicist architecture on the Ringstrasse. Though primarily Gothic in style, its eclecticism is evident in the mansard roof, the windows above the arcade, and the gas lamps set into the steps.

pointless anachronism unsuited to modern needs. In functionalism he saw a sound basis for developing a truly modern style of architecture capable of replacing historicism. Indeed, Wagner's own geometric style, which also appears in the works of his students, was adopted by him because of the importance he felt was attached to the straight line in modern technology and therefore to this form of design as a functional expression of the contemporary world (Figure 9). He felt that practicality in form and function was part of the modern spirit, and even went so far as to declare that "something impractical can never be beautiful" (40). Wagner felt that a building must be true to the purpose for which it was designed, that the materials utilized in its construction must conform to the building's needs, that the building techniques used ought to be the most advanced available,

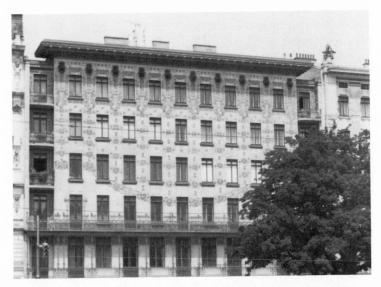

Figure 9 Photograph of Otto Wagner's "Majolica House" (Vienna) built in 1898–1899. A product of his early Secession style, it illustrates his interest in the use of flat surfaces and clear lines. The use of decoration so evident here remained in the work of Wagner and his pupils, but became increasingly restrained and largely geometrical in form.

and that finally, if these dicta were followed the resultant structure could not help but be representative of its age.

Wagner felt that architecture had to relate to contemporary human needs if it were to be a vital art form. Historicism was not vital because it had failed to do so. The problem, then, was "to perceive correctly the ideas of humanity" (41), and to realize "that the sole point of departure of our artistic creation should be modern life" (42). The kind of response Wagner saw as necessary on the part of architecture was also part of what he saw as the task of art generally (43):

> The problem of art which is thus also the problem of modern art has remained the same as it was in all times. Modern art must through the forms we have created represent our modernity, our ability, and our commissions and omissions.

Art was nothing less than a reflection of and a response to the life around it. The creations of one were stimulated by the requirements of the other so that art and life were indeed integrally related.

Such an outlook was absolutely compatible with that of the Secession. Wagner's insistence upon having architects capable of artistic expression and his opposition to historicism were akin to the Secession's own outcry against the members of the *Künstlergenossenschaft* and their historicist style. Moreover, his concern that art be an honest expression of its age and responsive to human needs fit in completely with the modern outlook of the Secession and its desire for art and life to be interrelated. Indeed, the compatibility of these two outlooks is also evident in Wagner's early support for the Secession when it was still only the *Jungen* faction, and though he did not join its ranks until October of 1899 (44), his two proteges, Olbrich and Hoffmann, became founding members and key figures, along with their master, in developing the Secession's version of the *Gesamtkunstwerk*.

To be sure, other members of the Secession such as Gustav Klimt and Koloman Moser contributed their considerable talents to the *Gesamtkunstwerk* ideal, but because of the need for a structure in which all the arts involved could coalesce into one entity, it was Wagner, Olbrich, and Hoffmann, as the group's architects, who had to be the overseers in any such effort. It may, in fact, have been the architects in the movement who were most familiar with this concept, for Hoffmann used the word *Gesamtkunstwerk* to describe the Palais Stoclet, the Secession's most ambitious effort in the realization of this ideal (Figures 10 and 11) (45). Wagner's dictum that when architecture worked in combination with its sister arts the staff of command must always be held by the architect (46) was applied here, and apparently accepted since there is no record of demur on the part of Hoffmann's colleagues. In part the reasons for this were practical, since there had to be one personality capable of coordinating all the different aspects involved in carrying out an undertaking like the creation of a *Gesamtkunstwerk* and besides, only the Secession's architects received commissions suitable for such an undertaking. A *Gesamtkunstwerk* in the form of a house or other building could not be created on a speculative basis. In addition to possessing the necessary acumen and opportunity, however, the architects, particularly Olbrich and Hoffmann, had a distinct zeal to see their ideas take concrete shape and all these factors combined to make them a dynamic force in the service of the *Gesamtkunstwerk.*

In the early days of the Secession, none of the three architects was perhaps more zealous in favor of the *Gesamtkunstwerk* ideal than Josef Olbrich. Prior to the founding of the Secession, Olbrich was a promising young talent in Wagner's architectural firm, and, though mainly employed as a draftsman, he often added his own ideas to the master's designs. (47). The advent of the Secession gave him his first chance to build something of his own, the Secession build-

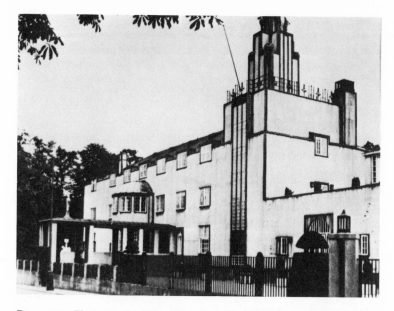

Figure 10 Photograph of the street facade of the Palais Stoclet in Brussels built 1905–1911. Josef Hoffmann was the architect and chief designer, but artists from the Secession and Wiener Werkstätte applied their talents to both its interior and exterior design to create it as a *Gesamtkunstwerk*.

ing itself; and the ferment of ideas and the artistically exciting atmosphere of the Secession generally stimulated him.

The enormous success of the Secession's first exhibition in 1898 encouraged its members and sympathizers alike and seemed to herald the dawning of a new day for Austrian art. To celebrate this first triumph a party was held at the Victoria Hotel, and on that occasion Olbrich stood up in the midst of his fellow revelers and held forth on what the Secession's next goal should be. Hermann Bahr was present at that affair, and in an article that he later wrote in *Ver Sacrum* he recalled what happened on that memorable night.

At the peak of the self-congratulatory atmosphere of the evening Olbrich suddenly stood up and shouted, "No this

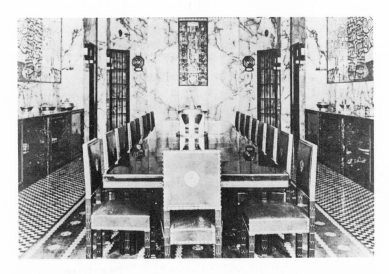

Figure 11 Photograph of the dining room of the Palais Stoclet in Brussels. The furnishings were made by the Wiener Werkstätte and the frieze was done by Gustav Klimt (1909).

is not all, all this is still nothing until we build a city, an entire city." Upon hearing this, Bahr relates (48) that:

> We looked up, it became quiet, everyone felt that this was it, what had lain in us so long was now spoken. But he went on and our souls spoke with him: 'Not one picture more that does not go with the wall; no room that does not agree with the house; [and] no house that is alien to the street! No, we want to demand from the government a field in Hietzing or on the Hohe Warte, a wide, empty, free field in order to here create our world with a temple of work for art and craft in a grove, and around it huts [for us] to live in, [a world] in which our spirit will dominate the entire establishment [just] as it does every chair and pot. That is indeed so simple and clear that one can understand it immediately. All that needs to be done is for someone to speak with the [appropriate] minister.

Unfortunately, the creation of Olbrich's ideal city was not so easy as he had envisaged and, in fact, was never carried

out in either of the Viennese districts he named nor any-
where else in Austria, for that matter. Olbrich had to emi-
grate to Germany in order to see his dream even partially
realized. In 1899 he was called to Darmstadt by the reigning
duke to design and direct an artists' colony, but the small
hamlet he built on the Mathildenhöhe was far from the city
he had called for in the name of the Secession. Despite the
unfulfilled promise of his vision, however, it does provide an
insight into the nature and implications of the *Gesamtkunst-
werk* within the context of the Secession.

Bahr remarked that when Olbrich called for the creation
of an entire city he was expressing a sentiment shared by all
his colleagues in the Secession. This common feeling even
included the form such a city was to take, which, according
to Olbrich's description, was to be that of a *Gesamtkunstwerk*.
His concern with the relationship of pictures to the walls, of
rooms to their houses, and houses to their streets was clearly
a reflection of the unity of design-concept necessary to such
an undertaking. Exactly how such a city would have looked
is open to speculation, but judging from Olbrich's project in
Darmstadt and the city planning designs of his teacher, Otto
Wagner (Figure 12) (49), the basic approach can be dis-
cerned. The city called for by Olbrich would have been an
entity composed of separate units, each of which was a
complete design unto itself and linked to neighboring struc-
tures by common stylistic traits, while the streets along
which these buildings stood would be laid out according to
a master plan, so that when taken together the city would
appear as a harmonious whole. Thus, the requirement that
all the elements of a *Gesamtkunstwerk* must reflect the overall
design of the final creation would be carried out even in the
construction of a city.

Artistically, of course, such a city would have been a
triumph writ large for the Secession's style. Its core would
undoubtedly have been Olbrich's so-called temple of work,
and the artists' quarters surrounding it. From this installa-

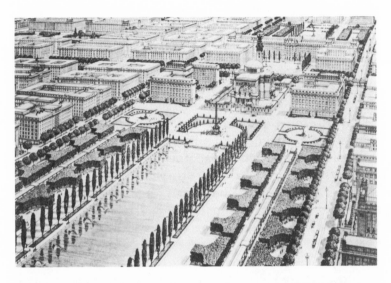

Figure 12 View of the open-air center of a proposed *XXII*nd Viennese district published in Otto Wagner's *Die Grosstadt* (1911). The symmetry and uniformity of design as well as the emphasis upon facilities for modern traffic and greenspace for the city dweller indicates one form that the city as *Gesamtkunstwerk* might have taken.

tion would probably have issued the designs and objects necessary to outfit the city in accordance with Secession taste, with the end result being the city as both *Gesamtkunstwerk* and a product of Secession art. Still, the most important thing to remember, however, is that the city as a total work of art not only meant the uniting of design and style, but was the creation of an environment for living as an artistic response to the needs of life.

When viewed as such a response, the city as *Gesamtkunstwerk* takes on the character of a sophisticated exercise in city planning and in that respect is not too dissimilar from Schinkel's efforts in Berlin or Haussmann's reconstruction of Paris, except that neither ever achieved the totality of this conception. Not only was it stylistically different from these examples, but the *Gesamtkunstwerk* in the context of the

Secession carried with it implications beyond just unity of design. The environment it was to create was one of content as well as form. In it all the views of the Secession on art and its purpose came together and found expression in the idea of the *Künstlerschaft* now given a greatly augmented dimension by the scope of the *Gesamtkunstwerk*.

It was pointed out earlier that through the *Künstlerschaft* the Secession sought the uniting of art and life in a more integral relationship to one another. Because the Secession's art, in its own view, was not corrupt as that of the *Künstlergenossenschaft* had been, but was rather a pure and honest expression of creative impulse, it was felt that the public would be better able to recognize the intrinsic value of its beauty and content as a necessary part of their lives. Through the exhibitions held by the Secession the public was to be exposed to the new art and come to appreciate it and, hopefully, having once appreciated it, to then want it, and, wanting it, to buy it, and, having bought it, to make it a part of their everyday environment. By being in constant contact with it the purchaser would then come to realize how much of what it had to offer was a valuable part of his life, and in so doing would enter into a common bond with the artist who made it. The work of art thereby linked the "consumers" and "creators" into one community—the *Künstlerschaft*.

The effect of the *Gesamtkunstwerk* was to expand the environment and thereby the number of people affected by this art and to break the limitations imposed upon it as mere *objets d'art*. From a single piece to a whole room and at last as a house in which everything down to the smallest nailhead reflected one common design, art became in a literal sense the environment in which men lived. The *Gesamtkunstwerk* as a city was only a logical extension of what had gone before and meant that art would now provide the environment for thousands and even millions of people. In a city the entire population would be one vast public coming into

daily contact with art in all its myriad forms from painting and sculpture to its application in the crafts. The *Gesamt-kunstwerk* gave full play to the equalization of the arts and as a city its aesthetic pleasures would be open to rich and poor alike. The world created in this manner would be artistic, but not, however, merely decorative.

The concept that these buildings, whether house or factory, grew out of the actual needs of the contemporary age and were constructed in a contemporary manner, gave them an organic quality that accentuated that already bestowed by their unity of design. In a real sense they were to grow out of and be dictated by the circumstances of their time, giving the environment they created both a truly modern and truly organic quality, but they were also to be created as works of art to act as the component parts of one total work of art. They were, in this sense, the functioning parts of a much larger body. Art by forming the environment in which men both lived and worked was forging the most integral of relationships between itself and life. What better way was there of eliminating the gap between consumers and creators than through this total environment of art? Society, itself, now formed the potential constituency of the *Künstlerschaft*.

In the *Gesamtkunstwerk* the Secession had found the vehicle of its ultimate significance. It had begun by championing the need for art to be a pure and honest expression of its age, and went on to see it as the very framework in which that age was to exist. From the city as a work of art to the world was but a short step if the means could have been found to take it. The *Künstlerschaft* as society uniting not only the so-called consumers and creators, but the rich and poor as well in one beautiful, functional, and harmonious environment was evidence of art's ambitious potential. Moreover, such a society was to enjoy this harmony because of art's mystic bond, all sociological realities notwithstanding. Society, like art, was to be a total unity.

The *Gesamtukunstwerk* was the means by which art could act for the benefit of humanity and the support of this concept by the Secession reveals the basically humanistic thrust of the group's ideas. In promoting the *Gesamtkunst- werk* the Secession was also in effect promoting the idea that environment influences man's well-being and whether it be a room, a house, or an entire city, if that environment be beautiful and harmonious man will be happier, especially if the artistry of this environment, via the concept of the *Künstlerschaft,* helps to form a closer bond between himself and his fellow men. Such a conception of the role of art went well beyond the humanistic quality art had acquired in the time of the Renaissance, when it ceased to depict exclusively religious subjects in order to concentrate on man's worldly existence. In this new context art played an active role in improving the very life it depicted. In so doing it had become humanistic in the profoundest sense of the word—it was concerned with man's welfare and it was the Secession that gave it this new responsibility.

The Secession's desire to make art a true expression of man's creative power, to let art reach every responsive hu- man breast, to have it unite men through its bond and give them a useful and beautiful environment, all this indicates a positive and humanistic outlook concerning art and, when brought into a synthesis, represents the philosophy of the Secession. The reasoning of its principles runs as follows: that art is a human creation and not a commodity, that it must first and foremost be an expression of the creative spirit of man, that it must be free to express the circum- stances of its time and in so doing become a relevant part of it, that being such a genuine expression of art it must inevi- tably touch the lives of men and communicate the vitality of its artistry to them, that in so doing, men in their appreci- ation and understanding of it will be brought to one another first as artist and beholder and then as beholder to beholder, and finally that supplying the beautiful yet functional daily

environment of man will expose the mass of men to art and expand the community it has formed among them. This is the point of the Secession's philosophy, that the life of man can somehow be improved through art.

Such a view may admittedly be unrealistic in its ultimate social goals, but is one that clearly attempts to surpass what is merely commercial or aesthetic in the role of art. Hermann Bahr observed that "An artist is he who feels himself capable of bringing happiness to men and by so doing can help them to become better and more beautiful" (50). Bahr's definition expresses what was the collective goal of the Secession and its artists, a goal that managed to survive despite criticism from without and disruption from within the ranks of the Secession itself.

Chapter Notes

1. Hermann Bahr, *Secession* (Vienna: Wiener Verlag, 1900), p. 2.
2. *Ibid.*, p. 8.
3. *Ibid.*, p. 12.
4. Theodor von Hörman died in July, 1895 and in December the *Jungen* arranged an exhibition of 234 of his paintings as a memorial gesture, but it was not until four years after his death that Hörmann finally received full recognition for his work. From February 22 to the 26th, 1899 a collective exhibition of his works took place at the Secession. On the following two days there was an auction in which all his works were sold to the sum of some 40,000 Gulden. His widow donated half that amount to a fund for the purchase of paintings by young, unknown, but promising artists. Administered by members of the Secession, it was known as the "Theodor von Hörmann Stiftung" and functioned up to 1919 when the collapse of Austria's currency wiped out the endowment.

 Taken from Oskar Matulla, "Die Theodor von Hörmann Stiftung," Ms. in possession of the author, and Walther Maria Neuwirth, "Die sieben heroischen Jahre der Wiener Moderne," in *Alt und Moderne Kunst,* 9. Jahrgang (Mai/Juni 1964), p. 31.

5. Quoted by Oskar Matulla in "Die Theodor von Hörmann Stiftung," Ms. in possession of author, p. 1.

6. Gertrude Wagner, "Die Einflüsse der Wiener Secession und das zeitgenössische Schriftum and die sich daraus ergebenden Wechselwirkungen" (Ms.). Ph.D. dissertation, University of Vienna, 1939, pp. 154–155.

7. Josef Engelhart, *Ein Wiener Maler Erzählt* (Vienna: Wilhelm Andermann Verlag, 1943), p. 66.

8. *Ibid.,* quoted in Engelhart.

9. *Ibid.*

10. *Ibid.,* p. 68.

11. Neuwirth, "Die Sieben heroischen Jahre der Wiener Moderne", p. 29.

12. *Ibid.*

13. *Ibid,* pp. 29, 31.

14. Fritz Novotny and Johannes Dobai, *Gustav Klimt* (London: Thames & Hudson, 1967), p. 382.

15. Neuwirth, p. 29.

16. *Ibid.*

17. Robert Waissenberger, *Die Wiener Secession: Eine Dokumentation* (Wien und München: Jugend und Volk, 1971), p. 33; and Neuwirth, p. 31.

18. Neuwirth, p. 31.

19. Waissenberger, p. 33.

20. Robert Waissenberger, *Die Wiener Secession: Eine Dokumentation* (Vienna und Munich: Jugend und Volk, 1971), p. 36.

21. Neuwirth, p. 31.

22. *Ibid.*

24. Waissenberger, p. 36.

25. Neuwirth, p. 31.

26. Otto Wagner, *Moderne Architektur* (Vienna: A. Schroll und Co., 1896), p. 29.

27. From the *Jahresberichte der Secession,* Vol. I (1899), p. 19.

28. Max Burckhard in *"Ver Sacrum,"* Vol. I (January, 1898), p. 3.

29. *Ibid.*

30. Waissenberger, *Die Wiener Secession,* p. 74.

31. Editorial Committee of *Ver Sacrum,* "Weshalb Wir Eine Zeitschrift Herausgeben," in *Ver Sacrum,* Vol. I (January, 1898), p. 6.

32. *Ibid.*

33. *Ibid.*

34. Werner Hofmann, *Gustav Klimt* (New York Graphics Society, 1971), p. 39.

35. Wilhelm Schaeffer, "Kunstenthusiasmus," in *Ver Sacrum*, Vol. II (Jaunary, 1899), pp. 15–18.
36. Joseph August Lux, *Josef M. Olbrich, Eine Monographie* (Berlin: Verlag Ernst Wasmuty, 1919), p. 29.
37. Wagner, *Moderne Architektur*, pp. 18–22.
38. *Ibid.*
39. *Ibid.*, pp. 26–27.
40. *Ibid.*, p. 41.
41. *Ibid.*, p. 40.
42. *Ibid.*, p. 8.
43. *Ibid.*, p. 3.
44. Waissenberger, *Die Wiener Secession*, p. 38.
45. Peter Vergo, *Art in Vienna 1898–1918* (London: Phaidon Press, Ltd., 1975), p. 145.
46. Wagner, *Moderne Architektur*, p. 45.
47. Robert Judson Clark, "J. M. Olbrich 1867–1908," in *Architectural Design*, Vol. XXXVII, London (December, 1967), pp. 565–72.
48. Hermann Bahr, "Ein Brief an die Secession," in *Ver Sacrum*, Vol. IV (July 15, 1901), pp. 227–28.
49. Olbrich's artist's colony in Darmstadt was designed completely by him with only one exception. The home of the architect Peter Behrens was after his own design. Nevertheless, all the buildings on the Mathildenhöhe were each a *Gesamtkunstwerk* in their own right and together formed an environment united by common design. As for Olbrich's teacher, Otto Wagner, he had been concerned with city planning as early as 1893 when he submitted a plan for the regulation of Vienna in a competition held that year. In 1911 in his book *Die Grosstadt* he elaborated his ideas about the city and presented plans for proposed new districts in Vienna. The illustrations of these plans show a projected layout and form that fits the general pattern of the city as *Gesamtkunstwerk* discussed in this chapter. The buildings and streets were all part of one unified design and reflected Wagner's own geometrical style, while the individual structures themselves would undoubtedly have followed the requirements of a *Gesamtkunstwerk* as far as possible since Wagner was committed to total design in his buildings. The setting for these designs also included gardens and parks. The Secession, in fact, was not insensitive to the need for green areas in the ideal city generally, and in 1907 the *Wiener Werkstätte* even drew up plans for providing Vienna with more open space.
50. Hermann Bahr, *Das Hermann Bahr Buch* (Berlin: S. Fischer Verlag, 1913), p. 87.

Chapter 2
Society, Politics, and the Secession

The commitment of the Secession to a philosophy that insisted upon the involvement of art in the affairs of society was reflected in the movement's diverse activities. From its beginning the Secession consciously took part in a variety of actions in which it was either the initiator or a prominent participant. Its stance on all issues in which its art might play a relevant role was never passive, and from 1897 to its division into two camps in 1905, and even afterward, the Secession sought to be an influential and positive force in Austrian society.

It manifested this desire in a variety of ways. The presentation of didactic exhibitions, its involvement with government policy concerning the arts, as well as its spirited defense of artistic causes it felt were just, all indicate the many-sided activities of the Secession. In each case its involvement was based on either an implied or an explicit concern with the public interest, and in expressing this concern it attempted to act the part of a popular advocate of society's aesthetic needs. In the course of this effort it took on an institutional character and a rather authoritative attitude toward the arts.

Yet the role played by the Secession was not always an active one. Not only did it react to society, but society re-acted to it as well and sometimes, as in the case of Klimt's *Fakultätbilder*, [1,2] that reaction could be quite unfavorable. Still, in its initial phase, the Secession was the recipient of a largely benign response from several important groups in Austrian society. It was, however, a response more often dictated by a form of self-interest rather than by a simple love of art.

Once the Secession got under way in 1897, elements of the two most broadly based political parties in Austria, the Christian Socialists and the Social Democrats, both took an active interest in what the movement did. Initially, this in-terest even included the Christian Socialist leadership, but for both parties it always and primarily involved the press. Each saw something in the Secession that was either useful to or had an affinity with their causes, while the obligations of patronage, modishness, and social position dictated that the dynasty and aristocracy also play some part in the Seces-sion's affairs. It was, however, from the ranks of the liberals, more than any other group, that the Secession received in-terest and support. The social and cultural aspirations of the liberal upper bourgeoisie in Austria and their contraction as a popular political force all contributed to their willingness to grant this artistic movement the patronage appropriate to the semi-aristocratic position they were coming to occupy in Austrian society. The Secession became the beneficiary of a process of social change over which it had no control.

Austria's political and social conditions moved liberalism in a direction that had not been indicated by its philosoph-ical outlook. Ideologically, Austrian liberals, like those elsewhere in Europe, accepted the same humanitarian and

[1]See Chapter 3 for the complete discussion of this affair.

[2]Paintings that represented the major subject divisions of the faculties at the University of Vienna.

laissez-faire concepts, and as the historian Albert Fuchs has remarked, they "responded to a succession of basic questions in absolutely the same manner as their colleagues in other countries" (1). In its most simplified form, the liberal outlook held that the problems of the Habsburg monarchy could be solved through the establishment of personal and economic freedom within the framework of a parliamentary state. In order to achieve this, however, they shed the revolutionary tradition of 1848 and willingly cooperated with Kaiser Franz Joseph in setting up a limited parliamentary regime. With their basic desires satisfied,[3] Austrian liberals became a very loyal opposition. They accepted the dynasty and the empire and opposed those who, like the radical George Ritter von Schönerer, held anti-Habsburg and anti-imperial views. Unfortunately for Austria's liberals their image also included an identification with the economic collapse of 1873 and all the scandals and misery associated with it. In the following years their German bias made them unable to diffuse Czech and other non-German national movements, and by the 1890s the industrial order they had helped create called into being the mutually hostile, but equally antiliberal movements of social democracy and Christian Socialism. By the turn of the century the parties of the exploited workers and the economically threatened class of shopkeepers and artisans overwhelmed their common enemy at the polls. As great a blow, however, as this change in political fortunes represented, the liberal bourgeoisie had other avenues of power. Because they lacked any real antipathy to the old ruling elite and were themselves largely an elite of skill and wealth, once the liberals began their popular decline after 1873 it is not surprising that they

[3]Rule by majority party and a responsible ministry was never achieved in the Austrian half of the empire and remained an unattained objective of the liberals from 1867 on. Their inability to become a permanent majority party after 1873, however, made this something of a moot point.

gradually began to merge with the older influential elements of Austrian society, particularly the aristocratic, and to adopt aspects of their lifestyle.

Dating from at least 1867 on, the German liberals of Austria formed the dominant group in the bureaucracy, business, and the professions. Men of bourgeois and liberal origins even comprised a large proportion of the lower nobility, the so-called *Dienstadel* (Service nobility), which ranged from men with the simple aristocratic *von* in their name to the *Rittershaft* (the Knighthood) and *Freiherren* (the Baronage)[4] (2). This group had risen to prominence through service to the state and dynasty and insofar as they continued to hold liberal attitudes they formed with their nonnoble brethren a well entrenched and influential ideological minority. Liberals by the 1890s might no longer be able to corner many votes at the polls, but they could still be heads of government bureaus, corporate leaders, professors and doctors, and have a significant influence in setting the tone of their society.

The tone of Austrian society as it was mirrored in the setting of the Vienna *haut monde* was, of course, not the sole product of the liberal bourgeoisie. As the writer Stefan Zweig has pointed out in his autobiography, the "Imperial house still set the tempo [for society] with the palace forming the center not only in a spatial sense, but also in a cultural sense of the supernationality of the monarchy." This was followed by the cosmopolitan high nobility, and then came what Zweig described as "good society," which consisted of "the lesser nobility, the higher officials, industry, and the old families [older bourgeoisie]. . . ." (3). It was, however, this rather large upper middle class group, from which Zweig himself stemmed, that taken together with the two exalted strata above them formed what was simply

[4]Although Freiherr and Baron indicate essentially the same status, they are distinct titles and will be used as such in the text.

known as *die Gesellschaft*—society. While there was rela-
tively little penetration from the lower third to the upper
two-thirds of this grouping (i.e. the higher nobility), the
lifestyle of the upper two-thirds penetrated into and mixed
with the liberal bourgeois "culture of law" that was indige-
nous to that lower third, and there, as the American his-
torian Carl Schorske notes, created an interesting amalgam
(4).

The "culture of grace" was that of an aristocratic aestheti-
cism that involved patronage of the arts and the cultivation
of a refined lifestyle, while the "culture of law" was embod-
ied in the positivism and parliamentarianism of reason and
legality that was the hallmark of the liberal bourgeoisie. It
was a combination that left the formal ideology of the upper
middle classes liberal, while their lifestyles at least partially
imitated the aristocratic. Thus, Zweig can recall the re-
strained liberalism of his father while at the same time re-
membering that "a Viennese who has no sense of art or who
found no enjoyment in form was unthinkable in good soci-
ety" (5). For Zweig such concerns were inherent in Viennese
life, while in Schorske's opinion they also represent an at-
tempt at assimilation into the pre-existing aristocratic "cul-
ture of grace" (6) and as such are a reflection of the relative
insecurity of the liberal bourgeoisie in their *nouveau* political
and social status—an insecurity that was heightened all the
more by their steady decline in the political arena so soon
after achieving power. It may also be that this intense bour-
geois involvement in cultural matters, particularly at the
turn of the century, was a retreat from a deteriorating politi-
cal situation to a more congenial and promising sphere. Nev-
ertheless, it is true that the liberal German bourgeoisie of
Vienna figure prominently in upholding what had originally
been an aristocratic "culture of grace," but a culture that by
the late 19th century had come to form an important part of
bourgeois life. One way in which this pseudo-aristocratic
element found expression was in playing the prestigious

double role of both admirer and patron of the fine arts, and the Secession came to fall within the scope of that rule.

As both Zweig and Arthur Schnitzler profess in their memoirs, the members of their class, if they took an active participation in a cultural pursuit, as they did, usually aspired to be literary men, but the general Viennese esteem for culture and "an uncommon respect for every artistic presentation" had led to "a connoisseurship without equal" (7) that included the arts of painting, sculpture, and architecture, as well as of literature. In her book on pre-1918 Vienna, Ilsa Barea corroborates this observation and also points out that, "The barons of finance were generous in their patronage to artists who added lustre to their houses" (8).

During the construction of the *Ringstrasse,* [5] with its monumental architecture and luxurious apartment houses, these liberal barons of finance found ample opportunity to distribute their patronage among all manner of artists who were engaged in the designing and decoration of their buildings. Since almost one-third of the buildings on the Ring were owned by aristocrats (9) the artistic grandeur of properties owned by the bourgeoisie was probably, at least in part, prompted by a necessity to keep up with that high standard and the dominantly bourgeois *Rathausviertel,* [6] though of later construction and heavier style, was hardly inferior to the aristocratic *Schwarzenbergplatz* [7] district with its earlier and more restrained design. Indeed, in the late 1870s and in

[5]The *Ringstrasse* is a semicircular street that bounds the old inner-city of Vienna on three sides. It occupies the site of the former fortifications and part of the outer parade grounds. Construction along it from the 1860s until 1914 made it the focus of Vienna's principal public buildings, a center of fashionable apartments and businesses, as well as the city's main thoroughfare. It is one of the great triumphs of 19th century historicist architecture and city planning.

[6]The district around the city hall.

[7]The Schwarzenberg Square was and, to a degree, still is a fashionable district just off the *Ringstrasse.*

the 1880s, the later phase of *Ringstrasse* construction was dominated by the upper middle class, and it is with this sociological shift that the more elaborate form of historicist architecture comes into its own on the Ring (10).

The period in which the upper bourgeoisie were becoming the dominant group on the Ring also corresponds to the period when the painter, Hans Makart, was lending his name to the elaborate artistic tastes of later historicism (see Figure 4). In fact, it is in 1879 that the "Makart style" reached its peak of dominance with the famous historical costume parade organized by him in honor of the Kaiser and Kaiserin's silver wedding anniversary. Although Makart died in 1884, his influence continued to be felt in the artistic tastes of the time, including those of the bourgeoisie. In interior design these tastes ran to "a profusion of 'picturesque' objects, curios, potted palms and ferns, Japanese fans, gleaming shells and dried flowers or reed stalks, everything screened by heavy dark curtains and bathed in a soft golden light. . . ." (11) (Figure 13). Though Makart had no hand in architecture, the buildings constructed at this time contained a complementary profusion of stylistic elements that was the hallmark of late historicism.

It is not very often that one finds such an apparently exclusive and pervasive personal influence in the arts, but Ilsa Barea's observation that "The taste of a whole generation of Vienna's upper middle class had been shaped by Makart or the struggle against his influence" (12), is quite significant for both the development of this social group's taste and the growth of Austrian art as a whole. In the years after Makart's death, while his style continued to hold sway, opinions about it were, nevertheless, changing and the failure of his own paintings to fetch much of a price at the auction of his goods shortly after his death (13) may have been the first sign of the revulsion for the "Makart style" and historicism that came so strongly to the surface in the late 1890s. The last decade of the 19th century witnessed a

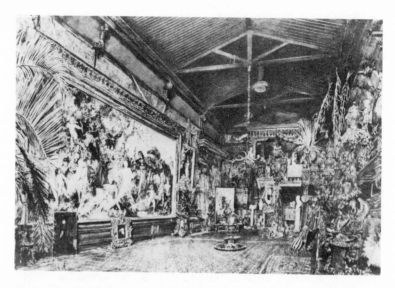

Figure 13 Rudolph von Alt, "Makart's Studio" (1895). The exotic objects, antiquities, casual pieces, and ferns of the artist's studio illustrate one of the ideal examples of historicist interior design.

growing discontent among the artists in Europe with all manifestations of historicism[8] and, in Austria, it was the artists of the Secession who finally revolted against it, but not without the assistance of that same bourgeoisie who had previously given themselves so willingly to the old "Makart style."

Support for the Secession movement among members of the Viennese upper bourgeoisie in the years before 1914 was initially manifested soon after the *Jungen* had left the *Künstlergenossenschaft*. The earliest and most significant form it took involved financially underwriting the Secession at the time of its founding. As Robert Waissenberger suggests in

[8]In addition to the growth of art nouveau in Belgium and France in the 1890s, the Munich Secession was founded in 1892 and by 1895 had been followed by several similar groups including those of Düsseldorf, Weimar, Dresden, and Karlsruhe.

his book on the movement, the support given it from bourgeois elements of *die Gesellschaft* was absolutely essential in the success of the Secession's revolt from the *Künstlergenossenschaft* (14) and, accordingly, one of the first things it did after leaving that organization was to try to secure funds for its activities from precisely that group. The two men entrusted with this important task were apparently the painters Carl Moll and Josef Engelhart.

In his memoirs, Engelhart recalled that it was due to "Moll's skill and my many connections . . . that in the course of a few weeks we had assembled the [necessary] capital" (15). Recruiting supporters for the fledgling Secession and raising money for the construction of its own building were considered of equal importance with the choice of its artistic membership (16). Again the abilities of Moll and Engelhart were employed to promote the money needed to construct the Secession's new home, and this they did with amazing dispatch. "It sounds today almost unbelievable," writes Engelhart, "that within [only] three weeks we succeeded in gathering together 70,000 Gulden from patrons and friends of art" (17). There is still, however, the question of exactly who these patrons and friends of art were.

While the Secession acknowledged the aid it had received from its various supporters, it never specified what that aid amounted to or who those supporters were. They are referred to anonymously, and one can only assume that they preferred it that way. Normally, such information might have been found in the official records of the Secession, but unfortunately these were lost during World War II when the Secession's building was gutted by Allied fire (18). Despite these formidable obstacles, however, it is possible to identify positively one of these original supporters and to speculate on the identity of at least one other.

When Engelhart referred to his many connections as the reason why he was chosen along with Moll to raise money for the Secession, he was apparently not exaggerating, for

one of those connections must have been with Karl Wittgenstein. In addition to being the father of the philosopher, Ludwig Wittgenstein, he was also one of the foremost industrialists in the Habsburg Monarchy. Originally trained as an engineer, Karl Wittgenstein became a leading entrepreneur in the Austrian iron and steel industry and by the turn of the century was counted as one of the richest men in the country (19). His achievements earned him the offer of ennoblement at the hands of the Kaiser, which, nevertheless, he declined to accept (20). Thus, Wittgenstein was both a prominent figure in the upper bourgeoisie and at the same time true to his bourgeois origins in his refusal to join the ranks of even the lower aristocracy. This assertion of his middle-class modesty did not, however, prevent him from following the aesthetic bent of his class and incorporating the culture of grace" into his own life and that of his family. The Wittgensteins cultivated the arts with great seriousness, and one of Karl Wittgenstein's sons, Paul, even became a concert pianist, while one of his daughters, Margaret Stonborough-Wittgenstein, had her portrait done by Klimt in 1905 and another, Hermine, was both a painter and a friend of Klimt (21). Along with cultivation of the arts, patronage of them was a natural complement.

As his friend and former business associate, Dr. Georg Günther, recalled in a brief article on Wittgenstein in 1927, not only was he incapable of doing anything petty, but he was also generous to "every kind of art," even serving as an honorary president of the Secession, which "owed to him its origin [Entstehung]" (22). More recently Allan Janik and Steven Toulmin in their book, *Wittgenstein's Vienna,* have stated that Karl Wittgenstein provided the money for the Secession's building (23). At the time of its construction the Secession expressed its gratitude for the help it had received from unnamed private sources (24), but characteristically said no more. The cost of the building, however, was not kept secret and seems to have been 60,000 Gulden (25).

When this figure is compared to the 70,000 Gulden Engelhart says he and Moll collected for the building from "patrons and friends of art," it would appear that Karl Wittgenstein was the chief supporter of the Secession in its early days. Where, however, did the other 10,000 Gulden come from?

Because it appears that no public funds went into the financing of the Secession's building (26), it must be assumed that all of the remaining money came from private sources.[9] Among these it does not seem likely that any funds came from members of the imperial court, since its attitude toward modern art at the time of the Secession's founding was only passive at best (27). It seems much more likely that the group's funds were supplied by other members of Vienna's upper middle class who, like Karl Wittgenstein, were more actively receptive to new developments in the arts. One such contributor may have been the liberal banker, industrialist, and art patron Nikolaus von Dumba. Indeed, his association with Wagner and Klimt may have moved him to donate the remaining 10,000 Gulden (28). In any event, bourgeois financial interest in the movement did not fall off. Even after the Secession and its style were well established, Wittgenstein continued to give it 20,000 to 40,000 Kronen yearly (29), and the financing of the *Wiener Werkstätte* (Viennese Workshops), an independent crafts offshoot of the movement founded in 1903, came from another bourgeois source, the industrialist Fritz Waerndorfer (30).

In addition to outright donations, however, there is also another type of financing that the Secession used to carry on its activities at the time of its founding—borrowing. According to a year-end financial report that appeared in its journal

[9]The city of Vienna did give the Secession a 300 Florin subvention, but it is unclear as to whether it was used to finance the *Secessionsgebäude*. (See *Erster Jahresbericht* der V. b.K. Ö., Secession [Wien, Juli 1899], p. 11.)

Ver Sacrum, the Secession was so successful in its first year
that it had sufficient funds to repay a loan it had contracted
at the time of its foundation (31). The report does not spec-
ify the source of this loan, but it seems doubtful that it
would have come from a bank, since the Secession had no
collateral resources at its inception, and were the source a
bank, it might reasonably be expected that there would have
been no obstacle to informing its members of that fact.
Again, it appears much more likely that the loan, like the
donations, came from a private individual in the upper strata
of the Viennese bourgeoisie who preferred to remain anony-
mous.

After its first year the income of the secession from its
exhibitions and other activities appears to have been sub-
stantial enough to allow it to dispense with private loans, at
least, as a way of meeting its operating expenses. Despite its
relatively quick attainment of financial solvency, however,
the group clearly owed a large debt of gratitude to its bour-
geois supporters for their willingness to aid such a fledgling
and avant-garde art movement. Even after the Secession
experienced its breakup of 1905 and the glamor of the move-
ment subsequently diminished, this same social group
would remain loyal to at least the schismatic *Klimtgruppe*
(Klimt Group) and the crafts-oriented *Wiener Werkstätte*. It
is also likely that the group, still calling itself the Secession,
received bourgeois patronage.

But why should the bourgeoisie have taken such a lasting
interest in this artistic movement? The reasons for this keen
interest in the Secession on the part of Vienna's liberal ori-
ented upper middle class may never be known for certain,
but there are some likely possibilities. As suggested earlier,
this change in taste can, in part, be ascribed to the normal
tiring of any social group with a formerly favored style of
art that has become too pervasive, and by 1897 that was
certainly the case with historicism. Then there is also the
much vaunted tradition of a passionate Viennese interest in
the arts, an interest that Zweig has noted cut across all

classes, but was especially intense in the upper strata (32). This would account for the ability of the Secession's patrons to recognize the value of its budding style and the bankruptcy of what had gone before, but there is one other explanation for this interest that, while still involving the role of artistic taste, is more sociologically significant.

Carl Schorske has suggested that the liberal German bourgeoisie of Vienna at the turn of the century were turning more and more to the aristocratic "culture of grace" as their sphere of activity in popular politics became increasingly restricted. Such a change in emphasis was to some degree forced by the set of circumstances Schorske has described, but there is also an element of free choice and social evolution involved in this process. It cannot be denied that the sociological models for a "culture of grace" are aristocratic and, initially, in copying their tastes via Makart and *Ringstrasse* palais the upper bourgeoisie were imitating those models on a grand scale. The "culture of grace," however, seems to have had a permeating effect as a model of the good life from the Baroque period on.

Though aristocratic in origin, the phenomenon of culture playing a role in many aspects of life finds a resounding echo in the great popularity of music and theater evident in Vienna since at least the 18th century. As early as the Biedermeier period, the gap left in support of the arts by "the virtual withering away of aristocratic patronage" (33) after the Napoleonic wars was being filled in music by members of the mercantile, bureaucratic, and newly enobled bourgeoisie (34). The case of Franz Schubert, himself bourgeois, whose "friends and supporters belonged by birth or upbringing to the upper reaches of the middle class" (35), is an example of the beginnings of a general and intimate bourgeois involvement in a cultural sphere once dominated by the aristocracy.

In view of what was really a long-standing tradition of middle class artistic patronage, it seems likely that the appreciation of Vienna's upper bourgeoisie for the primacy of

the arts in one's social upbringing and surroundings is less exclusively a result of their rise in the social hierarchy than is the degree to which they indulge this appreciation. The building of a palais in a style favored by the princely Schwarzenbergs or an imperial archduke is a compliment of imitation by a newly arrived class to its older predecessors, but that same class held on to its more measured "culture of law" that, while it may have created an odd amalgam with the "culture of grace," gave the bourgeoisie a set of values that was far from being entirely imitative and that also could provide it with a distinct sense of identity.

At the same time this bourgeoisie was gaining increased cultural and social prestige, it was moving steadily into the areas of political activity that had once served to elevate their aristocratic betters. Without a doubt at the turn of the century the Austrian liberals were being pushed out of popular politics, but they were not being pushed out of the bureaucracy, which continued to be a source of considerable political influence and, which, in a system that was only partially parliamentary, gave the liberals access to a great deal of power. The career of the jurist and last imperial prime minister, Heinrich Lammasch, in the pre-1918 bureaucracy with his cultured, liberal bourgeois background is but one example of how this class continued to have access to political power. Simultaneously with this penetration of the bureaucracy went the garnering of aristocratic titles as Wittgenstein could have done, but refused, but which Dumba accepted in the addition of *von* to his name along with the honorific title of *Geheimrat,* and which, in the 17th and 18th centuries, had facilitated the rise of the ruling aristocracy of an earlier *Dienstadel* (36). In light of these factors, the failure of liberal politics in the popular sphere is not necessarily a sign of decline, but rather a contraction in one sphere of political power and an expansion in another, and although indirect, a potentially more powerful and secure one. Add to this the continuing dominant role played

by this same group in the Austrian economy and one has a matrix of power that is formidable.

This combination of a sense of identity that could accommodate both the culture of "grace" and "law" with a political and economic role in Austrian life that was still quite vigorous, presents the image of a class that far from being in decline is actually assuming elitist characteristics that are liberal-aristocratic rather than merely liberal bourgeois. The very fact that men like Hugo von Hofmannsthal, Arthur Schnitzler, and Stefan Zweig could turn to lives in the arts and not become *déclassé*, but in fact add luster to their names bespeaks a social status that if not entirely aristocratic is certainly not just bourgeois. Even more significant than the cultural breadth present in this group is its ability to take on the more traditional cultural roles played by the aristocracy. From all indications, it is this liberal, upper bourgeoisie that acted as the initial and enduring patrons of the Secession and not the old aristocracy that had patronized its historicist predecessors and that traditionally had assumed the role of protector of the arts. Patronage from this older group comes to the Secession, but it follows that of the bourgeoisie. Moreover, much of this bourgeois patronage was coming from a group that had a great many members of Jewish or at least partial Jewish descent, who formed perhaps the newest element in the bourgeoisie. The Wittgensteins, though converts to Protestantism, are a case in point, and Waissenberger maintains that it was upper middle class Jewish youth who did much to popularize the Secession and make it a success.[10] In a society that lays stock by such outward signs of influence and taste, this is no mean achievement and suggests the beginnings of the transition of this upper middle class into an aristocracy in its own right in the years before 1914.

By providing a new outlet for the patronage of the bour-

[10]See Chapter Note 14.

geoisie in art, the Secession became a factor in legitimizing the social aspirations of an economic and political group that was assuming an altered role in Austrian society. Insofar as that role was being dictated by the pressures of mass politics, which had been created by modern industrial and social circumstances, the aristocratic transformation of the liberal upper bourgeoisie can be seen as a stabilizing process for a class whose popular political decline had left it with an uncertain position in Austrian society. Support of the Secession offered an opportunity to affirm the permanent influence of this group in the fine arts and thereby to have a sphere of activity that was prestigious, in the public eye, and secure. In this indirect way the Secession helped to reconstruct the self-image of the liberal elite who had become victims of their own rapid rise and fall in party politics.

The Secession's indirect impact on society and politics was further displayed in the support it gained from the liberals' arch rivals. Although this latter group was to prove more fickle in its support, it still figured prominently in helping the Secession get on its feet. It was, in fact, nothing less than the political arm of Vienna's lower middle class, the Christian Socialist government of the city, which included the mayor and leader of the party, Karl Lueger.

In order to construct its building, the Secession needed a piece of land and approached the municipal government about the use of a public site for this purpose in the *Ringstrasse* area. Once again the Secession's ubiquitous fixer, Josef Engelhart, was entrusted with the task of persuading the city to part with the land (37). He states in his memoirs that this commission was the occasion of his first meeting with Lueger (38), but even at that early date he may already have been a member of the Christian Socialist party (as he seems definitely to have been later on) (39), and so here, too, may have had connections that gave him access to the mayor. In any event, he was successful. Engelhart recalls

that there were many opponents in the city administration to giving the Secession land, but the "surpassing leader of Vienna's government (Lueger) decisively intervened on our behalf" (40).

In addition to working behind the scenes, Lueger also facilitated passage of the enabling legislation when it came up in the *Gemeinderat* (city council) (41). The land originally under consideration as a site for the Secession is today the *Karl Luegerplatz*[11] on the *Parkring*[12] (42), but by November 17, 1897, the site had been switched to the building's present location in the more central *Karlsplatz*[13] area just behind the Imperial and Royal Academy of Art (Figure 14). That institution had coveted the land as ground for its own potential expansion (43), but at the November 17 meeting this alternative was not raised. On the contrary, the Secession's opponents objected to any construction on the site, instead protesting that it was needed as park land (44). This protest, however, was to no avail, and the legislation giving the Secession the *Friedrichstrasse* site for its use was passed (45).

During the brief debate over this issue in the *Gemeinderat*, the proponents of the law justified their stand on the grounds that it was necessary "to protect modern artistic strivings which could not be valued in the *Künstlergenossenschaft*" (46). At first glance this appears to have been quite a progressive stance for a party not noted for its concern with art, especially avant-garde art, but the words uttered by the bill's spokesman, Dr. Porzer, immediately following

[11]A square along the *Ringstrasse* named after the popular first Christian Socialist mayor of Vienna, Karl Lueger (1844–1910).

[12]A section of the *Ringstrasse* bounded, in part, by the City Park of Vienna.

[13]The large square just beyond the *Kärtnerring* to the southwest at one end of which is situated the baroque *Karlskirche* (St. Charles Church or Church of St. Charles Borromeo).

Figure 14 View of the Secession building designed by Josef Olbrich as seen from across the old fruitmarket on the Karlsplatz (c. 1902). This unusual photograph, now in the Library of Congress, shows how the Secession looked before the site around it was altered by demolition and new construction. The large building to the right rear of the Secession is the Academy of Art, the two three-story structures to the left were demolished before 1914, and part of the old fruitmarket is now occupied by a travel bureau.

those quoted above, reveal the conditional nature of that stance. He quickly added that, "Naturally, the expectation would have to be expressed that these artistic strivings would not lead to works [Erzeugnissen] like those now being

exhibited[14] in the rooms of the *Gartenbaugesellschaft* (The Horticultural Society) [in den Gartenbausälen]" (47). Apparently, Lueger and his party were willing to support "modern artistic strivings," but not necessarily what they produced.

The mixed nature of Christian Socialist support for the Secession at this early stage of the movement's development suggested that it was far from firm, and this, as later events showed, proved to be the case. Although this support of a new movement in the arts at its very inception by the party of the little man was not to be repeated, its coming right on the heels of Lueger's long delayed imperial confirmation as mayor of Vienna suggests that a powerful reason for this support involved both the newly acquired sense of legitimacy Lueger's triumph gave to the Christian Socialist party as a whole and its desire to affirm that legitimacy by following the cultural examples of their aristocratic and liberal betters.

Even before Lueger and the Christian Socialists had come into power in Vienna, the municipal government had not been afraid to assert its sense of independence. Free municipal government was one of the principles of liberalism and in the *Rathaus* (City Hall) building itself (see Figure 8), embodying as it does in its Renaissance-Gothic style the golden age of German city-states, there was an assertion of a civic individuality that could stand alongside Vienna's more subservient incarnation as the imperial *Residenzstadt.*[15] With the coming of Lueger, though the city was no longer in liberal

[14]A reference to a privately sponsored exhibition of works by the German painter, Max Slevogt, and other practitioners of "modern painting." Slevogt was later exhibited by the Secession and became a prominent member of Berlin's own Secession movement.

[15]Literally, this means "residence-city," but refers to Vienna's status as the permanent residence and seat of the Habsburg dynasty.

hands, its independence was to be asserted all the more in the vigorous program of municipal socialism and the raising of municipally sponsored monuments instituted by him. Thus, in supporting an artistic movement like the Secession not only could the cultural image of Christian Socialism be improved, but it could also follow in the footsteps of its predecessors and assert the role of the municipality as an independent force in all aspects of Viennese life.

It should also be remembered that in those first months of its existence before the Secession had even had an exclusive exhibition of its own art, it was still something of an unknown quantity. Its list of members included men like Gustav Klimt, and the aged Rudolph von Alt (see Figure 15), who were respected members of the established artistic community so that the Secession did not necessarily seem as artistically radical as it would later on. Moreover, the *Künstlergenossenschaft* was overwhelmingly identified with the Viennese establishment of aristocrats and bourgeois liberals who had little but scorn for Lueger and his followers. In the Secession there may have been seen a chance to set up a rival to the institutionalized art of their opponents and so acquire some of that group's cultural luster for themselves. It is conceivable that for a man like Lueger who took a rather practical view of the uses of art (48) this could have been a powerful consideration. Even after the exhibition of Klimt's *Fakultätbilder* and the break in the Secession, the more stylistically conservative artists among Klimt's colleagues were patronized by the city government. Engelhart, for instance, was put to good use in designing civic monuments like that to the painter, Ferdinand Waldmüller, erected in 1913 (49).

Thus, from its very beginning the Secession became involved with the social and political side of life in Vienna even before it had become fully established as a cultural force. After its first two exhibitions, however, its cultural credentials would be established and its relationship to the sociopolitical sphere enlarged even further.

Although it took the Secession a little over a year from its foundation to lay the cornerstone of its new home on April 28, 1898 (50), this in no way inhibited it from launching its first exhibition before the construction for that home had been completed. As usual, Josef Engelhart seems to have been indispensable in making the necessary arrangements. Since the Secession had no exhibit rooms of its own, Engelhart went in search of some and managed to procure those of the *Gartenbaugesellschaft* on the *Parkring* right under the nose of the *Künstlergenossenschaft,* which was on the verge of renting them for its own use (51). The rooms of the *Gartenbaugesellschaft* were probably the most suitable in terms of size, and the most prominent because of their location, then available in Vienna for an exhibition that wanted to be noticed, and that was definitely the Secession's intention. The securing of this particular building for its first exhibition was of such importance to the Secession that it was willing to pay what was considered an extraordinarily high rent of 8,000 Gulden for the privilege (52). Indeed, Engelhart gives the impression in his memoirs that the securing of the *Gartenbausäle* was a kind of race between the Secession and the *Künstlergenossenschaft* and had the Secession not won, "the whole project would have come to nothing"(53).

The competitive spirit exhibited between the two art associations over securing the *Gartenbaugesellschaft* was merely the opening shot in a rivalry that lasted at least until 1905. Beginning in 1898 the exhibitions of the Secession and the *Künstlergenossenschaft* overlapped, with the former inevitably besting its older and more established opponent (54). The Secession's first exhibition was held from March 25 to June 20, 1898, which paralleled the *Jubiläumsausstellung* (Jubilee Exhibition) held that spring in the *Prater*[16] in celebration of

[16]A large public park and amusement grounds to the southeast of the *Ringstrasse.*

the fiftieth anniversary of Franz Joseph's ascent to the Austrian throne. The *Jubiläumsausstellung* was a general exhibition of the achievements of Austrian industry and culture, which included a display of Austrian art that was organized by the *Künstlergenossenschaft* (55). The main exhibit buildings were all centered around the huge *Rotunde*[17] of the 1873 World's Fair, but the *Künstlergenossenschaft* held its exhibition slightly ahead of the main display in the *Prater* and because of Engelhart's success in getting the *Gartenbaugesellschaft* for the Secession it had to hold its exhibition at both the *Künstlerhaus* and the *Musikverein*[18] (56). Thus, not only was the *Künstlergenossenschaft* forced into an inconvenient exhibiting format by its young rival, but works by members of the Secession found their way to parts of the *Jubiläumsausstellung* in the *Prater* not under the *Genossenschaft's* control (57), while the Secession's exhibition itself proved an overwhelming success despite its official competition.

This first exhibition not only marked the inauguration of the Secession as a major force in Austrian art, but also allowed it to put into action its then novel idea of utilizing its exhibitions as a didactic instrument for educating the public to the latest developments in art. Accordingly, the exhibition at the *Gartenbaugesellschaft* contained only a handful of works by contemporary Austrian artists, with the majority of hangings and art objects having come from abroad. As Klimt noted in the March issue of *Ver Sacrum*, the preponderance of foreign artists at the first exhibition was to give the Viennese public an over-view of the best of modern art and through this exposure prepare them to appreciate it (58). Exposure to this new art was not meant for the public alone,

[17]A large circular exhibition hall that was destroyed by fire in 1937.

[18]This is the shortened name for *Das Haus der Gesellschaft der Musikfreunde in Wien* (The House of the Society of the Friends of Music in Vienna), the building that houses the society and serves today as the seat of the Vienna Philharmonic. It is located directly across from the *Künstlerhaus* on the *Karlsplatz*.

however, but also for the edification of Austrian artists. As the art critic and friend of the Secession, Ludwig Hevesi, pointed out in his review of the exhibition, an equally important part of its goal was to inspire local (*einheimisch*) artists "to strive forward in the same direction" (59).

Preparations for this exhibition occupied the Secession for much of the previous year, and Engelhart, because he had apparently had more contacts with foreign artists than any other member, and a better command of foreign languages, was sent abroad to solicit their participation and support, which was fully forthcoming (60). For a country that had had very little exposure to the art trends of even the last ten years, the Secession's exhibition promised to be quite an experience. According to Engelhart, "It was the first time in Austria [bei uns] that one could get a general idea of the best French, English, Belgian, and German artists of this epoch" (61). The exhibiting artists included such names as Rodin, Puvis de Chavannes, Whistler, Brangwyn, Khnopff, and Klinger (62), most of whom had already been well known for quite some time outside of Austria, but were little or unknown within it. Still, the exhibition was to be the herald of the new and far more vital art promised in the coming of the Secession's "sacred Spring." Klimt's poster for the exhibition (see frontispiece) even lent an heroic quality to it, since it depicted a naked Theseus about to slay the Minotaur, an allegory easily related to the Secession's struggle against the *Künstlergenossenschaft* and historicism. The fact that the censors confiscated the poster on moral grounds shortly before the opening and then obliged Klimt to put a discrete black line over Theseus' genitalia (63) only served to emphasize the element of struggle and daring involved in the Secession's venture and probably heightened the public's curiosity all the more.

When the Secession finally opened its doors at the *Gartenbaugesellschaft* to the public, the reaction was immediately

favorable. The liberal and establishment-oriented *Neue Freie Presse,* [19] Austria's most prestigious newspaper, which had been noncommital at the time of the Secession's founding (64), and its middle brow, pseudoliberal, but influential rival the *Neues Wiener Tagblatt,* [20] which had hailed the new group with cautious optimism (65), both greeted the Secession's first exhibition with favorable and even enthusiastic reviews.

The *Presse* gave its initial opinion of the exhibition on the day after it opened and praised it for the innovative quality of its setting, decoration, and format as well as favorably reviewing the works exhibited (66). This was followed on March 31 by an essay in the paper's much esteemed *Feuilleton* section, which was reserved exclusively for worthy contributions and commentaries on literature and the arts. Beginning on the front page and running over into the next two, the essay was a thoughtful and definitely favorable examination of both the exhibition and its purpose by the critic Karl von Vincenti. Not only did Vincenti find the new artistic directions represented by the various works to be the harbingers of a welcome and "fresh artistic air" to Vienna, but noted that the concern they displayed with depicting the human experience was endowing the new art with a soul. Finally, he observed with satisfaction that the exhibition was living up to its didactic promise and was "to be viewed as an outstanding means of educating the people [*Volksbildungsmittel*]. We greet the Secession as a rejuvenating and active force to [the attainment of] this goal" (67).

The *Neues Wiener Tagblatt* was no less generous in its praise than its more august competitor. In a review that appeared on March 26, the Secession was lauded for its

[19] *The New Free Press* (referred to henceforth also as the *Presse*).
[20] *The New Vienna Daily* (referred to henceforth also as the *Tagblatt*).

efforts on behalf of Austrian art and, in reference, no doubt, to the strong feelings generated by its break with the *Künstlergenossenschaft*, the pious hope was expressed (68) that

> ... the struggle of ideas be limited to the artistic sphere and not alienated to a battle of personalities [*Kampf der Personen*]—if so, then from the opening of the Secession's exhibition one will date an epoch of new artistic resurgence.

Like the *Presse*, even the mass circulation *Tagblatt* could boast a *Feuilleton* section, and on April 6 a discussion of the exhibition appeared and declared that "praise cannot be withheld" from a group that had done "everything" possible "to give our artistic life a jolt forward" (69). Though the *Tagblatt's* reportage was more sensational, it nevertheless confirmed the opinion of the *Presse* and gave the seal of approval of Austria's most influential journalism to this first effort of the Secession. There were, however, other newspapers in Vienna that, while smaller than the *Presse* and *Tagblatt*, acted as the mouthpieces of significant sections of Austrian society, and they also took an interest in what was going on at the *Gartenbaugesellschaft*. Two of these were the *Reichspost*[21] and the *Arbeiter Zeitung*.[22]

Both the *Reichspost* and *Arbeiter Zeitung* were newspapers closely identified with important political parties and as such had relatively large readerships (30,000–55,000). In the case of the *Reichspost*, this identification was with the Christian Socialist party and generally it had a strong Catholic bias with elements of antisemitism in its journalism. With respect to the *Arbeiter Zeitung*, it was the official organ of the Austrian Social Democratic party and the ideological opposite of the *Reichspost*. Despite their great dissimilarity in outlook, both papers felt an obligation to cover cultural

[21]There is no good translation of this name, but it can be roughly translated as *The Imperial Post.*

[22]*The Workers' Newspaper.*

events for their readers, even though lack of time and money might prohibit them from actually attending any. This obligation was fulfilled only on an irregular basis by the *Reichspost,* but in the *Arbeiter Zeitung* the cultural edification and education of its working class readers was a main part of its *raison d'etre,* and in the field of cultural affairs it was probably the best socialist newspaper in Europe. When the Secession opened its first exhibition, both papers felt it important enough to warrant serious review articles.

The main review of the exhibition by the *Reichspost* appeared in the form of a *feuilleton* on April 9 (70). While the overall effect of the comments was favorable, the Catholic and artistically conservative bias of the reviewer ("W"), and his paper, came through in several instances. He criticized other newspapers for having emphasized the modernity of the art on exhibit and saw in such an emphasis an unwarranted neglect of the old masters. He also pointed out that the work of Stuck, Böcklin, and other modern masters had, in fact, already been seen in Vienna, thereby further diminishing the novelty of the Secession's effort. The reviewer went on to criticize Klimt specifically for being too other worldly and Byzantine in his paintings while, in general, "W" disliked the modern use of naked women with their "unearthly slimness" *(überirdische Schlankheit)* and unpleasant facial features. As a result, many of the individual pieces did not please the reviewer since they were not serving beauty as he felt art should.

The final point of criticism directed by the *Reichspost's* reviewer was on religious grounds. In a brief notice that had appeared shortly after the opening of the exhibition (71), it was noted that a church window by the English artist Walter Crane was on display. Significantly, this was the only work specifically mentioned in that very short report, and, indeed, subjects of a moral and religious nature were to be the *leitmotif* of the *Reichspost's* subsequent criticisms of the Secession. In this first review, however, such criticism was fairly mild. Though one or two of the religiously oriented paint-

ings were declared pleasing, the general criticism of their lack of historical accuracy and use of everyday people to depict a sacred subject acted as a negative judgment upon most of them. Moreover, the reviewer found in these works a disturbing atmosphere of atheism, which he felt was reflected in that same use of everyday people mentioned above. Still, even the *Reichspost* ended on an optimistic note by praising the design and decoration of the exhibition and expressing the hope that with more effort something good would develop from this "seed."

The *Reichspost's* reaction to the exhibition was the most restrained of the four newspapers, but in sharp contrast to it was the commentary of the socialist *Arbeiter Zeitung,* which was both more extensive and favorably balanced than the reviews of even the *Presse* and *Tagblatt.* The *Arbeiter Zeitung* devoted two very erudite and rather analytical articles to the exhibition, one at its beginning and one at its end, with several smaller notices as well. As the workers' paper, it was, of course, particularly interested in the social implications of the Secession, but although ideology was an important concern, by the tone of their work, the reviewers were clearly far from being party hacks.

The first of the *Arbeiter Zeitung's* two articles on the exhibition appeared on April 7, in its "Art and Science" section (72). The reviewer ("-n-") began the notice by pointing out that Vienna was at last following the German trend of artistic secessions (Berlin and Munich), but in contrast to the others the Secession sought to create a new art. Taking an historical perspective, he even speculated on the appearance of a new artistic spirit, which, however, only the course of the epoch could determine. Still, everything appeared propitious in the new group's exhibition from its format and art works to its didacticism. On the social front, optimism was expressed in the new art's potential for removing itself from the category of a "sporting article" for the rich to that of an element in the education of the people (*Volkserziehung*). After encouraging everyone to visit the exhibition, the re-

viewer concluded with the exhortation that the Secession "should seek to further understanding through clarity . . . and free exhibit days [for the workers]" (73).

The second review article was printed in the "bourgeois" feuilleton form on June 12 and was by Eugen Lelse (74). Stretching over two pages, it mixed a strong dose of ideology with professional art criticism. It began by noting that the Secession's exhibition was occurring at the same time in Austria as were significant political events, but that it was of equal importance in being reported (75). Because of its dedication to the new art, its use of new and innovative exhibiting techniques, which made the art work more accessible to the people, as well as its avowed declaration in its exhibit catalog that it was a party dedicated to reinvigorating Vienna's artistic life and educating the people and artists to the new art (76), all this gave the Secession the character of an artistic revolutionary struggling with reactionary powers not dissimilar from those confronting the socialists in their own struggle to bring forth a new world. Thus, at least in this review, the Austrian socialist movement seems to have seen in the Secession at the very least a sympathetic movement, although, to be sure, only in a cultural sense.

This impression on the part of Lelse was no doubt reinforced by the presence of works by the Belgian painter and sculptor, Constantine Meunier, whose drawings and statues of industrial scenes and working men had been given an exhibit room of their own. In discussing their realism, Lelse maintained that they depicted both grinding despair and the hope of revolutionary consciousness that would eliminate that despair. Finally, the review ended with the image of Meunier's statues of a sower and reaper, which Lelse interpreted according to the Greek legend in which the sowing of the dragon's teeth would bring forth a race of fighters. On that triumphantly hopeful note, upheaval in art at the Secession became linked with upheaval in society.

Clearly, from these reviews alone, the Secession's first exhibition was a critical success. The popular reaction was

no less reassuring. The light and airy exhibition rooms, which purposely had their walls hung with a minimal burden of paintings so that the viewer was not overwhelmed by the usual plethora of works, was an innovation Vienna had not seen before, but the art works themselves were equally as innovative and new to the vast majority of those drawn to the rooms at the *Gartenbaugesellschaft*. In addition to the obligatory statutes and paintings, the Secession also devoted part of its exhibit space to the applied arts with designs of a type and quality not generally seen at that time in Austria. If the Secession had received its initial nurturing at the hands of Vienna's *haute bourgeoisie*, it was, from this exhibition on, to receive additional nourishment from a public that now included the aristocracy itself, and, at least to some extent, even the workers.

In addition to writing critical reviews of the various art exhibitions, most newspapers, with the exception of the *Arbeiter Zeitung*, also took it upon themselves to provide their readers with periodic reports concerning which members of *die Gesellschaft* had frequented the exhibitions. As a result of this practice, it is possible to compile at least a partial list of Vienna's great and near great who paid a visit to the Secession's exhibition.

As early as March 27, the *Presse* reported on the crowds of spectators who came to the exhibition and on the large number of prominent personages among them (77). On that same day, for instance, the *Presse* noted that *Obersthofmeister*[23] Prince Montenuovo, Princess Pauline Metternich, Baron Chlumecky, and Mayor Dr. Karl Lueger had attended the Secession's exhibition on the previous day (78). The following day saw a similar notice regarding the attendance of Prince Ferdinand of Bulgaria, the prime minister Count Thun, and the Cardinal-Prince-Archbishop Count Schönborn (79). On April 6, however, the Kaiser, himself, paid an official visit to the Secession (80) (Figure 15).

In line with his policy of being evenhanded in cultural affairs, Franz Joseph, who also put in an appearance at the

[23]Chief Master of Ceremonies of the Court.

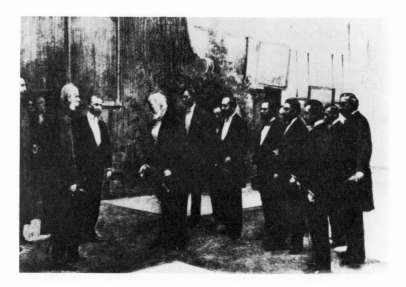

Figure 15 Rudolph Bacher, "The Kaiser Franz Joseph at the First Secession Exhibition." The Kaiser is shown with Klimt to his left and is being received by Rudolph von Alt behind whom are other members of the Secession.

Genossenschaft's Jubiläumsausstellung, had promised to examine the Secession's effort (81). Ever since a casually critical remark of his concerning the steps of the opera house had supposedly resulted in the suicide of the architect responsible, the Kaiser was careful never to pass judgment on works of art in public, and in the case of the Secession he expressed himself to be universally pleased with the works of art and the mounting of the exhibition itself (82). It was reported that he also praised the Secessionist architects, Josef Olbrich and Josef Hoffmann (83). The effect of the Kaiser's visit was to give the appearance of an official stamp of approval to the Secession's efforts that could only help its attempt to establish a legitimate place for itself in the Austrian art world.

Whether it can be ascribed to the Kaiser's visit or not, the

number of notables reported to have attended the Secession rose shortly thereafter. On April 18, it was reported in the *Reichspost* that the Prince and Princess Schwarzenberg, Prince Auersperg, Prince Montenuovo (again), Count Lanc-koronski, Countess Paar, Prince Liechtenstein, Prince Win-dischgrätz, and Prince Trautsmannsdorf-Weinsberg had visited the exhibition (84). The string of luminaries was capped off by Archduke Ludwig Victor, the most prominent Habsburg patron of the arts, who visited the exhibition on April 7 (85) and again on June 18, at which time he made several encouraging remarks including his own personal ex-pression of pleasure at its success (86). With the exception of Karl Lueger, all of these eminent visitors were from either very high or at least very old, noble families (87). Their presence and perhaps even purchase of works at the exhibi-tion was a definite sign of the Secession's success among the aristocratic elements of *die Gesellschaft.*

As mentioned earlier, this success was not limited to high society only. The *Arbeiter Zeitung's* praise of the Secession's exhibition had aroused the interest of the workers in attend-ing it, and the Secession, true to its didactic commitment and desire to have the new art reach all the people, made special arrangements for visits by the workers to the exhibition. Originally, the Secession wanted to let the workers in for nothing, but at the insistence of the workers themselves, who wanted to pay, an admission price of 10 Kreuzer (88) was agreed upon with the *Arbeiterbildungsverein*[24] (89). This price was only good, however, on Sunday mornings from 8 to 10 (90).

The first visit by the workers took place on April 17. In the *Presse* it was only summarily reported that 20 or 30 were

[24]This is best translated as "The Workers' Educational Society," but because the word *Bildung* involves the spiritual as well as the technical meaning of education it must be remembered that the society was mainly cultural in orientation.

present, with a brief mention of their reaction to the art
works (91). The *Tagblatt,* however, devoted more space to
this evidently novel occurrence, and noted that the workers
often made correct artistic judgments on their own concern-
ing the various works they saw and that the members of the
Secession who showed them around were very pleased with
their ability to appreciate the decorative quality of much of
the art (92). Despite the interest of the *Tagblatt* in the
workers' visit, it was, of course, the *Arbeiter Zeitung* that
gave the most complete report of the event.

On April 19 there was a brief notice recounting the visit
of both male and female workers to the exhibition. It re-
ported that the painters, Alfred Roller, V. Ottengeld, and the
literateur, Hermann Bahr, had acted as guides to the group
and that the workers had been impressed most of all by
Meunier's bronzes (93). The complete report on the visit,
however, did not appear until August, but it was by an
anonymous worker who had attended the April 17 tour (94).
He repeated in more detail what had already been reported,
but pointed out that the workers had been able to appreciate
the art they saw as human beings and not merely as workers,
and that the Secession's emphasis on the need to experience
art as the best way of understanding it was correct. More-
over, though he felt labeling art with party names like Seces-
sion was prejudicial to appreciating it, he came out in favor
of a didactic approach toward introducing the public to an
understanding of art, which was, of course, one of the main
goals of the Secession. In all, the Secession's contact with the
workers was easily as successful as that with society's upper
strata.

At its close in June the Secession had recorded some
70,000 visitors to its rooms at the *Gartenbaugesellschaft* and
sales of around 100,000 Gulden (95). While the exhibition
had come off as an almost completely unqualified triumph
for the new artists' group, one sour note had been sounded.
In April the *Tagblatt* had carried an anonymous article enti-

tled "Young Art," supposedly by a reader of the paper (96). Calling himself someone with "healthy eyes," he panned all of the art works at the exhibition, particularly criticizing the bizarre female images in many of the paintings. He concluded by making an obscure connection between "birdhouse painter" (*Vogelhäuselanstreicher*), and the practitioners of the new art. Such sarcastic and hostile criticism was obviously in the minority at the time, but its appearance at such a high point was, nevertheless, a sign of that to which the Secession would be exposed as it asserted its more controversial side.

To a certain degree the truly avant-garde quality of the Secession was masked rather than revealed by its first exhibition. The concentration on foreign artists, many of whom had been active since the 1880s and still retained several of the standard elements of the establishment styles, plus the location of the exhibition in a revered and conventionally designed building may have had a reassuring effect on the public that was out of proportion to the Secession's more radical potential. With the second exhibition in that same year, the youth and artistic novelty of these "*Jungen*" was made more apparent by their works and especially by the structure that housed them.

This second exhibition ran from November 12 to December 28 and was held in the Secession's recently completed headquarters on the *Karlsplatz*. Unlike its predecessor, this exhibition was composed primarily of works by Secession artists, with 29 of its members being represented among the more than 200 pieces on exhibit (97). Basically the art works continued the symbolic, mystic, and general art nouveau themes present in the first exhibition. Eroticism was a constant leitmotif as in Engelhart's "The Sleeping Ones" ("*Die Schlafenden*") or Otto Friedrich's "A Study" ("*Studie*"), while both the erotic and mystic were combined with the symbolic in Ernst Stöhr's "Woman" ("*Das Weib*"). Then, of course, Klimt with the increasingly more pronounced sexual, fe-

male, and Byzantine qualities of his early Secession years aroused both interest and controversy. As a contemporary commentary pointed out, the Secession was bringing creative individualism back into an art that had for too long been formalized (98). Again the Secession proved to be an irresistible magnet to the Viennese public, and on the third day of the exhibition the crowds were so great that the ticket office had to be closed for half an hour (99). The Secession was well on its way to its second success.

The comments in the Viennese newspapers repeated their largely laudatory performance of that previous spring. The *Presse, Tagblatt, Reichspost,* and *Arbeiter Zeitung* all gave favorable reviews and were impressed by the works of Klimt and his colleagues, and despite some critical comments about some of the former's work, it was only the *Reichspost* that expressed itself with a generally reserved enthusiasm (100). The work of art, however, that proved to be the real showpiece of the exhibition was the Secession's building itself.

Designed by a student of Otto Wagner, Josef Olbrich, it was in an architectural style never before seen in Vienna. The building, which is still extant (though modified), is situated on a small irregular piece of ground behind and to one side of the academy of art (see Figure 14). It is rectangular in shape with a stylized floral frieze at each of its corners along the upper portion of its walls and has a series of skylights running along the roof. The main facade contains a recessed entrance reached by steps leading up from the street and surrounding it is a frieze depicting the faces of three female muses (?) framed by slender, entwining trees reaching up towards the roof with their foliage. Above the doorway is a raised quadrilateral base with four pylons enclosing a very large wrought iron sphere constructed to resemble the crown of a laurel tree. At its base directly above the door are inscribed the words of the Secession's motto: "To the time its art, to art its freedom." The building was

painted a bright white and the laurel crown was brilliantly
gilded with gold leaf so that the structure stood out as an
unmistakable landmark (Figure 16).

The home of the Secession was one of the first buildings
to break with the dominant baroque and historicist tradition
of Viennese architecture. Only Otto Wagner's stations for
the *Wiener Stadtbahn*[25] (Figure 17), which Olbrich had
worked on, bore any relation to it. Above all, it was in stark
contrast to the historicist home of the Secession's rival, the
Künstlerhaus, which was located not far away on the same
square. In terms of its design, it was as simple inside as it was
outside. True to the principles of Wagner's *Modern Architec-
ture* the building was designed according to its purpose,
which was first and foremost to be an exhibition hall. Hence,
the row of skylights built to let in the maximum of natural
light to illuminate the exhibition rooms below. These rooms
consisted of a large one in the center and potentially several
smaller ones off it along the sides and in the rear. The inte-
rior space could be manipulated by means of removable
walls according to the requirements of any given exhibition.
The combination of maximum natural lighting and fluid
space gave the Secession's building design advantages that
no other comparable structure in Vienna possessed (Figure
18). Indeed, at the time, it may have been the most advanced
art gallery in existence.

The construction of the building had been by a private
firm, but all its design and decorative features were con-
tributed by members of the Secession itself. It was, in that
sense, an expression of the group's community feeling and
also of the *Gesamtkunstwerk* ideal. It stood as a total work of
art combining many different arts in the carrying out of a
common design for a common goal and, because of its inge-
niously designed interior, it could be compatible with virtu-
ally any work of art it contained. Thus, it was not just the

[25]The municipal railway still used for mass transit in Vienna.

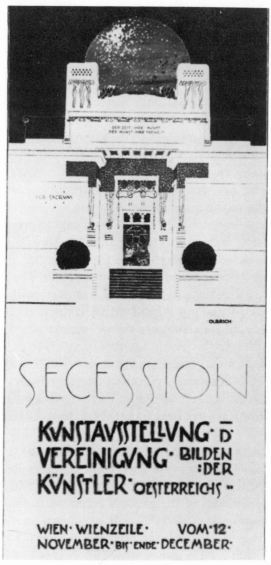

Figure 16 Josef Maria Olbrich, "Poster for the second Secession Exhibition" (1898). Drawn by the designer of the Secession building, the poster shows the details of the main facade and the prominence of the laurel dome.

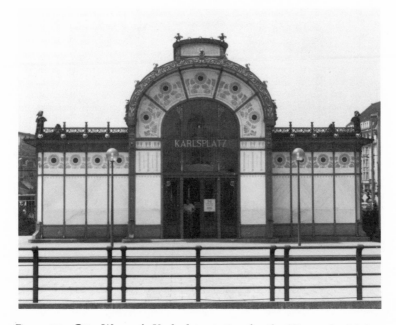

Figure 17 Otto Wagner's Karlsplatz station for the Vienna Stadtbahn.

radical facade that distinguished the building as the work of an avant-garde art movement, but its entire design and purpose, so that in a very real sense the art works on display and the building that held them were a unity that constituted what was really new in the Secession.

This unitary aspect was not, however, what struck the Viennese public. The form and decoration of the Secession's home was their primary interest. Reviewers commented on the work of Klimt and Carl Moll, but the *Secessionsgebäude* stood out as a constantly recurring theme. Its newness was such that the Secession's stalwart supporter, Ludwig Hevesi, felt compelled to write an introductory article on its relationship to contemporary architecture as a means of acquainting the public with it (101). Yet, even he had to confess that it brought a touch of the Orient to Vienna with its exotic pylons (102). The *Presse* also noted its eastern

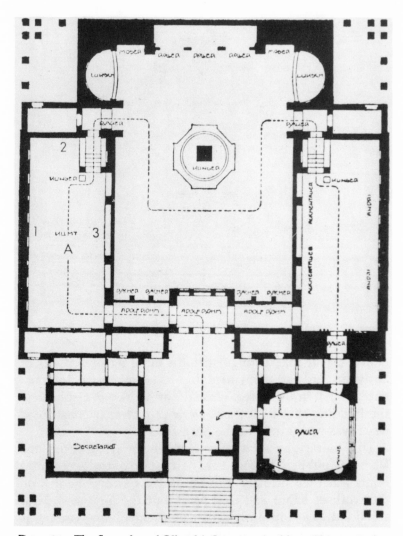

Figure 18 The floor plan of Olbrich's Secession building. This particular view is from the Beethoven Exhibition of 1902.

qualities and called it the "temple" of the secession, observing that "its mausoleum-like reserve and the symbolic ornamentation on the exterior walls [gives] the impression of a mysterious cult sanctuary [*Cutusstätte*] for the new art"

(103). All comments on the building, however, were not so diplomatic. The *Arbeiter Zeitung,* which praised the Secession and its art for being "revolutionary" (104), frankly did not like the building, though it praised its interior (105). In the *Tagblatt* an openly satirical article by the wit, Edward Pötzl, criticized the building for being too Egyptian and poked fun at the Secession generally (106). From the man on the street the commentary was a bit less good natured, with the building being likened to the grave of the Mahdi, a gasometer, and a blast furnace, while the sphere of laurel was dubbed the "golden cabbage" (107).

The critical comments and witticisms at the expense of the Secession's new home did not prevent it from selling 61 art works (108), receiving two archducal visits (109), and accommodating hosts of spectators. Moreover, what was fast becoming known as the *Secessionstil* was cropping up everywhere, at the *Jubiläumsausstellung* in the *Prater* and even in commerce. Industry was rushing to include in their products art nouveau motifs that resembled those present in works exhibited by the Secession (110). In *Ver Sacrum,* itself, advertisers began to utilize art nouveau lettering in their advertisements, and ads appeared in the papers for products that incorporated the semigeometric, semisinuous motifs of the early Secession in their designs. Finally, at the traditional Christmas market for that year there were cheap articles of all kinds for sale a la Secession (111). All this indicates that by the end of only its second exhibition the Secession was not merely a success, but occupying a prominent place in the public imagination.

This popular and critical interest in the Secession, though it waned somewhat after the 1905 schism, was in part sustained by the Secession's active participation in the major and minor art questions of the day as well as by the group's steady presentation of well organized and often provocative exhibitions of modern art. The first two exhibitions were followed by many others on a regular basis of three per year (winter, spring, and fall), and during its most active period

in the years up to 1905, the Secession mounted 23 exhibitions. If one also includes those held by the Secession up to the eve of World War I, the total for the years 1898–1914 comes to 47. In short, the Secession, despite its avant-garde calling, rapidly took on the aspect of a regular fixture in the Viennese art world.

The extent of the stable and institutionalized side of its character is borne out by the Secession's financial circumstances. As previously indicated, the Secession was monetarily as well as critically successful in its first two exhibitions and, as far as can be determined from the incomplete records available, its finances continued along a fairly prosperous course so that in its own way it was probably as financially sound as the rival *Künstlergenossenshaft.*

In its second, third, and fourth exhibitions the Secession saw 234 of the 575 works exhibited sold for the sum of 72,500 Florins (112). The income of the Secession from exhibitions was based on the admission price and a 10 percent commission charged exhibitors for all art works sold at its exhibitions (113). The accounts of the Secession as published in its first yearly report, which apparently covered the last three of its first four exhibitions, are far from clear in listing the exact sources of income, but its total income for the period ending July 1, 1899 was 85,899.05 Florins (114). Of this amount 50,201.28 Florins was still credited to anonymous donations, but the Secession was prosperous enough in its own right to establish a working fund of 20,000 Florins and another fund, for the purchase of art works, containing a balance of 1,656.04 Florins (115). This prosperity apparently grew as the fame of the Secession itself grew for, in June 1901, the Secession's previous three exhibitions accounted for 290,000 Kronen in sales (116), giving it 29,000 Kronen from commissions alone, and in 1908, three years after the break, it still was getting an income in excess of 38,000 Kronen out of which it could afford a 17,000 Kronen renovation of its building and still end up with a surplus of

5,984.94 Kronen (117). Although figures on the Secession's income after this date were unavailable, its unabated activity plus the generally prosperous condition of the arts in the prewar years (118) all suggest that this prosperity continued.

The institutionalizing tendencies of the Secession and the popularity of its style were such that in 1903 those of the group's members who were more interested in the *Kunstgewerbe* (crafts) side of the movement were able, with the financial assistance of the industrialist and arts and crafts enthusiast, Fritz Waerndorfer, to set up the *Wiener Werkstätte.* Though a completely independent organization dedicated to the applied arts (including architecture), its founders, Josef Hoffmann and Koloman Moser,[26] were also founding members of the Secession and the links between the two groups were quite close up until 1905 when those links were largely transferred to the *Klimtgruppe.* The Secession's distinctive geometric style was in large part, though not exclusively, the creation of Hoffmann and was also the hallmark of the *Werkstätte* (119). Moreover, though more commercially oriented, the group shared much of the same outlook as the Secession including an admiration for English crafts' principles and an adherence to the *Gesamtkunstwerk's* ideal, so that it was essentially a part of the overall Secession movement.

Like the Secession, the *Werkstätte* received most of its patronage from *die Gesellschaft,* and had its own display and sales rooms in the fashionable shopping district of Vienna's old city. The quality of its production gained international recognition, and it was responsible for the best extant example of the Secession's total design concept in the form of the Palais Stoclet in Brussels, which was built for a Belgian

[26]Koloman Moser ultimately left the *Werkstätte* in 1907 because of disappointment at having to cater to the tastes of what he considered a fickle public and over a financial disagreement between him and Waerndorfer. [See Werner Fenz, *Kolo Moser: internationale Jugendstil und Wiener Secession* (Salzburg, Residenz Verlag, 1976), p. 34.]

industrialist in 1905–1908 at a still undisclosed, but reputedly fabulous, sum (120) (see Figures 10 and 11). The *Werkstätte* remained a going concern until the Great Depression forced it out of business in 1932, but from 1903 to 1914 it stood as the main Austrian exponent of modern art in contemporary applied design.

The furthering of applied art was but one of the tasks taken on by the Secession, and to whatever it turned its energies, it did so with a fairly authoritative air. The didacticism of its exhibition policy, which led in 1900 to the holding of an all Japanese show and in 1903 to having one dedicated to the history of Impressionism, was but one example of this trait, which, in these cases, allowed the Secession to act like a museum for the history of modern art. Despite its avowed desire to be open to all ideas, its position as practically the only organized exponent of modern art in Austria, plus its combative origins as that art's champion, lent its utterances a semi-official quality as those of the designated voice of modern art. Indeed, Hermann Bahr even declared that the Secession should take on the task of the "missing" government and provide the necessary artistic leadership for Austria (121).

Though the government was actually far from "missing," the authority of the Secession was acknowledged by it through a kind of tacit and sometimes even open recognition of the group's artistic importance. This recognition came almost immediately when in 1897 two of the Secession's members were placed on the 16 man committee named by the Ministry of Public Religion and Education[27] (*Ministerium für Cultus und Unterricht*) to make plans for Austria's participation in the upcoming Paris World's Fair of 1900 (122). When the committee was reconstructed in 1900, the Secession succeeded in getting half of the ten member artistic representation composed of its own people, and after

[27]To be subsequently referred to as the Ministry of Education.

much lobbying and protest it received a prominent share of the allotted exhibition space for itself, on virtually its own terms (123), and with a 6,000 Florin subvention from the state (124). The resulting exhibition was a resounding success as was the Secession's own private exhibition held in Paris before the opening of the Fair. Both were received with distinction, with the latter also benefitting from several official purchases made by the Austrian government (125). The success of the Secession in Paris had the dual effect of giving international recognition to its art while identifying it as the progenitor of that art in Austria to the extent that it had received government sponsorship at the Fair.

This official recognition of the Secession's importance was further enhanced by the participation of its members in the government sponsored *Kunstrat* (Arts Council). Set up in 1899 by the Ministry of Education (126), its purpose was to create a mixed advisory council of artists and laymen to provide the government with a representative spectrum of opinion on artistic matters. From its inception Otto Wagner and Carl Moll, both prominent members of the Secession, served in the *Kunstrat,* and both men, especially Wagner, actively pressed for artistic reforms in the public sphere, thereby carrying out the Secession policy connecting the best interests of the public with those of art. These efforts involved questions of government support, the design of official buildings, and matters of public taste, generally, but an issue that was of great importance to the Secession was the creation of the Modern Gallery.

The need for a separate gallery dedicated to the display of contemporary art works had first come under study in the *Kunstrat* in 1899, but it was not until the next year that a formal motion concerning it was made by Carl Moll and plans for its administration and construction presented to the *Kunstrat* (127). Though referred to another committee for financing, that year saw the gallery's acceptance and the establishment of its cause in the Ministry of Education, and

with official government purchases of modern art increasing after this time, the Secession itself launched a relatively intense purchasing and propaganda campaign for the furtherance of the project.

Wagner drew up plans for a modest gallery in art nouveau style (Figure 19) and the Secession set aside a specific amount of its profits expressly for the acquisition of works for the Modern Gallery (128). Indeed, several of the works that now hang in the Austrian Gallery (*Österreichische Galerie*) in the Belvedere palace and the New Gallery (*Neue Galerie*) in the *Stahlberg* branch of the Art Historical Museum were donated by the Secession. The government, in turn, was constantly prodded to buy contemporary works while they were still available and to exhibit them as soon as possible, even if a permanent structure was not yet ready (129). A temporary home for the Modern Gallery was finally found in the Baroque Unteres Belvedere and formally opened in April 1903 (130). A permanent home for the collection was never built, but nevertheless official recognition of the value of modern art had been won from the government in the form of an official institution dedicated to its collection and display, and this had largely been the work of the Secession. In light of both this success and the Secession's position vis-a-vis the *Kunstrat,* it seemed to one commentator that the Secession had been given official approval (131).

In realizing the project of the Modern Gallery the Secession had carried out an extension of its didactic program of exposing the public to the new art and at the same time had managed to get the government involved in this process, an involvement obviously of great potential in disseminating the new art to the broadest possible strata of the people. Another way, of course, was through direct government commissions that came to members of the Secession. Although private commissions were fairly plentiful, those in public buildings because of their usual monumentality and

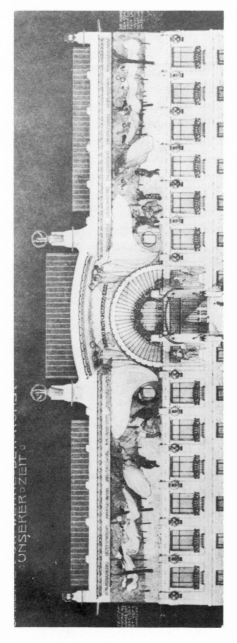

Figure 19 Otto Wagner's design for the Modern Gallery (1900) as reproduced in his collected sketches and drawings.

exposure to daily public use could reach a large number of people, and in the years before the outbreak of World War I, both Otto Wagner and his pupil, Josef Hoffmann, received commissions for public works. This was especially true for Wagner, who designed the Postal Savings Bank (*Postsparkassegebäude*) (Figures 20) and the Church on the Steinhof[28] (Kirche am Steinhof)(Figure 22) and several other projects in those years. In addition, he was involved in two public projects that, though never realized, caused a great deal of debate, a museum for the city of Vienna and the construction of a new academy of art. Hoffmann, on the other hand, was responsible for only one public building at that time, the *Purkersdorf Sanitorium,*[29] which he and the *Werkstätte* designed.

If one goes a bit farther afield, another of Wagner's students, Hubert Gessner, designed a district headquarters and workers' home (*Arbeiterheim*) for the Social Democrats in Vienna in 1905 (132), and although not a public commission, its daily use by a mass party was exposing the public to the benefits of the new art. Before his death in 1908, yet another of Wagner's pupils, Josef Olbrich, though he spent most of his time out of Austria, had received several public commissions from the Grandduke of Hesse-Darmstadt, including the construction of an entire artists' colony in the hills above the city of Darmstadt. Thus, through semipublic, foreign, but most of all Austrian official commissions, the Secession was able to have its style and art disseminated in a relatively large number of public works in a rather short period of time, and while not the only group involved in the long standing question of government responsibility in Austria toward the arts, it proved the most successful in getting results (133).

[28]The church located on the grounds of the provincial hospital for nervous and psychological disorders in Vienna.

[29]A sanatorium in Purkersdorf built in 1904–1905.

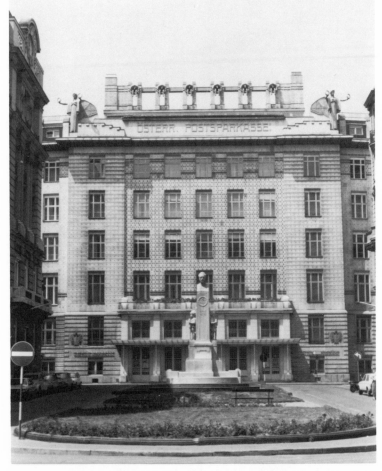

Figure 20 Exterior view of the main facade of Wagner's Imperial and Royal Savings Bank (1904–1906). In general, it is more reminiscent of a design from the 1920s or 1930s than from pre-World War I Europe.

The success of the Secession in gaining the ear of the government, in acting as a spokesman for modern art, and in garnering of major commissions all contributed to its ever increasing institutional character. It was still artistically radical, but in all other respects it was becoming as solid as its

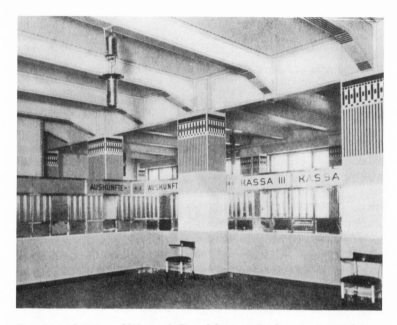

Figure 21 Interior of Wagner's Postal Savings Bank as it appeared in an early work on Wagner by J. A. Lux. This is a view of the pay office for securities and bonds that was part of an addition done in 1910–1912.

counterpart in the *Künstlerhaus*. All this recognition meant that the Secession had arrived in Austrian society, and in a state of bureaucratic institutions, nothing was more respectable than another institution. The controversial quality of its art notwithstanding, the Secession was establishing itself as securely in Austria's art world as its building had been anchored in the ground of the *Karlsplatz*. It was there to stay,[30] and when the movement split in 1905 and the schismatic *Klimtgruppe* closely associated itself with the well entrenched *Werkstätte,* it was clear that even when divided the Secession retained an institutional character.

The Secession as an institution made it into a kind of vested interest, and it willingly engaged in controversy to

[30]The Secession still exists as an organization and occupies the same building on the *Karlsplatz*.

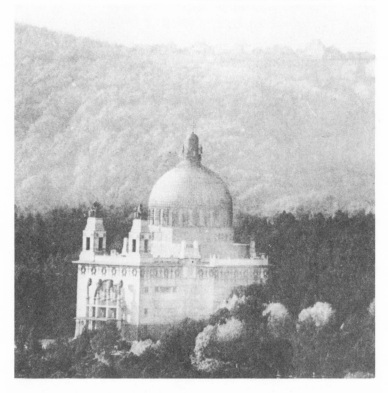

Figure 22 Otto Wagner's Church on the Steinhof (1905–1907).

defend that interest. To be sure, by its avant-garde stance it was often thrust into controversy, but true to its strong sense of purpose the Secession felt obliged to involve itself in any art question of interest to it, and in so doing it spoke with the dedicated voice of the new art. As a result of the Secession's boundless energy in this area, one observer noted that not only was the Viennese art market livelier, but Vienna had become far more involved in the artistic questions of the day (134). One of its favorite topics was reform of the Imperial and Royal Art Academy. Though this issue did not originate with the Secession, it was of considerable interest to it, for if art as a whole were to be raised to a higher

plane, the places where it was taught would also have to undergo a reorientation in their methods and outlook. During much of the time between 1898 and 1914, Otto Wagner, who was himself one of its professors, was constantly putting forth projects for the academy's reconstruction, while as early as 1899, the Secession called for a complete reform in its teaching methods because of their stultifying tendencies (135). Again in 1902, *Ver Sacrum* carried an attack by the painter, Ernst Stöhr, that was directed not only at Vienna's academy, but at all art academies in general (136). In it he called them useless institutions that occupied the students in pointless pursuits. He capped it off by affirming hand work (*Handwerk*) as the real foundation of all art, and therefore, only craft schools were necessary because the articles they produced served the necessities of life (137).

Yet for all of Stöhr's thunderings in the pages of *Ver Sacrum* and the Secession's critical views, in practice it was not at all indisposed to associating with the official educational establishment and by 1902 it had already been in control of one of Austria's most important art schools for three years. Despite Wagner's connection with the academy, that institution never came under significant Secession influence. Even the Secession's leading artist, Gustav Klimt, failed in his bid to join its faculty and was never granted more than an honorary membership and that only in 1917, a year before his death. There was, however, another institution that was more receptive to the movement. As early as the first year of the Secession's existence, 1897, the painter Felician Freiherr von Myrbach, had been appointed to the faculty of the state supported School of Applied Art *(Kunstgewerbeschule)* in Vienna. In 1899 he replaced its conservative director, Joseph Storck (138), and in the same year was joined at the school by his fellow Secessionists Josef Hoffmann, Koloman Moser, and Alfred Roller, thereby making it the most advanced faculty of design in the empire.

This triumph, however, was not attained without outside help. The revolution at the school had probably, in large

part, been engineered by the pro-Secession head of the Austrian Museum of Art and Industry, Arthur von Scala. Because the museum was the parent institution of the school, Scala was in a position to influence it. He became director in 1897, and the following year appointed Otto Wagner to the curatorial board of the museum and was later the one who secured Hoffmann a place on the faculty (139). No doubt Moser, Roller, and Myrbach owed much to him as well, but Scala played the role of colleague rather than that of creditor with them. Both Scala and his Secessionist associates favored the design ethic of the English arts and crafts movement that was so integral a part of art nouveau as a whole. The museum's exhibitions became showcases of historic and contemporary English furnishings and the school a center of English and English-influenced Secessionist design theory. The official bastion of applied art in Austria thus fell into pro-Secession hands and was able to put its stamp upon a new generation of craftsmen. Cooptation proved a more effective and lasting means of reform than Ernst Stöhr's manifesto.

The Secession's interest in the applied arts was not limited to an institutional level. How they were actually used stirred the movement's interest as well and a case in point was the design of banknotes. As an item that was an indispensable piece of everyday life, it was worthy of a contemporary and artistic design, clear, but pleasing to all who used it. In 1901 a competition for the design of a new 20 Kronen banknote, however, resulted in a refusal by the Secession to participate, because the government failed to guarantee use of the design chosen in competition. The members of the Secession as well as nonmembers, who sat on the official committee resigned. The Secession justified its action by stating that "the banknote of a people [Volk] is an unerring document of its culture[31] (140).

[31]The Secession was more successful with postage stamps. In 1908 seven stamps designed by Koloman Moser were issued in honor of the Kaiser's sixtieth year on the throne.

In line with protecting the nation's culture, the Secession concerned itself with another timely issue, the restoration of national monuments. It was strongly influenced by Ruskin's ideas on the subject, and was opposed to any restoration a la Viollet-le-Duc. Therefore, when a project for the restoration of the main portal of St. Stephen's was broached in 1901 it engaged in a pamphlet skirmish with the government official in charge, Freiherr von Helfert, concerning how much rebuilding the portal should undergo in order to be restored (141). As far as the Secession was concerned, the government's plan was a destructive rather than a constructive restoration, and it opposed any rebuilding as contrary to the integrity of the portal. Such a controversy was of relatively minor importance outside of artistic circles, but in another case where restoration figured as part of the issue, the Secession involved itself in something that was potentially explosive.

In 1903 the Secession gave space in *Ver Sacrum* for one of its members to publish an open reply to an official rejection of some sketches he had done as part of the restoration of a cathedral in the Polish town of Ptouck (142). The artist, Josef Edler von Mehoffer, of Cracow, was also Polish and the man responsible for rejecting his work was a Germanized member of the Polish nobility, Count Lanckoronski. A friend of the Minister of Education, Wilhelm von Hartel, Lanckoronski was also a well-known art patron, and in an official capacity sat as president of the commission charged with the upkeep of monuments and was vice-president of the overall bureau concerned with them (143). It was in these latter capacities that he took it upon himself to reject Mehoffer's sketches despite their approval by the official jury. The grounds upon which this rejection was based were simply that Lanckoronski felt their modern style unsuitable to the spirituality of the cathedral (144). Mehoffer's reply to this judgment was based on the validity of modern art as an apt expression of its age and a rejection of the old histori-

cism, all good Secession principles, but it was also inter-
twined with Polish nationalism since not only was Mehoffer
an exponent of modern art, but of a modern Polish art,
which he felt was then struggling to find expression (145).
Thus, the Secession, by supporting Mehoffer, was involving
itself in an issue that had potential political implications in
a state where nationality was such an important and sensi-
tive issue.

Ultimately, Mehoffer was vindicated and the affair over
his fresco sketches caused no political uproar. The Secession,
though largely German, had supported Mehoffer on the ba-
sis of its artistic principles with apparently no nationality
concerns being taken into consideration. Indeed, in this
sense, since the Secession continued to give friendly support
to non-German Austrian artists, it acted in the international
spirit that the Habsburg state attempted to cultivate. The
Mehoffer incident also illustrated the Secession's continuing
commitment to standing up for what it considered valid art
despite whatever official or popular opposition it encoun-
tered.

The Mehoffer case and the other involvements of the
Secession that have been discussed so far, largely represent
the positive achievements of a movement that actively
sought an intimate involvement with its society. The Seces-
sion in its didacticism, its recognition by political and social
groups, and its vociferous concern for a variety of issues
touching on the relationship between art and society illus-
trates the degree to which it was able to actualize its desire
to reshape man's environment according to the movement's
ideals.

While its achievements fall considerably short of creating
a new world, they do show how the Secession was attempt-
ing to grapple with the problems of change, disunity, and a
lack of continuity in contemporary society. With respect to
the first of these issues the Secession showed itself willing
to accept change in its art and was, indeed, its principal

apostle whether in asserting new canons of design or intro-
ducing reformed banknotes. It also acted as a more or less
passive factor in the changing outlooks of sociopolitical
groups as diverse as liberals, Christian Socialists, and Social
Democrats. The Secession's desire to make art available to
all was reflected in its enthusiasm to open its doors to the
workers, and its efforts at getting public commissions illus-
trates the concept, mentioned earlier, of art as a social bond,
for it was the physical environment created by the applica-
tion of the *Gesamtkunstwerk* that would provide men with a
sense of unity, whether in a postal savings bank or a colony
of artists.

The desire for continuity in society was reflected in the
historical diversity of the art exhibited by the Secession
from that of old Japan on through the Impressionists to art
nouveau itself, while the presence of stylistic elements as
relatively old as those of the Romantics within the tech-
niques of its members indicates that the Secession had no
desire to leave its own artistic roots behind. The movement's
concern with the exact preservation of an historic past, as in
the St. Stephen's controversy, is a testament to how much
it favored a recognition of the historical roots of the people
as embodied in the buildings and other art treasures around
them. As a movement in modern art the Secession might
stand for change, but its reverence and concern for the past
indicated how even something modern could be part of
something old. In itself it was able to reconcile change with
continuity.

These positive aspects of the movement did not, however,
prevent it from suffering a telling setback even while show-
ing such promise. In addition to the controversy surround-
ing Mehoffer's work, there was also a struggle that was far
more intrinsically related to the Secession's ideals and its
position in Austrian society, though it too involved the issue
of artistic freedom. The affair generated by the question of
how suitable Klimt's *Fakultätbilder* were as allegories of phi-

losophy, medicine, and jurisprudence was like an open sore for the movement and its founder from 1900 to 1905. More than any limitation of the Secession's social impact due to the cost of its works or its less than overwhelming number of public commissions, the existence of this sore showed how fragile the promise of art was in attempting an aesthetic reconstruction of modern life according to a more harmonious blueprint.

Chapter Notes

1. Albert Fuchs, *Geistige Strömungen in Österreich 1867–1918* (Wien: Globus Verlag, 1949), p. 11.
2. See Adam Wandruszka, "Die 'Zweite Gesellschaft' der Donaumonarchie," in Heinz Siegert, *Adel in Österreich* (Wien: Verlag Kremayr and Scheriau, 1971).
3. Stefan Zweig, *The World of Yesterday* (New York: The Viking Press, 1943), pp. 17–18.
4. See Carl Schorske, "Politics and the Psyche in *fin de siècle* Vienna: Schnitzler and Hofmannstahl," in *The American Historical Review*, Vol. LXVI, No. 4 (July, 1961).
5. Zweig, p. 20.
6. Schorske, p. 935.
7. Zweig, p. 18.
8. Ilsa Barea, *Vienna* (New York: Alfred A. Knopf, 1967), p. 283.
9. Elisabeth Lichtenberger, *Wirtschafts Funktion und Sozialstruktur der Wiener Ringstrasse* (Wien: Verlag Hermann Böhlaus Nachf., 1970), p. 50, Volume VI of *Die Wiener Ringstrasse-Bild einer Epoche, Die Erweiterung der Inneren Stadt Wien unter Kaiser Franz Joseph,* edited by Renate Wagner-Rieger.
10. *Ibid.*
11. Barea, p. 288.
12. *Ibid.,* p. 289.
13. *Ibid.,* p. 288.
14. Robert Waissenberger, *Die Wiener Secession, Eine Dokumentation* (Wien: Verlag Jugend & Volk, 1971), p. 25 (puts special emphasis on role of Jewish youth).

15. Josef Engelhart, *Ein Wiener Maler Erzählt* (Wien: Wilhelm Andermann Verlag, 1943), p. 79.
16. *Ibid.*
17. *Ibid.*
18. From a conversation with Professor Oskar Matulla in Vienna in May, 1973.
19. Dr. Georg Günther, "Karl Wittgenstein und seine Bedeutung für den Aufbau und die Entwicklung der österreichischen Volkswirtschaft," p. 162 in Volume IV of the *Neue Österreichische Biographie* (Wien: Amalthea Verlag, 1927).
20. H. Stuart Hughes, *The Sea Change* (New York: Harper & Row, 1975), p. 43.
21. Alessandra Comini, *Gustav Klimt* (New York: George Braziller, 1975), note 15, p. 29.
22. Günther, p. 163.
23. Allan Janik and Stephen Toulmin, *Wittgenstein's Vienna* (New York: Simon & Schuster, 1973), p. 122.
24. *Ver Sacrum*, Vol. 1 (November, 1898), published as the official journal of the *Vereinigung bildender Künstler Österreichs (Secession)*, Wien, p. 24 (hereafter referred to as V.S.).
25. Ludwig Hevesi, *Acht Jahre Sezession (März 1897–Juni 1905) Kritik-Polemik-Chronik* (Wien: Verlagsbuchhandlung Carl Konegan, 1906), p. 64. Nebehay in his recent work on *Ver Sacrum* claims that the *Secessionsgebäude* cost 120,000 Kronen of which 40,000 came from the province of Lower Austria. He, too, however, agrees that Karl Wittgenstein paid most of the cost and also speculates about Nicholas von Dumba as an additional contributor. (See Nebehay, Christian M.; *Ver Sacrum* 1898–1903; New York: Rizzoli, 1975, p 18.)
26. Christian M. Nebehay, *Gustav Klimt, Dokumentation* (Wien: Verlag der Galerie Christian M. Nebehay, 1969), p. 169.
27. *Ibid.*, p. 112.
28. While it cannot be said with certainty who Wittgenstein's fellow contributors were in 1897, it seems very possible that someone like the prominent liberal banker, industrialist, and art patron, Nikolaus von Dumba, might have donated money to the Secession's building fund. Dumba had earlier commissioned the decoration of his study from Hans Makart, but between 1896 and 1899, Gustav Klimt designed and executed a music room for him. In addition to being directly involved with Klimt who was founding the Secession at the time he was working on the music room, Dumba was also acquainted with the aged and much esteemed painter, Rudolph von Alt, who became the Secession's honorary president in 1897. To be sure, all this evidence is circumstantial and cannot be called anything

more than informed speculation, but the conjunction of two leading personalities of the Secession with a well-known patron of the arts at the very time that the group needed money appears to suggest that Dumba may have been one of the possible donors of the remaining 10,000 Gulden. (See Nebehay, p. 170; and Gerhardt Kapner, *Ringstrassendenkmäler, zur Geschichte der Ringstrassendenkmäler* [Wiesbaden: Franz Steiner Verlag GMBH, 1973], p. 173; Band IX of *Die Wiener Ringstrasse, Bild einer Epoche,* edited by Renate Wagner-Rieger—in 1896–1897, both Alt and Dumba served on the same committee to erect a monument to the memory of Hans Makat. There is a painting depicting the committee at a meeting in Dumba's study that dates from 1897 and shows both him and Alt sitting together.)

29. Ludwig Wittgenstein (and Georg Henrik von Wright and Walter Methlagl, Editors), *Briefe an Ludwig von Ficker* (Salzburg: Otto Müller Verlag, 1969), p. 47.

30. "Die Wiener Werkstätte" (Exhibition Catalogue) (Wien: Österreichisches Museum für angewandte Kunst, 1967), text by Wilhelm Mrazek, p. 13.

31. *V.S.,* Vol. II (May, 1899), p. 30.

32. Zweig, p. 17.

33. Barea, p. 137.

34. *Ibid.,* pp. 137–40.

35. *Ibid.,* p. 149.

36. See Wandruszka.

37. Engelhart, p. 205.

38. *Ibid.*

39. *Matulla* (in the course of our conversation Matulla stated that Engelhart was a *"Parteigenosse"* of the Christian Socialists and that this accounted for his numerous public commissions from the city).

40. Engelhart, p. 80.

41. *Neue Freie Presse;* Donnerstag (November 18, 1897), p. 7. (Hereafter referred to as *N.F.P.*) Lueger as presiding officer at the *Gemeinderat* session appears to have sidetracked all the obstructionist proposals of the opposition and forced the matter to be brought to a vote.

42. Nebehay, p. 164.

43. Walter Wagner, *Die Geschichte der Akademie der bildenden Künste in Wien* (printed by the Akademie der bildenden Künst in Wien [Wien, 1967]), p. 259.

44. *N.F.P.,* p. 7.

45. *Ibid.* (There was also an objection made that the land was needed as a connecting link for two local streets, but this too failed. The

terms laid out in the successful legislation concerning the Secession's use of the land were as follows: 1) it was to be granted for 10 years at a rent of 10 Florins a year; 2) that there was to be no cost to the city and the Secession was to pay all taxes and fees; 3) the building was to be well constructed of durable materials and meet all municipal codes; 4) and that the remaining land around the building was to be laid out as a garden and be maintained by the Secession. It was also expected that work on the site would be finished by the coming spring. The *N.F.P.* reported that the Secession's building was to be ceded to the city, but this is not mentioned in the official record, although the provision of a 10-year lease suggests that the original grant was temporary in nature. See *Protokolle der öffentlichen Sitzungen des Gemeinderates der k.k. Reichshaupt-und Residenzstadt Wien 1897*, pp. 512–13).

46. *Ibid.*
47. *Ibid.*
48. Engelhart, p. 207.
49. Kapner, p. 233.
50. *V.S.,* Vol. I (November, 1898), p. 24.
51. Engelhart, p. 81.
52. *Ibid.*
53. *Ibid.*
54. Nebehay, p. 128.
55. Official catalogue of the *Jubiläums-Kunst-ausstellung 1898;* veranstaltet von der Genossenschaft der bildenden Künstler Wiens (Wien: 19 April 1898).
56. *Ibid.*
57. Hevesi, pp. 45–48.
58. *V.S.,* Vol. I. (März, 1898), pp. 23–24.
59. Hevesi, p. 42.
60. Engelhart, p. 80. (Engelhart had also studied in Paris and met artists who later became well known, something which many *Secessionisten* had not done.)
61. *Ibid.*
62. *V.S.,* Vol. I (Mai–Juni, 1898).
63. *N.F.P.,* Freitag (25 März 1898), p. 8.
64. *N.F.P.,* Dienstag (6 April 1897).
65. *Neues Wiener Tagblatt, Demokratisches Organ* (3 April 1897), p. 1. (Hereafter referred to as *N.W.T.*)
66. *N.F.P.,* Samstag (26 März 1898), pp. 3–4.
67. *N.F.P.,* Donnerstag (31 März 1898), p. 3.

68. *N.W.T.*, Samstag (26 März 1898), p. 2.
69. *N.W.T.*, Mittwoch (6 April 1898), p. 3.
70. *Reichspost*, Samstag (9 April 1898), pp. 1–3. (Hereafter referred to as *RP.*)
71. *RP*, Dienstag (29 März 1898), p. 4.
72. *Arbeiter Zeitung*, Donnerstag (7 April 1898), p. 6. (Hereafter referred to as *A.Z.*)
73. *Ibid.*
74. *A.Z.*, Sonntag (12 Juni 1898), pp. 6–8.
75. *Ibid.*, p. 6.
76. *Ibid.*
77. *N.F.P.*, Sonntag (27 März 1898), pp. 7–8.
78. *Ibid.*
79. *N.F.P.*, Montag (28 März 1898), p. 3.
80. *RP*, Mittwoch (6 April 1898), pp. 4–5.
81. *N.F.P.*, Freitag (25 März 1898), p. 8.
82. *RP*, Mittwoch (6 April 1898), pp. 4–5.
83. *Ibid.*
84. *RP*, Samstag (16 April 1898), p. 7.
85. *N.W.T.*, Freitag (8 April 1898), p. 8.
86. *N.W.T.*, Samstag (18 June 1898), p. 8.
87. See Dr. Constant von Wurzbach, *Biographisches Lexikon des Kaiserthums Österreich, enthaltend die Lebensskizzen der denkwürdigen Personen welch seit 1750 in den Österreichischen Kronländern geboren wurden oder darin gelebt und gewirkt haben*, 66 vols. (in 1856 published by Verlag der Universitäts—Buchdruckerei von L. C. Zamarski; from 1857–1859 by Druck und Verlag der typogr.-literar.-artist. Anstalt, and from 1860 by Druck und Verlag der K. K. Hof-und Staatsdruckerei, Wien; 1859–1891).
88. *N.W.T.*, Montag (18 April 1898), p. 3.
89. *N.F.P.*, Sonntag (17 April 1898), p. 9.
90. *Ibid.*
91. *N.F.P.*, Montag (18 April 1898), p. 3.
92. *N.W.T.*, Montag (18 April 1898), p. 3.
93. *A.Z.*, Dienstag (19 April 1898), p. 4.
94. *A.Z.*, Donnerstag (4 August 1898), pp. 5–6.
95. Engelhart, p. 103.
96. *N.W.T.*, Sonntag (10 April 1898), p. 8.
97. *N.F.P.*, Samstag (12 November 1898), p. 7.
98. *A.Z.*, Donnerstag (1 Dezember 1898), pp. 5–6.
99. *N.W.T.*, Mittwoch (16 November 1898), p. 8.
100. *RP*, Sonntag (13 November 1898), pp. 1–3.

101. Hevesi, pp. 63–68 and p. 68 (explanation at beginning of why he wrote preceding article). In two articles (see Note 102 below), Hevesi talked about the background to Olbrich's design in terms of its modern antecedents from William Morris on through to the work of contemporary Belgian, Dutch, and French architects. This was done to show that it was not a mere aberration, but part of a European wide trend. He also discussed it in terms of its functionalism and the significance of its decorative elements. All of this was meant to defend and justify the house of the Secession before the highly critical and rather close-minded Viennese public.

102. Hevesi, p. 70.

103. *N.F.P.*, Samstag (12 November 1898), p. 7.

104. *A.Z.*, Donnerstag (1 Dezember 1898), pp. 5–6.

105. *A.Z.*, Samstag (12 November 1898), pp. 5–6.

106. *N.W.T.*, Sonntag (20 November 1898), pp. 1–2.

107. Hevesi, p. 63.

108. *V.S.* (März 1899), page unnumbered.

109. *N.W.T.*, Sonntag (13 November) and Samstag 19 November 1898); see "Theater, Kunst, und Literatur" section for both issues.

110. *N.F.P.*, Sonntag (20 November 1898), p. 6.

111. *N.F.P.*, Sonntag (18 Dezember 1898), pp. 7–8.

112. *Erster Jahresbericht der V.b.K.Ö. "Secession"* (Wien: 1 Juli 1899), p. 10.

113. *Ibid.*, p. 21.

114. *Ibid.*, pp. 16–17.

115. *Ibid.*, p. 17.

116. *V.S.*, Heft 11 (Juni 1, 1901), p. 183.

117. *Zehnter Jahresbericht der V.b.K.Ö. "Secession"* (Wien: 1 July 1908), pp. 15 and 8.

118. From its catalogues between 1908–1914 it is evident that the Secession was still quite active in both Viennese and international artistic circles, and by that time the Secession minus the *Klimtgruppe* was virtually part of the Austrian artistic "establishment," all of which bespeaks a solvent organization. Moreover, as Professor Oskar Matulla has pointed out in his article "Die Soziale Seite der bildenden Kunst 1900–1945" (in *Kultur Berichte aus Niederösterreich*, Vol. VI, 1966), Austrian artists before the First World War if they were at all successful could count on having at the very least a solid bourgeois existence from the income derived from official and private commissions and the policy of government support for the arts. The members of the Secession and the artists who exhibited there, for the most part, fell into the above category, so that the Secession should have had no trouble in deriving a steady income at least from its exhibitions.

119. Helene Kowalski, *Die Stellung der Wiener Werkstätte in der Entwicklung des Kunstgewerbes seit 1900,* an unpublished doctoral dissertation written for the Philosophische Fakultät der Universität Wien (1951), pp. 110–12.
120. *A.Z.* (A.Z. Journal), Sonntag (23 Juni 1973), pp. 12–13.
121. *V.S.,* Heft 4 (15 Februar 1901), pp. 71–85.
122. *V.S.,* Heft 4 (15 Februar 1900), p. 55.
123. *Ibid.,* p. 64.
124. *V.S.,* Heft 11 (1 Juni 1900), p. 177.
125. *V.S.,* Heft 2 (15 Jänner 1900), p. 19.
126. Wagner, p. 248.
127. *V.S.,* Heft 11 (1 Juni 1900), p. 178.
128. *V.S.,* Heft 20 (15 Oktober 1902), p. 343. [In 1900 Wagner wrote about his plans for a modern gallery that would cost around 2,-000,000 Kronen and proposed a site along the canalized Vienna River near the Imperial and Royal Museum of Art and Industry. He felt that the main goal of the project would be "to gain a clear picture of actual artistic creation in the coming century." See Otto Wagner, "Zur Studie, Galerie für Werke der Kunst unserer Zeit," in *Einige Skizzen, Projekte und ausgeführte Bauwerke*, Band III (Wien: Anton Schroll und Comp., 1906), pp. 3–8.]
129. *Ibid.,* p. 348.
130. Hevesi, pp. 431–436.
131. Gerhard Ramberg, *Öffentliche Kunstpflege ein Stückchen Sozialpolitik* (Wien: publisher unnamed, 1904), p. 9.
132. *Österreichischer Arbeiter Kalendar für das Jahr 1905,* organ of Social Democratic Party, pp. 126–28.
133. There is a long history in Austria of both government involvement in and support of the arts that goes back to the 18th century. Between 1900 and 1914 with the advent of the Secession and the subsequent enlivening of the artistic scene, the issue of what role the government would play in the art world also took on a liveliness. Not only the Secession, but other art groups including the *Künstlergenossenschaft* and the pro-Secession *Hagenbund* took part in the debate as did private individuals like the critics Gerhard Ramberg and Ludwig Hevesi.
134. Ramberg, p. 25.
135. *V.S.* (August, 1899), pp. 26–30.
136. *V.S.,* Heft 15 (1 August 1902), pp. 228–29.
137. *Ibid.*
138. Peter Vergo, *Art in Vienna 1898–1918, Klimt, Kokoschka, Schiele and their Contemporaries* (London: Phaidon Press Ltd., 1975), p. 130.

139. *Ibid.*, pp. 129–30
140. *V.S.*, Heft 1 (1 Jänner 1901), p. 26.
141. See *Der Arbeitsschuss der Vereinigung bildender Künstlers Österreichs (Secession);* "Die Wiener Secession und Seine Excellenz Freiherr von Helfert" (Wien: Ostern, 1902).
142. *V.S.*, Heft 14 (15 Juli 1903), pp. 245–61.
143. *Österreichische Akademie der Wissenschaft; Österreichisches Biographisches Lexikon,* Bd. IV (Wien: Hermann Böhlaus Nachf., 1969), p. 423.
144. *V.S.*, Heft 14 (15 Juli 1903), pp. 245–61.
145. *Ibid.*

Chapter 3
Conflict and Division

The three allegorical paintings depicting the academic faculties of philosophy, medicine, and jurisprudence, known collectively as the *Fakultätbilder,* were commissioned from Gustav Klimt by the Ministry of Education in 1894, and were intended for the ceiling of the Festival Hall (Aula) of the University of Vienna (1). This was three years before Klimt became the moving force behind the Secession and underwent a basic change in his style. It was still another three years before the first of the paintings was far enough along to be put on public exhibition in 1900. The appearance of this painting, the "Philosophy," with its radically different approach to the subject, set off an instantaneous sensation and scandal unlike any that had previously been experienced in Austrian art. Fed by the subsequent unveiling of its two companion pieces, this uproar continued off and on for the next five years, until it was terminated by Klimt's refusal to hand over his paintings to the ministry and the return by him of his official commission fee in 1905.

The affair of the *Fakultätbilder,* because it involved the most outstanding artist of the Secession and the most controversial works he ever produced, is significant for this study in that the impact of this five-year conflict on the Secession and its relation to Austrian society reveals both

the limitation of the new art in that relationship as well as the disturbing force it could generate in a society unaccustomed to the kind of radical alteration of its self-image present in Klimt's unorthodox allegories. It showed that the Secession could not realistically assume that the public would accept it as the authoritative representative of modern art, especially when that art represented society's scholarly, medical, and legal embodiments in a way that appeared ambiguous and uncomplimentary. Nineteenth-century Austrian society was accustomed to seeing itself in the clear and noble forms of classical symbolism so much in evidence along the *Ringstrasse* and was very reluctant to bind itself to an art whose image of society's attributes was both less distinct and less flattering. Indeed, during this period of conflict the Secession itself could not entirely agree on how it should represent its art to the public, and the resultant split in 1905 did not augur well for a movement that desired unity both in art and society.

The form in which these allegories appeared was, in fact, the cause of the whole controversy. Unlike the allegorical works that had preceded them in Austria, Klimt's paintings utilized neither formalistic classicism nor Raphael's "School of Athens" technique of incorporating famous personages associated with the subject matter into the composition. Instead, he relied on the use of highly symbolic and atmospheric presentations that involved a minimum of traditional representation with even that minimum being reworked in his own unique style.

To an age now grown accustomed to the unusual in art and the radically allegorical possibilities of a "Guernica," the three *Fakultätbilder* may seem quite tame. If, however, one examines some of Klimt's own earlier allegorical works, which were then fairly typical of their genre, such as "Fable" (1883) (Figure 23) or "Allegories of Music" (1885) (Figure 24), the shift from a semiclassical and naturalist stance in one, and Baroque symbolism in the other to what he does

Figure 23 Gustav Klimt, "Fable" (1883).

in "Philosophy," "Medicine," and "Jurisprudence" is quite
a change. In the first of these, "Philosophy," (Figures 25 and
26), the painting depicts a dark and starry void on the left-
hand side of which a sexually and generationally mixed
column of intertwined and nude humanity rises into the
firmament with expressions of fear, anxiety, expectation,
insight, and hope written upon their faces, while beside
them in the distance is the partially distinct image of a
sphinx that merges with the void itself. At the bottom of
the canvas is the face of a beautiful woman with intensely
probing eyes to depict the revealed face of "Knowledge"
(*Wissen*). Here is the Klimtian vision of philosophy. Not a
disputation between Kant and Aristotle, but the striving of
an uncertain and even tortured mankind after the knowl-
edge of life and death posed to them by an unfeeling sphinx
as an unending riddle, the solving of which stretches into the
void of time and holds man from birth to death.

Figure 24 Gustav Klimt, "Allegories of Music" (c. 1885).

In "Medicine" (Figure 27) Klimt used a similar stylistic technique, and indeed both paintings were first exhibited around the same time (1900).[1] In this allegory the column of humanity appears to have occupied a central position in the work. Again it was set against the background of a void, though not of the starry heavens. Within this human column are depicted men, women, the new-born, the aged, the pregnant, the dying, the dead, and even death itself in the form of a skeleton in their very midst. To one side of the column is the floating body of an unconscious, nude woman. Her arm is outstretched toward the human mass in a gesture of helplessness, while the arm of a man stretches out from that same mass as if to grasp the ends of her trailing tresses and keep her from being borne away, one presumes, to the oblivion of death. Unlike the "Philosophy," however, in the bottom foreground stands a very distinct symbolic figure— Hygeia. Though a traditional and even classical representation of the embodiment of medicine with her female form, bowl, and serpent, she has been given a completely Klimtian form with her hair bedecked in flowers and her body lost in the diaphanous red of her robes with their bright gold, floral-like ornamentation. Here, in the general composition, Klimt had depicted the burdens of medicine in the form of all the physical processes to which man is subject; however, the warm vividness of human life stands in rather sharp contrast to the cold beauty of the healing art's symbolic form that meets the viewer's gaze with a distant and imperious expression seemingly detached from an intimate relation with the scene behind her. The very aloofness of this figure suggests the modern transformation of medicine from a divine art to a divine science increasingly removed from the realities of a suffering humanity.

[1]In the case of the "Medicine" this seems to have been a painted sketch (*gemalter Kompositionsentwurf*). It was not the final work exhibited in 1901.

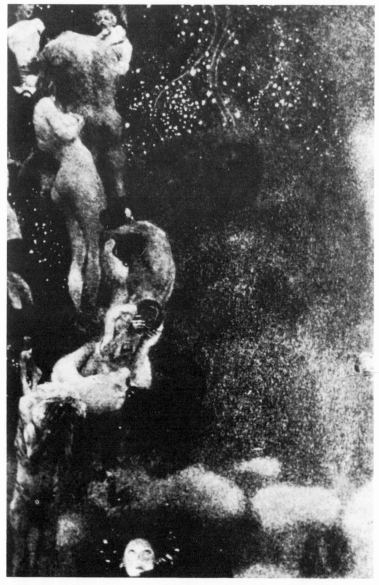

Figure 25 Gustav Klimt, "Philosophy" (1900).

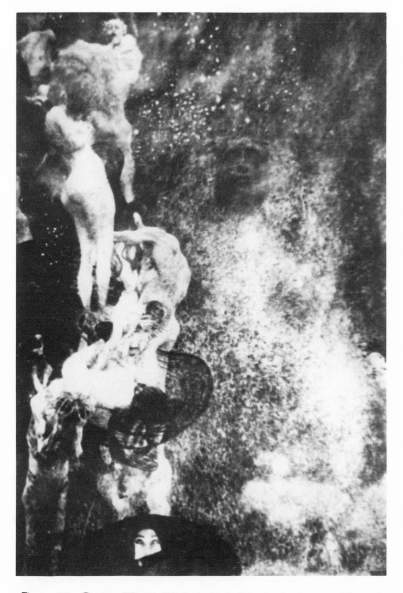

Figure 26 Gustav Klimt, "Philosophy" (1907)—final state. Note the lightening of the coloration and the more ominous appearance of "Wissen" at the bottom of the painting.

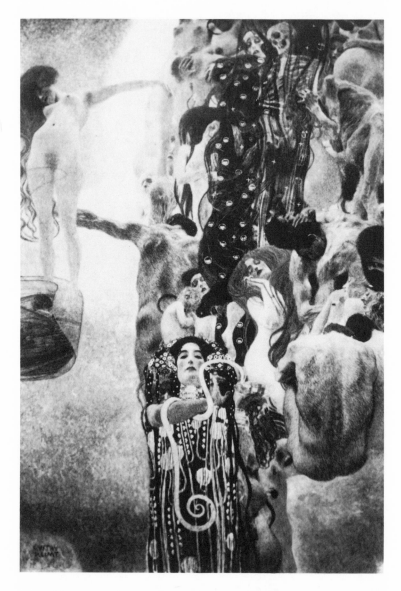

Figure 27 Gustav Klimt, "Medicine" (1907—final state).

Finally, in the "Jurisprudence," (Figure 28), which was the last of the paintings to be shown (first representation in 1903), Klimt used a completely different form of composition. Like the other two paintings, the original studies for this one date from 1897–1898, but in the interim Klimt had changed his approach completely. Instead of continuing the columnar technique of his first two works in the series, Klimt utilized a more stratified composition that relied on fewer, though more specifically symbolic, figures. The general background of the painting is of a dark hue, but of an indeterminate nature. In the upper third of the canvas is a mosaic-like insert that encloses three allegorical female figures. The central one seems to be a variation on the traditional representation of justice only minus the scales and blindfold, while of the two side figures one holds a book with the inscription "Lex" symbolizing the law, while the other is partially nude and may be a variation on an earlier Klimtian theme, the "Nuda veritas," only in this case as a half robed nude she may be meant to indicate the not always clear nature of judicial truth. Behind and below these figures are the solemn heads of what may be, as Carl Schorske suggests, areopagites (2).

This gem-like upper portion of the painting with its idealistic presentation of justice is in sharp contrast to the level below it. The three distant and apparently unfeeling figures above are replaced by three erotically nude women, possibly furies, arranged in a parody of their chaste counterparts. Their lush hair intertwined with tendrils and snakes, they are themselves partially enveloped in a wave of black hair. To the left of the central figure one of the women, partially covered by the hair, sleeps in a pose similar to that of the partially nude and dreaming "truth" above her, while on the right the counterpart to the bearer of "law" stands almost completely nude and with a whore-like appearance, the direct opposite of the covered and angelic-looking keeper of

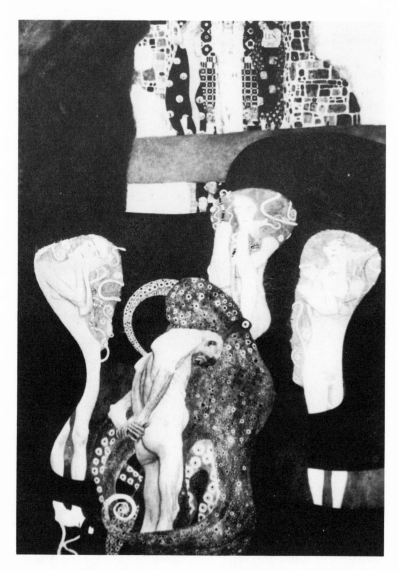

Figure 28 Gustav Klimt, "Jurisprudence" (1907—final state).

the laws above. In the center of this triad and raised above them somewhat is the alter ego of the glittering figure of justice who stands almost directly above her. Unlike her, however, this fury does not have her eyes closed, but crouches staring with a terrible gaze at the scene before her. In place of the sword of justice is a huge multi-colored octopus, a monster about to ensnare with its tentacles the haggard body of an old man condemned by the three unfeeling beauties above.

The abandonment of a columnar composition in "Jurisprudence" in favor of a layered effect comprised of comparatively few figures in each level is a striking departure from the unitary form conveyed by Klimt's earlier images of an intertwined humanity. Instead, one finds a hierarchy of authority with man as its victim. Moreover, in both the "Philosophy" and "Medicine" the most prominent figure was at least symbolically benign and essentially human, but here that position is occupied by a monster that, despite its place in the lower third of the canvas, dominates the scene and draws the eye of the beholder to its dazzling, yet repellant form. As if to reveal for all time the discrepancy between the ideal and the real, Klimt has shown the two sides of justice in a painting that was meant originally to be inspirational and, no doubt, even comforting to the teachers and students of the law. Instead, they have an allegorical object lesson of the law's awesome power over man.

All three of these paintings underwent alterations between 1900 and their final completion in 1907. In the interim, Klimt's final treatment of the "Jurisprudence," the faculty most closely associated with officialdom, may have been influenced by the calumny heaped upon him by his critics and what he felt to be the bad faith of the government.[2] Regardless of what may have motivated the final

[2]See Chapter Note 2.

versions, however, all three paintings taken together were received like bombshells in the Austrian capital.

The "Philosophy" got its debut on March 8, 1900, at the opening of the seventh exhibition of the Secession. It became almost immediately a focal point of interest and controversy, with crowds greater than those when the Secession had launched its first exhibition streaming in to see Klimt's latest work. With their usual speed, the newspapers of the city provided their readers with appraisals of the painting, which soon were followed by reports of the uproar it was causing.

While overall the reviews of the exhibition itself were favorable, that could not be claimed for its star attraction. Only the *Presse* and the *Arbeiter Zeitung* liked the "Philosophy," but even those two staunch supporters of the Secession were moved to express reservations about it. In the *Presse* Franz von Servaes had to admit that not everyone would be able to understand the meaning of the allegory (3), with the reviewer for the *Arbeiter Zeitung* confessing to a lack of certainty about the symbolism of the painting (4). The opinion of Friedrich Stern in the *Tagblatt* was unfavorable to the "Philosophy," and he even expressed himself as preferring the older, more conventional form of allegory to the new symbolism used by Klimt (5). In the *Reichspost* there was the usual mixed review of the exhibition as a whole, with a negative evaluation of the "Philosophy" in particular as being too mystic, unsuitable for the Aula of the university, and an unfortunate stylistic direction from which an artist of Klimt's caliber would do well to retreat (6).

What began as a stylistic controversy soon took on a more political tone, and on March 25 the *Tagblatt* reported that a petition was being circulated among the faculty by the theologian and rector of the university, Dr. Wilhelm Neumann, against Klimt's painting of philosophy (7). There followed on the 27th the report in the *Presse* of an interview with Neumann, who both as rector and a member of the

artistic commission concerned with decorating the Aula expressed the opinion (8) that Klimt's painting was completely unsuitable for its subject because

> This discipline [philosophy] which today seeks its sources in the exact sciences, precisely in our time does not deserve to be presented as a foggy, fantastic form, [or] puzzling sphinx. . . .

In answer to the professorial attack on the work of their colleague, the Secession presented a resolution to Minister of Education von Hartel, calling on him to protect Austrian art in general and Klimt's great work in particular from the incompetent attacks of the professors (9). Hartel replied by noting that no formal representation had been made to him by the professors, that the procedures followed in the commissioning of the painting had been proper, that criticism of the work was premature, and that in any event one should wait upon the unbiased opinion of the French judges at the Paris exposition where the "Philosophy" would be placed on exhibition (10).

In addition to the action of the Secession, an association for the protection of a free art was formed as a result of the protest, with the student body (*Studentenschaft*) of the university favoring Klimt (11). Among the faculty a counter-movement sprang up that was sharply critical of Neumann and his supporters. On March 28, Doctors Schauta and Emil Zuckerkandl (an eminent physician and friend of the Secession), the leaders of the counter-protest, personally called on von Hartel to state that he must carry out the Klimt commission because an art work should not be prejudged, especially by academics who are laymen in such matters (12). On the heels of this counter-protest, Dr. R. v. Schneider, who was director of the antiquities collection of the Art Historical Museum, cabled his opposition to Neumann and support of Klimt from Rome (13). Then on March 29 the *Arbeiter Zeitung* carried an interview with one of the anti-Neumann protesters, an anonymous professor of medicine (perhaps

Zuckerkandl), who roundly impugned the motives of both Neumann and his supporters for their opposition, noting that Neumann had been against Klimt as early as 1894 and that this attack on his painting was an attack on culture (14). To underscore this opposition to the attitudes of their colleagues the pro-Klimt professors also drew up a petition and presented it to von Hartel. Unfortunately, they were able to garner only 12 signatures (15).[3]

The storm over Klimt's "Philosophy" continued to rage and also on March 29 three of the anti-"Philosophy" professors published an explanatory statement in defense of themselves and their colleagues. In it they denied that they were against either Klimt or the Secession, but felt they were merely exercising their nonspecialist right of expressing criticism, noting that such a privilege should not be limited to specialists in art. They further emphasized that their actions were motivated from a sense of duty to their Alma Mater, which was in danger of receiving a painting unsuited to its decoration (16). Shortly after this statement was made public, the "Philosophy" was shipped to Paris (April 2). It ulti-

[3]The conflict between the pro- and anti-Klimt professors involved an emergent Viennese school of art history. Franz Wickhoff, the art historian who was responsible for the counterpetition, represented along with Alois Riegl an approach to judging art forms that was based on the cultural values that had given rise to them. They rejected the notion of an absolute aesthetic standard in favor of an historically relativistic one reminiscent of Rankean historicism. When Friedrich Jodl, a philosopher and leader of the anti-Klimt professors, justified their opposition to Klimt's painting on the grounds that it was "ugly art" Wickhoff responded with a lecture on Klimt entitled, "What is Ugly." In the spirit of his and Riegl's ideas Wickhoff equated the anti-Klimt forces who saw his work as ugly with primitive aesthetic impulses and a mistaken identification of beauty with the standards of the classical past. He maintained that the public was being misled by "second class" minds and thereby separated from the work of the progressive contemporary artist who expressed the true feelings of the present era. He implied that those who saw modern art as ugly were unable to face modern truth. Carl Schorske, *Fin de siècle Vienna, Politics and Culture* (New York: Alfred A. Knopf, 1980), pp. 234–35.

mately received a gold medal there, but in the meantime the controversy continued.

In April things were quiet, but in May the storm blew up again. The May issue of *Ver Sacrum* published an article expressing the official support of the Secession for Klimt and reported what one of the protesting professors supposedly gave as his idea of what the "Philosophy" should have been like. The composition according to him should have contained "portraits" of the most famous philosophers of all times (17). This statement was interpreted by the Secession as meaning that a kind of "School of Athens" format should have been used, which they rejected as being contrary to the pure expression of the artist. The professor's opinion was dismissed as merely serving his own particular taste. In short, the Secession found this attitude to be contrary to its basic principles of artistic expression, which, by the tone of their article, they seemed to feel could not be determined by the layman (18). The Secession was in turn criticized in the *Tagblatt* by Stern for taking such an exclusive position meant to stifle criticism and which had the effect of being unfair to the opposition (19).

On May 17 the professors finally presented their petition to the Ministry of Education with a list of 87 signatures. In it they protested their respect for Klimt as a great artist of the modern movement, but held stubbornly to the position that the rendering of the subject was unsuitable both in terms of its content and its stylistic incompatibility with the Renaissance ceiling of the Aula. The rejection of Klimt's rendering was based on a feeling that the work lacked the necessary order the professors felt the subject demanded. The variety of human forms and sexes as well as the colors and symbols used suggested only confusion to them. They could not help but doubt (20) "whether this visionary symphony of colors is really suitable . . . to call forth idea associations which are capable of enlightening the viewer about the intellectual content of the picture. . . ."

Through all of this Klimt had remained remarkably un-

ruffled, and in an interview that appeared in the *Presse* he defended the artistic value of his work and expressed himself satisfied so long as those who had commissioned him approved of it (21). For the time being, he needed to have no worries on that score. On May 12 a meeting of the *Kunstrat,* which had jurisdiction over contractual questions concerning the fine arts (22), was convened to deal with the professors' petition. In 1898 Klimt had been criticized by the ministry's arts commission over the dark coloring of the "Philosophy" and on some other points relating to the "Medicine" and "Jurisprudence." At the time, Klimt's damaged pride was smoothed over by the insertion of a clause in the contract that stated he would undertake the desired changes to the extent he could and still remain within the bounds of artistic freedom (23). The *Kunstrat,* on whose board sat the Secessionists Carl Moll, Felician von Myrbach, and Otto Wagner, ruled that Klimt had fulfilled the terms of the 1898 contract and that the protest of the petitioners, therefore, was without merit (24). Thus, the presentation of the professors' petition did not have its desired effect, and things cooled down for a time until the tenth exhibition of the Secession (March 15–May 12, 1901), when the second of the three *Fakultätbilder,* "Medicine," was displayed at the all-Austrian show. The uproar resumed.

Again, large crowds mobbed the *Secessionsgebäude* and the critics gave their opinions. With the exception of Servaes, who was enthusiastically favorable (25), and the *Arbeiter Zeitung,* which said nothing, the critical reception of "Medicine" was unfavorable. The *Tagblatt* and *Reichspost* both expressed negative views (26), and the *Presse,* where Servaes' article had been published, also gave space to an unfavorable appraisal shortly after his had appeared (27). The public in general did not like the "Medicine," and though there was not another professors' petition, the controversy did reach the floor of the *Reichsrat* (The Imperial Parliament).

On March 20 an interpellation was directed to Minister von Hartel by a member of the lower house of the *Reichsrat,* Ritter von Skene. Including von Skene, the text was signed by 22 members of that body, among whom were Count Palffy and Prince Liechtenstein, two members of the high aristocracy, and Karl Lueger. The complaint of the interpellation centered on the supposedly morally offensive nature of the composition, which in its "rawness" would be damaging to the public. Moreover, the acceptance of this painting by the Ministry of Education would constitute, they felt, official support of an artistic style that was claimed to be contrary to the aesthetic feelings of the majority of the people (28). The ministry did not agree with the deputies. On May 29 von Hartel replied to the interpellation. He pointed out that there could be no question about acceptance of the painting because it was already owned by the state and that it was not the ministry's position to give official approval to any art movement. Its survival, in fact, depended on freedom and public support (29). The minister's reply succeeded in defending the "Medicine" and art, in general, without appearing to give government support to Klimt and the Secession in particular. However, as Carl Schorske points out, the original draft of von Hartel's reply was much less ambiguous (30). An examination of the text of the draft indicates that he had initially intended a rather passionate defense of Klimt and the Secessionist tendency *(secessionistische Richtung)* in art (31). Political caution apparently caused him to change the tone of his reply when confronting leaders of the powerful Christian Socialist party. The presence of a Liechtenstein and of Karl Lueger among the protesting deputies clearly illustrates the limitations of Christian Socialist and, to a lesser extent, of aristocratic[4] support for the Secession. Von Hartel, though he might overlook the atti-

[4]Prince Aloys Liechtenstein was a leader of the Christian Socialist party.

tude of aristocrats, could not ignore the views of those who could obstruct the policies of the entire government. Perhaps for those reasons, the interpellation incident marks a turning point in official support for Klimt (32).[5] From here on the affair of the *Fakultätbilder* became an increasingly frustrating and losing battle for him.

Although the interpellation resulted in no action being taken against the Secession, earlier, on March 19, the office of the public prosecutor confiscated the latest issue of *Ver Sacrum* for having printed nude studies for the "Medicine." It was claimed that they were pornographic, but the charge was dismissed two days later. (33). Through all of this Klimt once again remained outwardly calm.

This time, however, signs of anger could be detected

[5]Carl Schorske has pointed out the highly suggestive congruence between the aims of the 1900–1904 ministry of Dr. Ernst von Koerber and the interests of the Secession during the period of the *Fakultätbilder* affair. Koerber sought to transcend and pacify the nationality conflicts of the monarchy through the use of economic and cultural development. His new Minister of Education, Wilhelm von Hartel, was open minded about artistic freedom and was well disposed toward modern art and even encouraged the *Kunstrat* "to sustain . . . the fresh breeze that is blowing in domestic art. . . ." Thus, for a time, an otherwise conservative state became the supporter of avant-garde art. The toning down of von Hartel's reply to the Christian Socialist interpellation over the "Medicine" is seen by Schorske as a turning point in that support, at least with respect to Klimt. Shortly after the incidents in the *Reichsrat* the ministry failed to confirm Klimt's appointment to a professorship at the Imperial and Royal Academy of Art and one of his leading critics among the protesting professors, Friedrich Jodl, was given a new chair of aesthetics at Vienna's Technical University. (For a full presentation of his arguments see Schorske, pp. 236–44). The evidence seems convincing that at least from 1900 to 1901 and to a lesser degree after that, the Koerber ministry through von Hartel found it in its interest to give at least indirect support to the Secession. The creation of the Modern Gallery in 1902–1903 at the instigation of the Secession may be taken as further evidence of that support.

(*Continued next page*)

beneath the surface. In 1902 Klimt completed a painting that contained three lush female nudes, one of which is depicted slyly smiling over her shoulder as she displays her ample posterior to the viewer. Klimt originally intended to call it "To My Critics" but was dissuaded by friends and named it "Goldfish" (Figure 29) instead (34). Although a jocular riposte to his critics, it indicated the inner tensions that Klimt was feeling at the time and that were now finding their way into his art, and not only in his minor work.

That same year at the Secession's Beethoven exhibition Klimt provided an elaborate frieze on the theme of the Ninth Symphony. The exhibition was organized as a *Gesamtkunst-werk* to harmonize with and glorify Max Klinger's newly completed statue of Beethoven (35). Klimt's painting was one of his most elaborate works, running over three walls and containing gilding effects that presage his later mosaic and gold paintings such as "The Kiss" (1908) (Figure 30). In general, his Beethoven frieze reflected an optimistic attitude about art's impact upon mankind and in describing the work

[5](Continued)

The actions of the Koerber ministry, however, should also be viewed in the perspective of a long history of state involvement in the arts that was highly developed when the Secession appeared and that was extended to it almost immediately. The Kaiser himself had shown formal interest in the Secession by visiting its first exhibition in 1898 and in the following year, 1899, when the *Kunstrat* was created, prominent members of the Secession were named to the council. Considering that the *Kunstrat* had responsibility for virtually all legal and aesthetic aspects of state activity in the fine arts, Secessionist participation in such a body already represented a considerable degree of official recognition and support a year before the Koerber ministry was formed. After 1900 the benign attitude of the government was certainly not a disadvantage for Klimt and the Secession, but until the interpellation of 1901, neither was supporting a fashionable avant-garde without benefits for a regime that wished to appear culturally progressive. Indeed, even after the fall of the Koerber ministry both the *Klimtgruppe* and the "Rump" Secession remained prominent factors in public artistic policy.

Figure 29 Gustav Klimt, "Goldfish" (1901–1902).

the catalogue noted that "The arts lead us over into the realm of the ideal in which alone we can find pure joy, happiness, and love" (36). What they led over, however, were "hostile forces" (*feindliche Gewalten*) (Figure 31) among which were the monster Typhoeus, gorgons, and the darker appetites of man. These allegorical figures are a counterpoise to the otherwise positive tone of the frieze, but more specifically may again have been meant as an allusion to his critics (37), from whom Klimt was still sheltered by faith in his own art's ability to overcome them. An earnest of that faith is represented in another panel of the work, which depicts a stalwart knight in golden armor to whom a suffering humanity pleads for protection against the "hostile forces" (Figure 32). This might be Klimt's symbolic image of himself in heroic struggle as the champion of art and humanity against the malevolence of his philistine critics (38). Thus, by the sensuous mockery of "Goldfish" and the heroism of a knight in shining armor Klimt seems to have maintained his equilibrium only by striking at his enemies through his art.

Following the exhibition of the "Medicine" and of the Beethoven frieze that followed, things quieted down until the eighteenth exhibition of the Secession. Held from November 14, 1903 to January 6, 1904, it was a retrospective show of Klimt's works and also was the occasion for the first public display of the "Jurisprudence." The "Philosophy" and the "Medicine" were also reexhibited so that all three works could be seen together. Again opinion, with the exception of Servaes (39) and the *Arbeiter Zeitung,* was negative (40), but the stormy events that accompanied the debuts of the "Philosophy" and "Medicine" did not follow and more concern was shown over Klimt's work in general than that one picture in particular. While the controversy was no longer sensational, it did continue and in 1904, because of disagreements with the Ministry of Education over exhibition arrangements and the Secession's participation in the

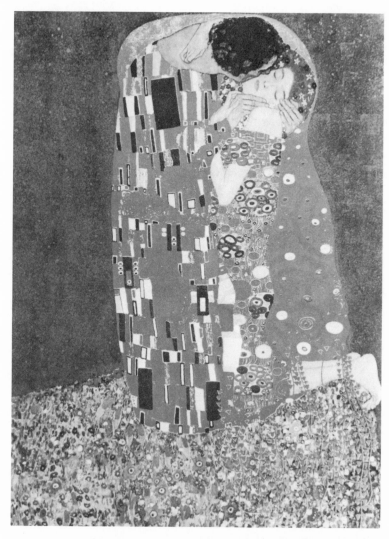

Figure 30 Gustav Klimt, "The Kiss" (1908).

St. Louis World's Fair, Klimt withdrew from painting the ten lunettes that were to accompany the main ceiling group, but less than a year later a more dramatic withdrawal was to follow.

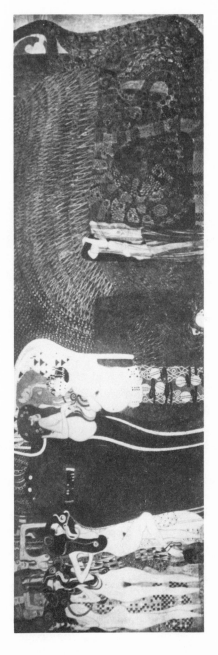

Figure 31 Gustav Klimt, "The Hostile Powers" from his Beethoven Frieze of 1902 on the theme of the Ninth Symphony.

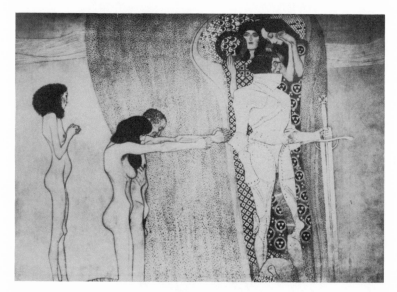

Figure 32 Gustav Klimt, "Pleading Humanity" from his Beethoven Frieze of 1902.

Since 1900 the government had consistently stood by its contract with Klimt and its ostensible intention of actually placing his paintings on the ceiling of the Aula. After 1901, however, this position was maintained with diminishing determination. Nevertheless, on February 27, 1905 the Ministry of Education proposed a trial mounting of the *Fakultät-bilder* in the Aula of the university as a preliminary to their permanent placement. In a meeting on March 10 the artistic commission of the univeristy refused permission for the trial hanging on the grounds of expense and that renewed controversy over the paintings could result. On March 24 they further decided to accept Matsch's paintings, "The Triumph of Light" and "Theology," and, in addition, give him the contract for the ten lunettes. As for the panels where Klimt's allegories were to have gone, the commission directed that they be covered over until new paintings could be acquired. The Ministry of Education did not reverse this *fait accompli*

and appears to have been reconciled to merely displaying the paintings at the Modern Gallery (41).

Because of these events, in April 1905 Klimt announced his intention to withdraw from the commission, keep his paintings, and return the fee. After some initial resistance by the ministry, which claimed the paintings as state property, Klimt gave back the 30,000 Kronen he had received and kept his paintings, which were ultimately lost along with many other of his works in a fire at the end of World War II in 1945 (42).

Klimt's withdrawal of his paintings came only after he had been almost constantly attacked over them for the previous five years, but the deciding factor was the final unwillingness of the Ministry of Education, because of the controversy involved, to hang the paintings in the Aula after all. Klimt had maintained all along that he was satisfied so long as those who had commissioned him still wanted his work. By 1905 he felt that condition no longer obtained.

In an interview given by Klimt to Berta Zuckerkandl at the time of his withdrawal from the *Fakultätbilder* commission he expressed his bitter disappointment over the ministry's decision concerning his paintings. He recounted the various indignities he and his works had been subjected to by a ministry that had come to regard him as an embarrassment. Clearly, those who had commissioned him were no longer appreciative of his paintings. Not only did he announce his intention to withdraw from the commission and keep what he had created, but he took the opportunity of the interview to criticize vigorously official artistic policy. His greatest anger, however, was directed at the high-handed and shabby manner in which the ministry treated Austrian art and artists. Klimt accused the Ministry of Education of protecting the false in art and attacking the genuine, of being dictatorial in its exhibition policies instead of restricting itself to the role of mediator and manager, and of interfering too much in the education and freedom of artists. The single incident that seemed finally to stand out in

Klimt's memory as typical of the attitude of the Ministry of Education was that of a scurrilous attack against the Secession during a sitting of the budget committee in response to which the Minister of Education had attempted no defense of it. Such an attack was for Klimt an attack against genuine art and he could not tolerate the weakness of the ministry in not reacting to it (43).

In the aftermath of this affair the *Fakultätbilder* were again put on exhibition and eventually went into private hands. Klimt himself, though he never engaged in another public commission (whether by choice or not is unknown), was apparently reconciled enough with the government in 1908 to accept a subvention for his group's *Kunstschau*[6] (44) and to speak at the exhibition's opening of the need for official commissions as the best way of establishing contact between the public and the artist (45).

Regardless, however, of how Klimt was able to deal with what must have been a very painful memory for him, the affair of the *Fakultätbilder* stands out in retrospect as the single most important controversy generated by the Secession or one of its members. It acted as a test both of how committed the Secession was to supporting its principles of furthering a genuine and a modern art and of how capable and willing Austrian society would be to accept the more substantial results of such an art. In the first instance, the steadfast support of Klimt by his colleagues as well as Klimt's own insistence on the validity of his renderings show the earnestness with which the Secession took its artistic mission, but with respect to Austrian society, the record is less positive.

The storm that raged over the *Fakultätbilder* has no counterpart of like magnitude in the history of Austrian art. The Viennese usually reserved their energies for the traditionally more important spheres of music and drama so that for

[6]Art Show (the name of the two exhibitions mounted by the post-1905 Klimt Group).

passions to be aroused over the merits of three paintings must mean that they touched some rather sensitive chords in the popular psyche. Since the founding of the Secession in 1897, the appearance of this new group and the modern movement it represented had aroused considerable interest in artistic questions, and the rise in public interest was greeted with gratification by artists and critics alike. Thus, to a certain extent, by the time the "Philosophy" appeared in 1900, a basis had been created for popular participation in artistic controversy. Still, when the furor broke over the *Fakultätbilder,* the general success of both the Secession and Klimt up to that time had not prepared anyone for what happened.

Throughout the controversy the patronage of the Secession by the upper classes and the government does not seem to have noticeably diminished, and this can also be said for the *Werkstätte,* which opened its doors in the same year as the appearance of the "Jurisprudence." This patronage, however, was largely limited to the purchase of the usual *objets d'art,* which, though they might be destined for a museum like the Modern Gallery, carried no official symbolic value. This, of course, was not the case with the *Fakultätbilder.* From first to last they owed their existence to an official commission, and they were designed to be hung in a public place and depict subject matter of broad symbolical importance to society. The first two circumstances explain why the controversy was political and not merely aesthetic; the last point, however, explains why there was controversy in the first place.

In 1903 Franz von Servaes referred to Klimt as "the greatest, but also the most dangerous artist" in the Secession (46). In the case of the *Fakultätbilder* it is this latter attribute that touched off the controversy. When he had received the commission in 1894, Klimt had been anything but controversial. His decorative works on the ceiling and walls of the Burgtheater and Art Historical Museum were technically proficient and fairly conventional. It could be assumed that the

creation of allegories to symbolize the three great areas of secular learning were in safe hands. When, however, it was discovered that they had been entrusted to an iconoclast, it was a signal for general alarm. People living in the *fin de siècle* entered the 20th century with ideas that were firmly rooted in the 19th century. One such idea was the positivist belief in the significance of knowledge, science, and law as the underpinnings of contemporary society. These three factors were neatly preserved and nurtured within the academic atmosphere of the university and specifically in the philosophical, medical, and juridical faculties. The abolition of ignorance and striving toward the ideal, the scientific elimination of the physical afflictions of man, and the securing of an ordered liberty were among the key attributes of the 19th-century positivistic world. By 1900 in Austria as in most of Europe, and notwithstanding the appearance of socialism, the decline of liberalism, and the rise of antipositivism, the validity of these attributes was widely accepted and formed a key part of society's progressive self-image. The benefits derived from them seemed palpable and distinct, and for Klimt to depict them in an unclear and disturbing symbolism was a direct threat to that self-image.

In the squibs of the popular wit Edward Pötzl, the chagrin of the "common man" over the ethereal lack of clarity found in Klimt's *Fakultätbilder* took the form of a well-aimed lampoon. A satire written by Pötzl during the uproar over the "Philosophy" on a proposed *Kunstamt* (Art Bureau) depicted a panel of judges who were to evaluate art works as being pro-Secession and suspended their bench in mid-air as a symbol of how far from reality the new art stood (47). The man on the street may not have been able to say exactly what an allegory of philosophy should be like, but seeing every day the classical and unequivocal symbolism of Athena before the *Reichsrat* (Figure 33) or a muse atop the *Hofoper* (Court Opera) (Figure 34), not to mention the solid image of the Kaiser himself, it was clear to him that modern art did not have the answer.

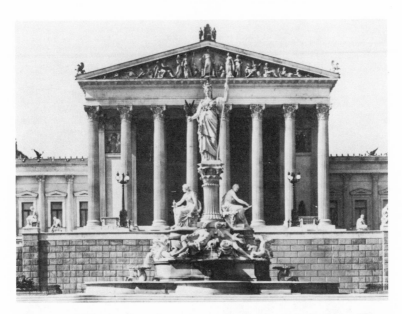

Figure 33 Main facade and entrance to the Reichsrat designed by Theophil Hansen (1874–1883). Note the unambiguous symbolism of a wise Athena upon the fountain and of a law-giving Franz Joseph in the center of the pediment.

On a more elevated plane, Klimt was criticized precisely for having misrepresented his subject matter. The protest of the professors clearly pointed to the unfitting lack of clarity and excess of confusion in the "Philosophy," which could not convey the proper "ideal associations" needed for "enlightening the viewer about the intellectual content of the picture." Rector Neumann also implied that such a foggy depiction was damaging to a discipline "which today seeks its sources in the exact sciences." If the report that appeared in *Ver Sacrum* is to be believed, the good professors would have been much happier with an unconfusing "School of Athens" approach. On the "Medicine" an anonymous reviewer in the *Presse* also criticized Klimt for his lack of clarity and noted that "He should have painted an allegory

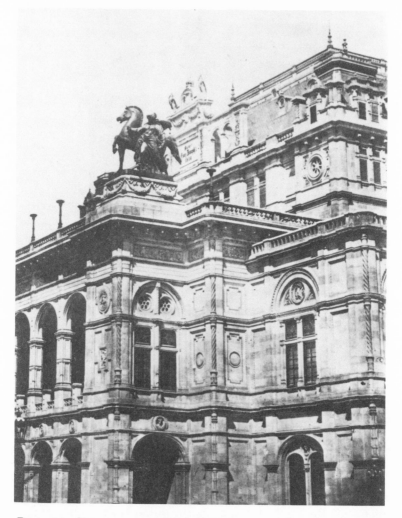

Figure 34 Statue group entitled "Poetry" above the entrance to the Staatsoper (Hofoper) designed by Eduard van der Nüll and August Sicard von Sicardsburg (1863–1869).

of the healing art, [but] he painted a triumph of death . . ." instead of its "wonderful success . . . the artist painted the powerlessness of medicine" (48). As for the "Jurisprudence," which was even less soothing than the "Medicine,"

it evoked the comment from the self-styled culture critic, Karl Kraus, that Klimt had wanted to paint justice, but had ended by symbolizing punishment; moreover, he had concentrated only on the sensational aspects of law rather than its higher ideals, which he felt were so important to life in the 20th century (49). On the other hand, the *Arbeiter Zeitung,* the official organ of the party most critical of Austrian society, liked the "Jurisprudence" along with all of Klimt's art then on exhibit (50). The imprimatur of the "revolutionary" party, despite its mass following, however, was hardly a general seal of approval.

In attempting to bring a fresh and honest artistic approach to three ancient allegorical subjects, Klimt ended by goring three sacred cows. He and the Secession were still hailed as in the vanguard of the new art and Austrian society was even willing to let that art create public buildings for it as in the case of Otto Wagner and his students, but its symbols could not be tampered with in such a radical manner as Klimt had done. In any event, the limits of the Secession's art had been set.

In the same year as the conclusion of the *Fakultätbilder* controversy the Secession experienced an internal crisis that revealed the limitations of the group vis-a-vis its own members. The spring of 1905 saw a break in the Secession, and just as in 1897 another "secession" occurred, but not from the *Künstlerhaus,* although many of the same people were involved.

The success of the Secession and its relative longevity (eight years) as a center of avant-garde art up to 1905 caused inner tensions to develop. The individual triumph of some artists and the subsequent overshadowing of others became causes for bad feelings between the members. Both Hevesi and Engelhart cite this as one of the main reasons for the eventual break (51), but there was also the development of artistic factionalism in the Secession, which had been gnawing away at the group's unity for quite some time.

The sides may have been drawn as early as the Beethoven

exhibition (52), but at least by 1903 there was already a strong difference of opinion concerning the artistic direction of the Secession. In that year the *Wiener Werkstätte* was opened with its dedication to applied art, which siphoned off the activities of some of the Secession's preeminent members like Josef Hoffmann and Koloman Moser. Waissenberger argues that this caused resentment among many in the Secession (53). It seems likely that the divisions between those who were inclined toward a more exclusively painterly outlook known as the Naturalists (*Naturalisten*) (54) and those more committed to the *Gesamtkunstwerk* ideal, the Stylists (*Stilisten*) began to develop in earnest at this time. In this division it is the Stylists who came down on the side of the *Werkstätte* and the broadest possible interpretation for the uses of art.[7]

Another grievance against the Stylists, according to Engelhart, was their supposed attempt to have followers of theirs named to the Secession even though they were undeserving (55). Still, it was not until 1904 that another major cause for dissension in the Secession developed. It arose over a controversy concerning Austrian participation at the St. Louis World's Fair, and it is Hevesi's opinion that this affair marked the real beginning of the break (56). That year saw the appearance of a special issue of the previously discontinued *Ver Sacrum* put out by the Secession to explain its position with regard to the exposition at St. Louis (57). The crux of the controversy was centered on what and how many art works were to be exhibited.

Originally, Austria had not intended to participate at St. Louis until it discovered that only it and Turkey of the European states were not to be represented. Her late com-

[7]Werner Fenz in his book on Koloman Moser feels that the issue of the *Gesamtkunstwerk* was one of the crucial reasons for the break in the Secession. [See Werner Fenz, *Kolo Moser: internationale Jugendstil und Wiener Secession* (Salzburg, Residenz Verlag, 1976) p. 33.]

mitment to the exposition left Austria with a smaller
amount of exhibit space than she had had in Paris, so osten-
sibly only the best art works were to be sent. The Secession
was chosen to participate and decorate a display room. Hoff-
mann was chosen for the task, and the Secession decided to
send Klimt's "Philosophy" and "Jurisprudence" as the cen-
tral exhibit pieces to be accompanied by some other works
of Klimt and members of the Secession (58). The govern-
ment rejected the plan on the ground that it allowed too few
paintings to be shown. In turn, the Secession declared that
it would be contrary to its principles and to artistic excel-
lence to accede to the government's demand. It, therefore,
did not participate at St. Louis.

Little is known about the actual repercussions of this deci-
sion within the Secession, but Nebehay feels that the close
friendship between Hoffmann and Klimt was the cause of
much bad feeling, probably because of their key and com-
plementary relationship in the proposed exhibition at St.
Louis (59). Jealousy of Klimt's fame and resentment over
such an exclusivist selection policy to the detriment of lesser
lights in the movement could easily have developed out of
this affair and further set the stage for the final break a year
later.

What had up to 1905 been primarily an in-house quarrel
became public over the old issue of art and business. Carl
Moll had become the adviser to the art gallery Miethke,
which specialized in handling Secession works. It also held
exhibitions using artists who were committed to the Seces-
sion, and it was felt, according to Engelhart, that this repre-
sented a conflict of interest on Moll's part. Engelhart, who
was then president of the Secession, told Moll that he would
have to decide between the gallery and the Secession (60).
At this same time, the gallery came up for sale, and it was
proposed by Klimt and Moll that the Secession should ac-
quire it as a commercial outlet for the group's art. A jeweler
and friend of Klimt's, Paul Bacher, was even willing to put

up the money (61). The opposition led by Engelhart opposed such a move on the grounds that it represented a return to the very situation the Secession had revolted against in 1897. Like the artists in the *Künstlerhaus,* it would run the danger of prostituting its art for monetary gain. By contrast, the highly successful commercial aspect of the Secession's own exhibitions and the numerous private commissions enjoyed by its members was never mentioned by Engelhart and was apparently not felt to be damaging to the integrity of their art. Perhaps it was feared that a formal commerical outlet would be too corrupting, though since the integrity of the Secession's art was based on the maintenance of ideals rather than the use of specific business practices, in principle the manner in which its art was sold should have had no effect so long as the inspiration remained pure. The issue, however, was put to a vote and the Klimt-Moll group lost.[8] The division within the Secession now became final, and Klimt and the other *Stilisten* (24 altogether) (62), which included most of the best artists in the Secession who had typified its style, such as Wagner, Hoffmann, Moll, and Moser, walked out.

The Engelhart group was left with the name of the Secession, and its building. It included the majority of its members, but few of its lights. Ernst Stöhr and Ferdinand Andri and, of course, Engelhart remained of the old group, but that did not prevent them from being dubbed by some the "Rump Secession" (*Rumpf Secession*) (63). In the main, they represented the more conservative side of the Secession and were far less concerned with the importance of architecture. Moreover, they tended to be impressionist or realist in style, and included among their ranks several genre painters who

[8]The Klimt-Moll group lost by one vote that Engelhart supposedly produced at the last minute in the form of a ballot from a member in Berlin. [See Hans Ankwicz von Kleehoven, "Die Anfänge der Wiener Secession", *Alte und Moderne Kunst,* 5. Jahrgang (Juni/Juli 1960), p. 9.]

specialized in subjects of the Austrian *Heimat* (Homeland). With such a membership the Secession ceased to be controversial, but remained financially successful and popular with the less avant-garde portion of *die Gesellschaft.* Yet, truncated as it was, the Secession, now under Engelhart's leadership, held to its old ideals and continued the use of thematic and didactic exhibitions, strove for integrity in art, and at least in the organization and mounting of its exhibitions, gave support to the *Gesamtkunstwerk* ideal as well. It was outside the parent organization, however, that the real spirit of the Secession was most in evidence. The group's self-imposed exiles, which included most of its founding members, were the most active in attempting to carry out the Secession's philosophy.

Among these exiles must be counted Josef Olbrich, who despite the maintenance of his formal ties to the Secession, had, in effect, become a stranger to it long before 1905 by taking up permanent residence in Germany. He belongs, therefore, more to the old guard that after 1905 carried on outside the Secession than to those who remained within it.

Up until his tragic death in 1908 of leukemia, Olbrich continued to design houses, housing projects, places of business, interiors, and furnishings with an eye to beauty, function, and the specific needs of his clients and their buildings. His structures with their unity of design and conformity to their surroundings were like organic creations grown to fit the needs for which they were required. The houses he designed in particular were examples of architecture brought to a very human level, for they were tailor-made to fit the needs and desires of the individuals who would occupy them. The man who had first given utterance to the previously unspoken wish of his colleagues to create an ideal city continued as best he could to realize that ideal in his own work.

In Austria proper many of those who had left the Secession were able to work toward its goals both individually

and in association with the crafts offshoot of the Secession, the *Wiener Werkstätte*. It continued after 1905 to pursue essentially the Secession philosophy concerning the relationship between art and life. Although inspired by the English example of craft guilds that had been encouraged by the ideas of Ruskin and Morris, its effort to create functional yet beautiful objects for everyday use was still part of the Secession's ideal of art providing the environment for man's existence. Not only did the *Werkstätte* make objects of applied art, but carried out architectural commissions as well. Its most notable achievement in this respect is the Palais Stoclet in Brussels (1911) (see Figures 10 and 11). The combined efforts of Gustav Klimt, the *Werkstätte*'s founders Josef Hoffmann and Koloman Moser along with the majority of the group's members, produced the most outstanding example of Secession domestic architecture in which beauty and function were fully integrated though on a very lavish scale.

Whereever and whenever possible, the opportunity to create a *Gesamtkunstwerk* and thereby expose more people to the salutary effects of an artistic environment was pursued. The *Werkstätte,* in addition to the Palais Stoclet, was responsible for the design and construction of many room interiors, but only once was it able to give mass exposure to its art through a public building. This opportunity came in the form of the Purkersdorf Sanitorium, which was designed by Josef Hoffmann and erected in 1903–1905. It was the *Gesamtkunstwerk* applied to what of necessity had to be a highly functional building, and the attempt was completely successful (64). Aside from this one success of the *Werkstätte,* however, the desirability of public buildings as examples of the *Gesamtkunstwerk* was only realized on a relatively large scale in the work of Otto Wagner.

Wagner's established prestige as an architect brought him a number of public commissions, which provided him with the opportunity to constantly refine the relationship be-

tween beauty and function and therefore to make his build-
ings examples of the practical integration of art and life. To
a certain extent his outspokenness in support of what was
then considered radical design affected the actual commis-
sions he was able to carry out, but nevertheless, they show
the wide range of his effort: the *Wiener Stadtbahn* (see Figure
17) (municipal railway) (1894–1899), dams for regulating the
Danube (1894–1898 and 1905–1916), the Imperial-Royal
Postal Savings Bank (see Figures 20 and 21) (1904–1906), the
Church on the Steinhof (see Figure 22) (1904–1907), and the
Lupus Sanitorium (1910–1913). Add to these the better ex-
amples of his numerous apartment houses and one can see
Wagner as a zealous representative of the Secession's *Ge-
samtkunstwerk* ideal.

This ongoing concern with creating environments capable
of reaching and affecting large numbers of people was also
reflected in the combined efforts of the 24 Stylists who had
rallied around Klimt after walking out of the Secession and
who now became known as the *Klimtgruppe* (Klimt group).
Forming themselves into a loose association of artists, they
held a major exhibition in Vienna in 1908–1909, called the
Kunstschau (Art Show), and exhibited abroad at Rome in
1914 and Berlin in 1916 (65). It was among them that the
spirit of avant-garde modern art continued in Austria, with
Klimt even taking under his wing the young "expression-
ists" Egon Schiele and Oskar Kokoschka. In tandem with
the *Wiener Werkstätte,* the *Klimtgruppe* continued to adhere
to the *Gesamtkunstwerk* philosophy and its principle of relat-
ing art to society, and even stated in an official communique
to the Minister of Education their desire to further that
principle as the main reason for their departure from the
Secession (66). Thus, although they lacked the formal name,
Klimt and his colleagues both represented and felt them-
selves to represent the real Secession after 1905 (67).

In accordance with this feeling, the *Kunstschau* served as
a showpiece of Secession ideals. The exhibition was housed

in a temporary building designed specifically for it, and contained both a small restaurant and a theater. Its contents displayed examples of interior design and applied art and tended to emphasize art's environmental potential. In his opening speech on the first day of the *Kunstschau,* Klimt noted that the current exhibition was not to be taken as "the ideal form for the restoration of contact between artist and public" since "the solution of greater public art commissions would be a far more desirable goal" (68). Nevertheless, he hoped that the *Kunstschau* would further the cause of the *Künstlerschaft* or, as he called it, that "ideal community of creators and enjoyers" (69). Klimt's speech echoed the basic Secession desire for the chance to create viable, aesthetic environments as the means of effecting a kind of brotherhood of man based upon the supposed unifying power of art. Such ideas continued to be operative among Klimt and many of his colleagues until the disillusionment that followed 1914, but even in 1908 his speech and the exhibition it inaugurated was the swan song of the Secession.

At that same exhibition works by the young artists Egon Schiele and Oskar Kokoschka were displayed and in 1909 a play by the latter artist entitled "Murder, Hope of Women," was produced at the *Kunstschau* theater. The overall effect of the works of the two men was disturbing and controversial for public and critic alike. The vision of life shown by their art was alien to the harmonious vision of the Secession and depicted that life in all its sordid disarray as if to foretell the chaos of war only a few years off. Despite their encouragement by Klimt himself, the art they represented in their paintings was meant to supersede and not to succeed that of the Secession. The very emergence of these artists with their disquieting and even tortured depiction of humanity was a testimony to the basic failure of the *Kunstschau* and the very ideals it had meant to further. Schiele and Kokoschka were proof that the Secession had failed to translate its philosophy into effective reality. The storm caused by Klimt's

Fakultätbilder was an earlier indication of that failure, and this negative judgment was carried further by the criticisms of Karl Kraus and Adolf Loos, who held up Schiele and Kokoschka as the true representatives of modern art.

Chapter Notes

1. The commission for the *Fakultätbilder* was given to both Klimt and his then artistic partner, Franz Matsch, who was to do the depiction of theology and the central painting depicting knowledge. Both Klimt and Matsch had made a reputation for themselves as decorators of public buildings all over the Dual Monarchy with work by Klimt still evident in the Burgtheater and *Kunsthistorisches Museum*. For a complete presentation of the backgrounds and events of the *Fakultätbilder* controversy see Alice Strobl's comprehensive study, "Zu den Fakultätbildern von Gustav Klimt," *Albertina Studien*, vol. II, 1964, pp. 138–69.
2. From a lecture on Gustav Klimt delivered at Stanford University in July of 1975 by Carl E. Schorske. This lecture has subsequently been expanded to form the fifth chapter of his book, *Fin-de-siècle Vienna, Politics and Culture* (New York: Alfred A. Knopf, 1980).
3. *N.F.P.*, Dienstag (13 März 1900), pp. 1–4.
4. *A.Z.*, Mittwoch (21 März 1900), pp. 1–3.
5. *N.W.T.*, Freitag (9 März 1900), pp. 1–3.
6. *RP.*, Dienstag (13 März 1900), pp. 1–3.
7. *N.W.T.*, Sonntag (25 März 1900), pp. 4–5.
8. *N.F.P.*, Dienstag (27 März 1900), p. 5.
9. *N.F.P.*, Mittwoch (28 März 1900), p. 5.
10. *Ibid.*
11. *N.W.T.*, Mittwoch (28 März 1900), pp. 6–7.
12. *N.F.P.*, Donnerstag (29 März 1900), p. 5.
13. *Ibid.*
14. *A.Z.*, Donnerstag (29 März 1900), p. 7.
15. Strobl, p. 167, n. 174.
16. *N.F.P.*, Freitag (30 März 1900), p. 5.
17. *V.S.*, Heft 10 (15 Mai 1900), pp. 151–66.
18. *Ibid.*
19. *N.W.T.*, Mittwoch (30 May 1900), pp. 1–2.

20. *N.W.T.,* Donnerstag (17 Mai 1900), p. 5.
21. *N.F.P.,* Dienstag (27 März 1900), p. 1.
22. *Österreichische Bürgerkunde. Handbuch der Staats-und Rechtskunde in ihren Beziehungen zum öffentlichen Leben,* vol. II [Wien: Verlag der Patriotischen Volksbuchhandlung, 1909(?)], p. 69.
23. Strobl, p. 142.
24. *Ibid.,* p. 153. (At that particular sitting the three members of the Secession accounted for one quarter of the members present.)
25. *N.F.P.,* Dienstag (19 März 1901), pp. 1–3.
26. *N.W.T.,* Samstag (16 März 1901), pp. 1–2; *RP.,* Mittwoch (3 April 1901), pp. 1–3.
27. *N.F.P.* (24 März 1901), pp. 1–3.
28. Hermann Bahr, *Gegen Klimt* (Wien, 1904), pp. 46–47.
29. *Stenographische Protokolle über die Sitzungen des österreichischen Reichsrates in Jahre 1901.* Sitzung der XVII. Session am 29 Mai 1901, pp. 4418–19.
30. Schorske, p. 243.
31. Strobl, p. 168, n. 87.
32. Schorske, p. 243.
33. Bahr, pp. 47–49.
34. Schorske, p. 253.
35. Marian Bisanz-Prakken, *Gustav Klimt - Der Beethovenfries, Geschichte, Funktion und Bedeutung* (Wien: Residenz Verlag, 1977), p. 12. Dr. Prakken's work deals with the origins, creation, and meaning of one of Klimt's most important works. The book's fine and insightful discussion of the subject is warmly recommended to the reader who desires a comprehensive study on the Beethoven exhibition.
36. *Ibid.,* p. 34.
37. *Ibid.,* p. 36.
38. *Ibid.,* pp. 38–39. (The actual face of the knight seems to be a likeness of Gustav Mahler.)
39. *N.F.P.,* Montag (23 November 1903), pp. 1–4.
40. *A.Z.,* Freitag (4 December 1903), pp. 1–2.
41. Strobl, p. 159.
42. M. Nebehay, *Gustav Klimt—Dokumentation* (Wien: Verlag der Galerie Christian M. Nebehay, 1969), p. 223; see also Berta Zuckerkandl, *Österreich Intim, Erinnerungen 1892–1942* (Frankfurt, Berlin, Wien: Verlag Ullstein, 1970), pp. 64–65, in which she describes how Klimt stood outside his studio with a gun as the movers from the ministry came to take back the paintings. He threatened to shoot anyone who tried. The movers left and did not return.
43. *Ibid.,* pp. 325–26.

44. Ludwig Hevesi, *Altkunst-Neukunst* (Wien: Verlagsbuchhandlung Carl Konegan, 1909), p. 290.
45. Nebehay, p. 394.
46. *N.F.P.* (30 April 1903), p. 1.
47. *N.W.T.*, Sonntag (20 Mai 1900), pp. 1–3.
48. *N.F.P.*, Sonntag (24 März 1901), p. 2.
49. Nebehay, pp. 320–21.
50. *A.Z.*, Freitag (4 Dezember 1903), pp. 1–2.
51. Ludwig Hevesi, *Acht Jahre Secession (März 1897–Juni 1905) Kritik-Polemik-Chronik* (Wien: Verlagsbuchhandlung Karl Konegan, 1906), pp. 502–3; and Josef Engelhart, *Ein Wiener Maler Erzählt* (Wien: Wilhelm Andermann Verlag, 1943), p. 123.
52. Bisanz-Prakken, p. 30.
53. Waissenberger, Robert, *Die Wiener Secession, Eine Dokumentation* (Wien: Verlag Jugend und Volk, 1971), p. 112.
54. This group was also known as the *"Nurmaler,"* and *"Impressionisten."*
55. Engelhart, p. 123.
56. Hevesi, *Acht Jahre Secession,* p. 504.
57. See *V.S.* (Februar 1904), pp. 5–14.
58. *Ibid.*
59. Nebehay, p. 246.
60. Engelhart, p. 124.
61. Nebehay, p. 345.
62. Engelhart, p. 124.
63. *Ibid.*
64. Wilhelm Mrazek, in *Die Wiener Werkstätte, Modernes Kunsthandwerk von 1903–1932* (Wien: Österreichisches Museum für Angewandte Kunst, 1967), p. 15.
65. Nebehay, p. 347.
66. *Ibid.,* p. 348.
67. *Ibid.*
68. Text of speech in Nebehay, p. 394.
69. *Ibid.*

Chapter 4
Rivals and Alternatives

In the years following the 1905 split within the Secession there appeared a generation of artists who in their work developed a style known as expressionism. Its beginning stages were in these years before 1914, but by 1918 and the early 1920s it had become one of the most important art movements of the 20th century. It was a movement that in the Austrian context had developed out of an artistic milieu that the Secession had created by its own iconoclastic activities in the late 1890s. Expressionism, however, benefited not only from the efforts of the Secession, but also from those of its cultural rivals as well. The literary figure Karl Kraus and the architect Adolf Loos both lent their patronage to one of its greatest talents, Oskar Kokoschka. The Secession movement through the *Klimtgruppe* did likewise, helping, in addition, the equally significant artist Egon Schiele.

Up until the appearance of these two men and their associates there had been no real alternative art style with a claim to being more modern than that of the Secession. There were cultural alternatives to its approach in art in the form of those offered by Karl Kraus and Adolf Loos, but until the advent of expressionism these were alternatives that at least shared a common belief in the necessity of an engaged art. That is, one that emphasized in a positive and

constructive manner art's relationship to society and its problems. Despite the support both sides gave to the development of this new movement, this fundamental belief was never held in common with their protégés.

The purpose of this chapter is to examine the nature of the relationship between the Secession, Kraus, Loos, and the expressionist painters Kokoschka and Schiele. An examination of this relationship involves not only a look at the last years of a very important segment of Austria's prewar literary and artistic scene, but also at the attitudes toward modernity that shaped their own versions of cultural responsibility or lack thereof. To that end, however, some words need first to be said about the fate of the Secession movement after 1905.

When Klimt and 24 of his colleagues marched out of the Secession in 1905 they signed an open letter to the Minister of Education, von Hartel, giving reasons for leaving (1). With the rejection of the gallery proposal still fresh in their minds, they felt that in order for their art to win greater "influence" over the "expressions of modern life," they could no longer endure the restrictions placed on their artistic activities by the formal Secession. True to the original spirit of the movement, however, they declared their continuing conviction "that no life is so rich that it cannot become richer through art, nor so poor that in it there is no room for art" (2). Their future efforts were to be aimed at furthering that contention and in 1908 and again in 1909, they materialized in the *Kunstschau*.

Housed in temporary buildings that were designed by Josef Hoffmann on what is now the site of the Vienna Concert House, the exhibition aimed at displaying the best of modern domestic and foreign art, particularly in its applied forms, and sought to do so within the physical context of the exhibition as a *Gesamtkunstwerk*. In general, though some of the presentations were controversial, the *Kunstschau* was favorably received and showed that in contrast to the

conservative Engelhart following the *Klimtgruppe* had retained the avant-garde quality of the Secession. This favorable impression, however, was not shared by everyone, and in Karl Kraus's (Figure 35) journal *Die Fackel* (The Torch) a largely critical review of the exhibition appeared after its opening in 1908.

The review was written by a minor literary figure, Otto Stoessl, and its main criticism of the *Kunstschau* centered on its exhibition of what the author called "democratized" art. This democratization stemmed from reducing art to a reliance upon a single guiding principle—"taste." Art was tastefully applied to everyday articles and even in its traditional forms a concern with what was tasteful was evident. In the process of being tasteful art was being separated from the true artistic impulse of free expression. As a prime example of an artist guilty of this type of art Stoessl cited Gustav Klimt (3).

Though not written by Kraus himself, Stoessl's remarks about the *Kunstschau* and Klimt essentially reflected Kraus's own attitudes concerning the Secession movement and its most representative artist. As owner, editor, and primary contributor to *Die Fackel,* Kruas printed only articles that were compatible with his own views, and where the art of the Secession was concerned he had substantially formed them as early as 1900. Even before founding *Die Fackel* in 1899, Kraus had made a reputation for himself as a merciless critic of new cultural trends by his attacks on Hermann Bahr and the *Jung Wien* movement.

Jung Wien was an *avant-garde* literary movement that began around 1892 in Vienna and reached its peak at the turn of the century. The style associated with it was that of a psychological impressionism, which concentrated upon life's sensual and transient moments. Hermann Bahr was its unofficial leader, but Hugo von Hofmannsthal, Arthur Schnitzler, Felix Salten, and most of Austria's leading poets, playwrights, and novelists of the generation that became

Figure 35 Photograph of Karl Kraus (1908).

active in the 1890s can be counted among its members and followers. Kraus was the movement's chief critic and nemesis. Because the writers of *Jung Wien* used the Cafe Griensteidl as their informal headquarters, Kraus used the occasion of the cafe's demolition to pen a scathingly witty attack upon the supposed shallowness of the movement and its leader entitled, "Die demolirte Literatur" (1897). Even long after *Jung Wien,* as such, had ceased to exist Kraus continued to single out not only Bahr, but also the likes of Hofmannsthal and Schnitzler as examples of the cultural decadence he detested. Accordingly, he did not hesitate to wade into the world of avant-garde art by joining in the controversy occasioned by Klimt's *Fakultätbilder.*

In January 1900, Kraus published a generally hostile evaluation of the Secession, claiming that the triumph of its "modern" style merely represented a transference of the "showplace of the art trade" from the *Künstlerhaus* to the Secession's "Little Temple of Art" ("Kunsttemplechen"). Of Klimt, he noted that the former Makart copier had now become a Khnopff copier (4). As for the art critics who supported the Secession, particularly Ludwig Hevesi, Kraus felt that their sudden switch to the new movement was done with dishonorable haste and involved an outpouring of extravagant praise, which in its misuse of words was dishonest. In Kraus's opinion the reputations of these critics allowed them to exercise a pernicious influence over public taste (5). Having thus established himself as a critic of the Secession and its supporters, two months later Kraus began attacking Klimt and his "Philosophy."

From the end of March to the middle of June, Kraus wrote a short series of articles, which appeared in *Die Fackel* as scathing commentaries on Klimt's "Philosophy." Kraus found himself in basic agreement with the faculty protest against the unsuitable nature of Klimt's allegory, but his criticisms were far less restrained. Klimt himself, he dis-

missed as an eclectic representative of decadent art whose vision of "cosmic fantasy," as Hevesi called it, was viewed by Kraus as nothing but a bad Austrian "compromise" (6). An unphilosophical artist, according to Kraus, should allegorize philosophy the way "it paints itself in the philosophical minds [*Köpfen*] of his time" (7).

Kraus, who generally considered any government support of the arts as damaging to their freedom (8), in the case of Klimt's "Philosophy" saw von Hartel's defense of it as hardly laudable (9), but that was nothing compared to the government's role in the judging at Paris. According to information supplied by an anonymous source, Kraus claimed that Klimt's "Philosophy" was awarded the gold medal at the Paris exposition through the intervention of the Ministry of Education, which put pressure on Austrian members of the jury to persuade their colleagues to vote for the "Philosophy." This was done because supposedly the majority of jurors had originally been in favor of another painting, but due to the recent criticisms of Klimt's work the Ministry of Education felt a victory for the "Philosophy" was necessary to strengthen its authority in artistic matters. The result was a 26 to 27 vote in favor of the "Philosophy," with numerous abstentions (10). This story appeared nowhere else at the time and apparently caused no stir, but to the upright Kraus it must have been clear proof of the tainted nature of the new art.

As the crisis over the *Fakultätbilder* continued, Kraus directed his critical eye at the "Medicine" and the "Jurisprudence." He considered the chaotic confusion of "decrepit bodies" depicted in the "Medicine" to be a symbolic representation of conditions in the Vienna General Hospital (*Allgemeines Krankenhaus*) (11), while the "Jurisprudence" by concentrating on the punishing power of the law was equivalent to the journalistic sensationalism Kraus hated so much (12). Like his comments about the "Philosophy," these remarks exuded a common sarcasm accompanied by an abhor-

rence of the false and dishonest in art. In all three allegories Kraus sees their symbolism as totally inappropriate for their subject matter. That they were painted by a mere "copier" of other styles and their praises sung by shameless critics, made it all the worse, but on top of that, dishonorable means had been used to secure for one of them an extraordinary recognition that was totally undeserved. This behavior, however, was all of a piece with the way Kraus viewed the Secession as a whole.

In addition to labeling the Secession as the new "show-place of the art trade," Kraus asserted that the Secession, because of its prominent Jewish supporters, was linked to the circles of high finance and strongly implied that it was a creature of those circles (13). To Kraus this showed the falseness of the Secession's professed abhorrence of an art prostituted for money. This supposed link to high finance also affirmed an earlier judgment on Kraus's part that Secession art was tainted by *gout juif* (Jewish taste) (14). More-over, in his judgment, the art of the movement was merely the work of old men masquerading as young (15). As Kraus later revealed, the true modern art of Austria resided with the architect, Adolf Loos, and the painter, Oskar Kokoschka, whose approaches to art were more in keeping with Kraus's view of the modern world.

In his criticism of Klimt, the *Fakultätbilder,* and the Seces-sion there is clearly a general dislike of what is false and dishonest, but there is also a specific hostility on Kraus's part towards newspaper critics, abuse of language, commercial-ism in art, government interference, Jews, and high finance. He did not, however, limit his criticism of these subjects to his comments on artistic matters. On the contrary, they constituted a permanent part of a broad spectrum of things that Kruas subjected to constant criticism because they were manifestations of the corrupt nature of contemporary life.

Kraus once remarked that he dated the end of the world "from the beginning of airship travel" (16), and that culture

was in such a state that in the end a dead humanity would be left lying next to the works "which had cost it so much spirit to invent that it had none left with which to use them" (17). These statements reflect not only Kraus's great mistrust of technology, but also his profound uneasiness about modern times. He felt them to be characterized by "the feverish progress of human stupidity" (18), which could create machines that fly, but in the process could not prevent them and everything else man created from destroying his culture and his spirit. So disturbed was he by what he saw that Kraus took it upon himself to become the voice crying out in the wilderness against the corruption all around him.

Kraus has been called "a Viennese critic of the twentieth century" (19), but, in fact, his criticism reached back beyond our own and into the 19th Century. It was in the last half of that century that Kraus saw the origins of the 20th, although in his criticism of man's over-reliance on reason (20), it is clear that the century of the Enlightenment also shared a good deal of that responsibility. In the hundred years before 1900 Kraus felt an affection for only the relatively brief interval between 1815 and 1848 known as the *Biedermeier*[1] or *Vormärz*[2] For Kraus, everything after that went downhill.

As Wilma Iggers in her book on Kraus has pointed out, "It was the preindustrial age of the *Vormärz* . . . which Kraus idealized" (22). In that bygone time he saw the values of human life as still intact. The destructive forces of capitalism, technology, journalism, and Jewish influence had not yet managed to pervert them. Ethical responsibility supported by the values of an unindustrialized, undemocratized, and traditional society still held sway in the consciences of most men. This was felt by Kraus to be in

[1]The period between the Napoleonic Wars and the Revolution of 1848 known for its bourgeois domesticity and relative tranquility.
[2]The period preceding the outbreak of revolution in March of 1848.

sharp contrast to the modern men of his age who were dominated by a self-destructive greed (23).

With the unchecked development of capitalism made possible by technology, which in turn had been made possible by science, the material side of man's nature had come to predominate over the spiritual. Language, which Kraus saw as the single most important means of expressing truth and human feeling, was pressed into the service of material gain by a venal journalism. The origins of this linguistic corruption he traced to Heinrich Heine, whom Kraus condemned for having used words to convey effect rather than ideas. From this one man Kraus traced the subsequent development of journalism and the modern literature (24), both of which were having such a pernicious effect on modern life. In the former, words were used to sell products and politics as in the case of the *Neue Freie Presse,* while in the latter, they acted as the facade of an empty and commercial literature of the kind typified by Bahr and the fashionable dilettantes of the *Jung Wien* movement (25).

Inseparable from this corrupt state of affairs was the Jew. Though a Jew himself, Kraus criticized his heritage and developed a kind of self-hate common to many "assimilated" Jews in late 19th-century Germany and Austria (26). In 1898 he converted to Catholicism, but despite his conversion he was never a strong Catholic or Christian and fell away from the church in 1918 (27). What had preceded his conversion and remained after it was his antisemitism. As that anomaly, the antisemitic Jew, Kraus, while no racialist, shared the conservative and *Völkisch* view of the Jew as a representative of pernicious modernity who could be found in the vanguards of capitalism, liberalism, and journalism. In leveling his criticisms at the Jew, Kraus was attacking one of the pillars of the corruption that surrounded him. This antisemitism directly influenced his views on art for, though he did credit some Jews like the writer Peter Altenberg (and himself) with positive cultural qualities, the *gout juif* of the

Secession and the largely "Jewish" composition of *Jung Wien* were telling strikes against their cultural pretentions.

It was precisely in the creative side of modern culture that the decay in human values ushered in by the changes since 1848 were felt by Kraus to have had their most devastating effect. He "considered the present an especially low-ebb in art" (28), and the Secession and *Jung Wien* acted as confirmation of that view. Contemporary art had become merely decorative because in modern times most men lacked the ability to strike a balance between the experiences of misery and luxury—a oneness with the all-embracing quality of nature was generally lacking (29). To Kraus, the purpose of art was to create "fresh visions of the eternal" and "to shock man into realizing how far he had drifted from truth . . ." (30). The artist as the superior being among men was to accomplish this by synthesizing past values and carrying them into the future (31). Although a very similar desire for continuity existed in the Secession and *Jung Wien*, Kraus did not perceive this. He saw that the two movements shared a common outlook (32), but only as part of the general nexus of corruption that dominated contemporary life.

In struggling against this current of corruption, Kraus, in his own eyes as well as in those of both friends and enemies, stood, in large part, as an isolated figure alternately heroic and vicious, depending on one's point of view. Yet, one thing that he did hold in common with a number of his contemporaries was his effort to find an appropriate response to modernity and in this respect he had a link even with the Secession and *Jung Wien*. This does not, however, minimize a still important difference between them. In terms of their respective approaches to this problem, Kraus's was essentially negative and that of the Secession and *Jung Wien* positive.

Superficially, the two camps shared similar feelings. They each opposed commercialization in art, believed in its creative freedom, saw the need for a new art, respected the

achievements of the past, and above all were conscious of living in "modern" times where change necessitated some kind of definite response to the conditions of their environment. Indeed, Bahr, as the chief spokesman of *Jung Wien* wrote of the movement's willingness to exist side by side with its literary predecessors, to build upon what had been achieved in the past, and to be modern in a socially as well as artistically positive manner (33). There is even a shared feeling that their environment is not what it should be, that the times are somewhat out of joint and society somehow atomized. In Kraus this is the underlying and strident theme of all his work. In the Secession the feeling is vaguer and less peremptory, but the concern with unity and continuity as a means of achieving stability makes it clear. Where the two camps divide along negative and positive poles is that Kraus sees the present as something to be opposed with the past, while the Secession sees it as something to be reconciled with that past.

Despite Kraus's view of the artist as a synthesizer of past values, there does not seem to be the same sense of the artist as a creator of new values that is found in the Secession. Culture, in its essentials, is not incremental for Kraus. New forms may be found, but their content remains old. In contrast to this view, to someone like Klimt or Bahr the strength of cultural expression lay in its ability to add something to what is inherited from each generation. In this way the cultural legacy is preserved and modernity made less alienating by accommodating change. For Kraus it is the opposite. Change in the modern world means the destruction of values and not their augmentation. In Kraus's thought, the *Vormärz* is a bastion of standards, to the Secession, it is a way-station. Sometimes, however, the bastion opened its gates to let in new defenders. It was in this manner that Kraus came to support Adolf Loos (Figure 36) and Oskar Kokoschka (Figure 37).

On occasion, Kraus adopted "modern" artistic figures

Figure 36 Photograph of Adolph Loos (c. 1900?).

Figure 37 Photograph of Oskar Kokoschka in 1909.

whom he perceived as being exceptions to the corrupt tenor of his age. Such had been the case with Peter Altenberg, but by far the most spectacular among his favorites were Loos and Kokoschka. Both were considered outrageous iconoclasts and had associations with the Secession, yet Kraus defended their cause as his own. This was, at least in part, because Kraus felt that their creative spirits were essentially out of step with their times, in fact, far above them, and, therefore, worthy of his attention. Like himself, they were opposition figures and where Kraus saw himself as standing for truth in language, he saw Loos and Kokoschka as his alter-egos in the fine arts.

In Loos, Kraus found a kindred spirit bent on attacking the sham and falseness of the Secession and much else in contemporary life. Though Kraus sang his praises in *Die Fackel,* the two men stood essentially as equals to one another, a situation illustrated by their joint patronage of Kokoschka in which Loos played the senior role. Their individuality was reflected in other ways as well. Unlike Kraus, Loos took a much more energetic and positive attitude toward modernity. He actively sought to bring Austria into line with what he felt were the essential features of a really contemporary world. Loos expressed this feeling primarily, though not exclusively, through the medium of architecture.

As a boy, Loos had acquired a great respect for the integrity of materials and the skills of master craftsmen. In the establishment of his father, a sculptor and stonemason, Loos gained practical knowledge of a wide variety of skills from carpentry to ironwork. Later, after being trained as an architect in Dresden, Loos went abroad to America where he remained from 1893 to 1896. While there he did several odd jobs, most of them in the building trades; he became familiar with the new skyscraper architecture then coming into its own in Chicago and St. Louis, and also made observations on life in America in general. When he returned to Austria in 1896, he came back convinced that only in the advanced

industrialized states of America and England, a country he
had earlier admired, could one find the essence of modern
Western culture.

Two years after his return to Austria he had taken up
residence in Vienna and started a one-man campaign
through articles written for the *Neue Freie Presse* against his-
toricist architecture and other Austrian shortcomings. That
same year two articles by him also appeared in the Seces-
sion's *Ver Sacrum.* His famous essay attacking Viennese ar-
chitecture for its false, eclectic facades, "The Potemkin
City," appeared in the July issue along with one entitled
"Our Young Architects," which essentially echoed Otto
Wagner's earlier call for reforms in architectural education
and included an exhortation by Loos that young architects
should follow their own ideas in what they built. While his
articles for the *Presse* continued into the mid-1920s, his asso-
ciation with *Ver Sacrum* and the Secession came to an end
with that one issue.

Initially, Loos had been sympathetic to the Secession and
entered into contact with it in 1897 (34). In addition, he was
a great admirer of Otto Wagner and even came to adopt
some of the latter's maxims as his own (35). In 1898, he came
forward and offered to design the boardroom in the *Seces-
sionsgebäude,* but his offer was turned down by Josef Hoff-
mann, and in that same year he began to express doubts
about art nouveau outside Austria (36). By 1903 the Seces-
sion had become his *bête noire.* How much of this was due
to Hoffmann's earlier rejection of his work or to simply his
own convictions, can never be known for certain. He contin-
ued, nevertheless, to admire Wagner while at the same time
detesting his school and the Secession (37). The criticisms he
came to level at the movement centered on its supposedly
false, artificial, and nonfunctional concept of design.

As early as 1900, in a little essay he wrote called "The
Story of a Poor Rich Man," Loos attacked the concept of the
Gesamtkunstwerk along with the idea of applied art, both of

which were central to the philosophy of the Secession (38). In it he described the woes of an aesthetic rich man who had let an architect design a complete artistic environment for him only to discover that he could never again experience the pleasure of making additions or subtractions to this total work of art without damaging its unity and had, therefore, become its joyless prisoner. It was Loos' opinion that the architect should concern himself only with the structural aspects of his building and leave the interior decoration to the owner and the appropriate craftsmen (39). This did not mean that Loos objected to architects designing hardware and built-in pieces of furniture such as bookshelves (40), but the art nouveau and Secession concept of the artist-architect was alien to him. In 1903, Loos began to aim his barbs directly at the Secession, this time in a brief story about a saddlemaker.

It appeared in a journal put out by Loos, himself, called *Das Andere* (The Other), and this time mentioned the Secession by name. The journal was extremely short-lived; it ran to only two numbers. It was in the second and last one that the story appeared (41). In it Loos related how a saddlemaker, who already made excellent saddles according to his best ability, heard about the Secession and, wishing to be modern, went to it for advice on how he could make his saddles more up to date. Because his saddles had nothing in common with past designs or foreign models, Loos felt that they were already modern, but the saddlemaker did not realize this at first. At the Secession one of its leaders, an unnamed "professor," undertook to correct the saddlemaker's designs, which were deficient in "fantasy." The professor came up with 49 different sketches, all of which were worthy of appearing in *Studio,* but none of which could be used to make a saddle. The saddlemaker then realized that the "fantasy" of the professor's designs was due to his ignorance of the practical requirements of what he was designing, and so the saddlemaker went back to his work a

contented man and continued to produce good, practical, and, therefore, "modern" saddles.

The emphasis in this story on the contrast between the practical and functional designs of the saddlemaker and the impractical and nonfunctional ones of the Secession "professor" points up Loos' central criticism of the Secession specifically and art nouveau generally. In the contemporary desire to beautify everyday objects, he saw the danger of perpetuating the useless ornamentation that historicism had already foisted off on society as an artistic necessity. Ornamentation for its own sake, no matter how advanced, added nothing to the functional beauty of an object whether a spoon or a building. In "The Potemkin City" and later in "Ornament and Crime" (1908), Loos attacked ornamentation, especially the kind copied from the past, as completely incompatible with the modern world. According to him (42)

> As ornament is no longer organically linked with our culture, it is also no longer an expression of our culture. Ornament as created today has no connection with us, has no human connections at all, no connection with the world as it is constituted. It cannot be developed.

Loos saw most ornament as anachronistic and thus deleterious to the "cultural progress of nations and humanity" (43). Moreover, it was a "crime" against the physical and economic well-being of the nation because it required excessive labor and material, none of which ever could be recouped in the price of the finished product (44). Ornament, therefore, was objectionable from a social as well as an artistic standpoint.

For Loos, art and social needs were linked. In his architecture he attempted to design and build structures that answered the needs of people in a modern society (45). His emphasis on functionalism and use of largely unadorned materials with clean lines and polished surfaces reflected the simple, practical beauty he saw as fitting for modern life. A

beauty that sprang from practical considerations was one that could develop organically (46), but the kind of beauty produced by art nouveau and the Secession was artificial and temporary. Loos was apparently unaware that they, too, had a desire to link art and life and a concept of organicism of their own or, if he did, he was clearly not sympathetic to it. Of Josef Olbrich, he noted that there will be "Cutlery for people who can eat, after the English fashion, and [for those] who cannot eat from designs by Olbrich" (47). For Loos, Secession art was not even capable of meeting the most elementary social requirement of applied art—that it be usable.

Between 1899 and 1903, Loos' outspoken ideas brought him jobs only as an interior decorator, though in these his theories on functionalism and natural materials found expression. The relative starkness of his designs, however, brought him considerable criticism and in the case of the Cafe Museum (Figure 38) his work there gave that establishment the nickname of the "Cafe Nihilismus" (48). His first architectural commission did not come until 1903 and it was to rebuild the Villa Karma on Lake Geneva (Figure 39), but it was only in 1910 that he was given the opportunity to design and construct an entire building. This came in the form of a commission, from the haberdasher, Leopold Goldman, for a combination business and residence to be constructed on the Michaelerplatz directly across from the Hofburg (Figure 40). Loos got the commission because Goldman felt his to be the most modern of the plans submitted (49). The resultant structure was in sharp contrast to its Baroque and historicist surroundings. It has a basically flat marble facade broken only by two large and severe columns at the entrance, big plate glass windows at the store frontage, and rows of windows with very restrained frames done in a classical motif. Its appearance caused a storm of controversy. Franz Joseph, according to popular legend, found the building so distasteful that he moved his bedroom to the

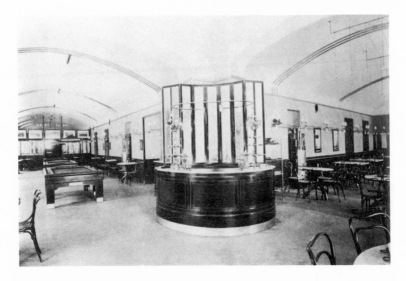

Figure 38 Interior of Cafe Museum in Vienna, designed by Adolf Loos (1899).

interior side of the palace. The storm and stress of all this furor gave Loos a nervous stomach disorder (50), and served to confirm his reputation as an architectural extremist.

In the years between 1910 and 1914, he did receive additional commissions, but none on the scale of the Goldman building. Loos was limited to mostly private residences, such as the Steiner and Scheu houses (Figures 41 and 42) done in 1912–1913. These structures have since been regarded as masterpieces of his style, but at the time they were a far cry from the major commissions of an architect like Wagner or even Olbrich, and illustrated the small recognition Loos and his ideas enjoyed. He was notorious, but appreciated by a restricted group of supporters. Some of those who commissioned homes from him also had to write supportive articles for him as well. This was true in the cases of Otto Stoessl and Robert Scheu, who gave Loos critical support in the pages of *Die Fackel* (51). That bespoke a narrow circle indeed.

Figure 39 Aerial view of the Villa Karma (Switzerland) designed by Adolf Loos and erected in 1904–1906.

Even to a major critic favorable to the *avant-garde* like Ludwig Hevesi, Loos had some merit, but even he felt it would take him eight years to be reconciled to Loos' style (52). Still, Loos, like Kraus, continued to insist on the correctness of his ideas despite all opposition.

By 1906 Loos had founded his own school of architecture. He gave public lectures and wrote articles on his opinions concerning modern life as often as possible, and in 1903 attempted to put out his one-man journal, *Das Andere,* all to disseminate his ideas. The parallels in this respect between Loos and Kraus are obvious, yet there is still the question of how an aggressive modernist like Loos could be compatible with so caustic a critic of modernity as Kraus. As mentioned earlier, this can, in part, be explained by a common dislike for cultural sham, hence their joint opposition to the Secession, but the link between them is perhaps better explained by their shared characteristic as extreme critics of Austrian culture and society.

Figure 40 The Goldman Building (the House on the Michaelerplatz) designed by Adolf Loos and erected in 1910–1911.

Where Kraus criticized contemporary life from the standpoint of the past, Loos did so from that of the future. Notwithstanding his strong respect for the classical principals of Greek and Roman art (53), Loos made himself into a complete prophet of modernity. His visit to America and study of England convinced him that, in their essentials, these were the promised lands of modern life. Loos, in fact, equated them with the epitome of Western culture. His journal *Das Andere* was founded as "A Paper for the Introduction of Western Culture into Austria" and was meant to give benighted Austria the benefit of Loos' insights into what was modern and, therefore Western. Most often his

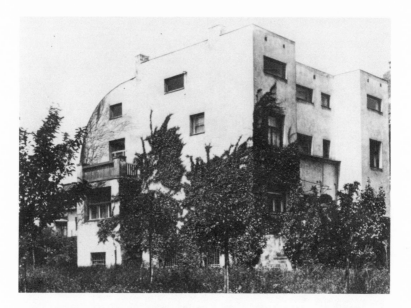

Figure 41 Adolf Loos, the Steiner House, Vienna (1910).

criticisms of the non-Western nature of Austrian culture and society were drawn from the American and English models. Thus, Austria was behind these countries because 80 percent of her people were ignorant of toilet paper and the Austrian population as a whole failed to use both sides of a sheet of paper when writing a letter (54). In his articles for the *Presse* and the lectures delivered at his school, Loos touched upon a broad spectrum of topics. Always the burden of his message was that one must be as up to date and modern as possible. As Kokoschka later recalled, Loos even maintained that no man was really modern who was not stylishly dressed like an English gentleman (55).

From America Loos brought with him a conviction of the need to demolish the gap in lifestyle between the city and the country. In America both the urbanite and the farmer dressed the same and had a common cultural outlook. In Austria, however, they lived in two distinct worlds sepa-

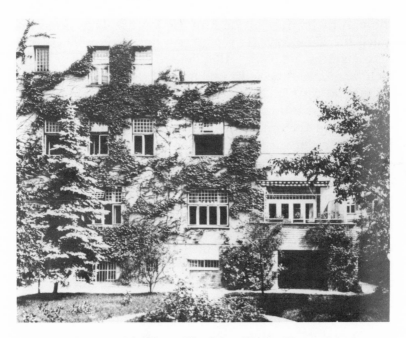

Figure 42 Adolf Loos, The Scheu House, Vienna (1912).

rated by a more traditional versus a more contemporary outlook. To overcome this basic division and make both of them modern men, these two worlds had to be merged (56). Where the Secession sought to exercise the salutary effect of an artistically unified physical environment to eliminate divisions within society, Loos attempted to do so through a basic cultural revolution involving a significant break with the past of which his architecture was but one part.

Clearly, Loos and Kraus might have had differences when it came to specifics of outlook, particularly with respect to tradition, but each offered a radical solution to the ills of contemporary life that, within the Austrian context, reflected their distaste for that life. Both men were further linked by an elitist approach to the problems involved.

Kraus shunned politics and spoke to a select group primarily through the narrow medium of his journal. Loos acted in much the same way. He served as a one-man publicist for his own ideas and had a rather limited following. In "Ornament and Crime" he addressed himself to the "Aristocrats," those who truly understood and appreciated life. He even went so far as to equate them with the "modern man" who stood above the ornament-dependent "herd" (57). It was Loos who prophesied and preached and others who were to accept and follow. When both he and Kraus took Kokoschka under their wing, it was to make an addition to the ranks of this elite.

Kokoschka became a protégé of Kraus and Loos because these two men each saw traits within his art that corresponded with their favorite themes. For Kraus these centered on the honesty of his creations, the extreme avant-garde and, therefore, oppositional nature of his art. These points impressed Loos as well, but in the imagery of the young Kokoschka, in his use of color and line Loos saw a style so different from that of its social and cultural surroundings that this very differentiation was proof of its modern quality and Loos sought to foster its development. This was the Kokoschka his two principal patrons saw, but there was also a Kokoschka who could be befriended by members of the Secession, be employed by the *Wiener Werkstätte,* and assert his own individuality regardless of his mentors.

Of that generation of Austrian artists who began their careers between the opening of the Secession and the outbreak of the war in 1914, only the young Egon Schiele ranks with Kokoschka. Though both men have come to be commonly identified as major pioneers of the expressionist style, Kokoschka alone survived the war to win a reputation as one of the greatest artists of the 20th century. Indeed, of all the figures discussed here, he alone lived well into the 20th century. Connected to both the Secession and its critics,

Kokoschka actually felt beholden to neither side. His art, like that of Schiele's, developed its own version of modern imagery that had more in common with what was to come in art after 1914 than with what came before.

Kokoschka did not make his appearance on the Viennese artistic scene until 1907, and when he did so it was through the aegis of the *Wiener Werkstätte.* As a student at the School of Applied Art, one of Kokoschka's professors was Carl Otto Czeschka who was also a member of the *Werkstätte* and Secession. Czeschka was impressed with his talent, and it was probably through him that Kokoschka came into contact with Josef Hoffmann who, in turn, gave him a job at the *Werkstätte* (58). There Kokoschka produced a wide variety of items from postcards to painted fans. The work did not pay well and he found it tiresome, but he did not have to endure it for very long for, in the following year, he reached a turning point in his career (59).

In 1908 Kokoschka met Loos. He described Loos as entering his life "like a fairy king in one of Raimund's magic plays" (60). Loos had great faith in Kokoschka's talent and helped to lift him out of the doldrums into which his piece-work at the *Werkstätte* had placed him. That same year, Czeschka got Kokoschka an invitation to exhibit at the first *Kunstschau* (61). Although Kokoschka places more importance upon his acquaintance with Loos at this time, it was the opportunity to participate in an exhibition sponsored by the leading artists of the Secession that put him squarely in the public eye.

Kokoschka had been an admirer of the Secession for some time before meeting Loos. In his memoirs he says that he never attended exhibitions at the Secession nor visited the Art History Museum because he did not feel worthy enough to stand before the masters (62). Clearly, he had more than a casual respect for the Secession and its artists and a few of them, including Gustav Klimt, came to return the feeling. In 1906 when Kokschka was 20, Klimt bought some of his

drawings (63). At that time Kokoschka was a great admirer of Klimt and his drawing resembled the master's linear style (64). This admiration continued at least into 1908, for in that year Kokoschka's story, "The Dreaming Boys" ("Die Träumenden Knaben") appeared, with illustrations by the author. It was published by the *Werkstätte* and dedicated to Klimt (65). It was also at this time that Kokoschka finally met Klimt on the occasion of his debut at the *Kunstschau*.

Not only was Kokoschka commissioned to do the poster for the exhibition, but Czeschka's influence also enabled him to have a small exhibit room at the *Kunstschau* allocated exclusively for his works (66). These were two rather distinct privileges for so young and unknown an artist as Kokoschka, but thanks to Klimt he was granted yet another. Before the opening a jury headed by Klimt examined the proposed exhibits to determine what should be deleted from the works assembled by the various artists. Upon coming to Kokoschka's room, they were met by the artist and refused entry. Kokoschka, at that time, was very defensive of his works and wanted them shown without any interference. Klimt, to Kokoschka's relief and gratitude, allowed him to have his way (67). Such was Kokoschka's one and only meeting with the leader of the Secession. Klimt's act of indulgence toward his young colleague was typical of the freedom granted Kokoschka by the *Kunstschau* and its director for, despite the controversial nature of his art, he was also invited to the second *Kunstschau* in 1909.

At the 1908 exhibitions his paintings and sculpture had caused a great uproar. Even Ludwig Hevesi called him the *Oberwildling* (chief wild animal) of the exhibition (68). As for the viewing public, they expressed their opinion of Kokoschka's rather naive and tortured vision of man by disfiguring several of his works (69). He did, however, have some successes. Loos bought a sculpture, but the other buyers whom Kokoschka recalls by name were the Secessionists Emil Orlik and Koloman Moser, both of whom bought

drawings, while the *Werkstätte* patron, Fritz Waerndorfer, purchased his painting, "The Bearer of Dreams" (70). It is also likely that at this time the Secessionist painter, Carl Moll, who would later become Kokoschka's friend and introduce him to his future mistress, Alma Mahler (71), became acquainted with the work of the young artist (72). Thus, the very artists whom Loos despised for their false modernity were conspicuously lending their support to an artist whom Loos himself considered unquestionably modern. At the 1909 *Kunstschau*, Kokoschka showed everyone exactly how modern he really was.

Kokoschka recalls the second *Kunstschau* as the occasion for his first contact with works by Gauguin, Van Gogh, and the Fauves (73), but he also acknowledges that it was the scene of a great public outrage caused by the premier of his play, "Murder, Hope of Women," at the garden theatre of the *Kunstschau*, July 4, 1909. It was a short one-act play dealing with rape and sexual struggle, which in the Vienna of 1909 were hardly considered appropriate subjects for the public stage. Even before the play was shown it caused a stir as a result of the poster Kokoschka had designed to advertise the performance (Figure 43). It consisted of two unorthodox looking figures done in bold lines. One of them was a blood-red man lying in the lap of a pale, white woman—a suggestion of murder and death. As a result of this poster and rumors concerning the play, it was sold out. At the actual performance Kokoschka presented scantily clad actors and actresses, who were painted all over with lines depicting muscles, tendons, and nerves in a manner similar to that of the poster. The combination of the play and production techniques upon an already agitated audience caused a less than overwhelmingly favorable response. In his memoirs Kokoschka claims that a riot broke out over the play and that he was spared bodily harm only by the timely intervention of the police, whom Loos and Kraus had arranged to be standing by. Their efforts also kept him out of jail (74).

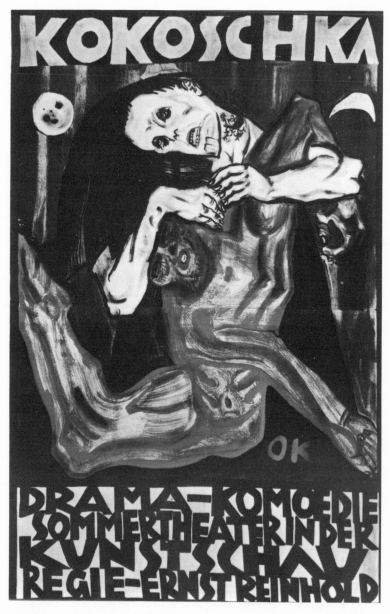

Figure 43 Oskar Kokoschka, Poster for 1909 Kunstschau production of "Murder, Hope of Women."

In fact, it's not clear what actually happened at that performance. The *Neue Freie Presse* reported in its review the following day that the audience had received the play good naturedly and with understanding, but that when the author and principals were called for their bows it was "not without protest" *(nicht ohne Protest)* from at least part of the audience. No special stress, however, is placed upon that opposition. Even Kraus, one of Kokoschka's supposed rescuers, is unaccustomedly quiet about the day's events. There is no review of the play and not a word about a riot in his issue of *Die Fackel* for that July (75). Either there was a conspiracy of silence from friend and foe alike on this subject or Kokoschka's memory magnified a "protest" into a riot. Still, the play won its author no plaudits and Kokoschka felt that whatever negative reaction it elicited caused the Minister of Education to put pressure on the director of the School of Applied Arts, which resulted in his being forced to leave (76). Never very happy with the emphasis on ornament at the school (77), he left more or less willingly. At this point Loos succeeded in persuading him to leave the *Werkstätte,* and from then until about 1916 he was Kokoschka's chief friend and promoter. Subsequently, his ties with the *Klimtgruppe* fell away though his friendship with Moll continued, and Alma Mahler recalls that Klimt always had great respect for his talent (78).

Kokoschka's appeal to both Loos and the Secession movement was based on a recognition by each side of his genuine talent. It is this which prompted Czeschka to help him in the first place; it also got him the job at the *Werkstätte,* a place in the *Kunstschau,* and the admiration of Klimt. This support from the Secession, however, differed in two important respects from that offered by Loos.

By the time of the *Kunstschau* both the formal Secession under Engelhart's control and the *Klimtgruppe* had become part of the solid artistic establishment of Vienna—they were virtually an institutionalized avant-garde. This was not true for Loos, and the circles in which he moved. His was a world

on the fringe of the establishment with a notorious reputation for iconoclasm, and to the restless young Kokoschka, who disliked the ornament of the School of Applied Art, was bored at the *Werkstätte,* and labeled as the "chief wild animal," that world had a definite appeal. Finally, Loos had an aggressive sense of his own modernity that was translated into an unwavering confidence in his ability to identify fellow representatives of what was modern. His enthusiasm had been unbounded when he discovered Kokoschka (79), and he did his best to convince Kraus and others that he was right. By comparison, the artists of the Secession, while they still considered themselves modern, were no longer aggressive about it. They liked Kokoschka, but their encouragement, though at first more substantial, was less effusive than Loos'. Among them, extensive recognition would have been much slower. With Loos there was less security, but immense encouragement.

Between March 1910 and April 1911 three articles concerning Kokoschka and his art appeared in *Die Fackel* (80). In the usual Krausian manner the authors of these essays praised Kokoschka for the strength and honesty of his art and noted that he was being neglected by Viennese "society." This neglect was related to Kokoschka having become *Ein Fall* (a case) due to his unorthodox opinions and style. For Kraus, of course, such a circumstance could merely affirm how superior Kokoschka really was. In the last of these articles, one written by L. E. Tesar, this neglect of Kokoschka was considered representative of the gulf between the artist and the layman, a gulf that meant constant struggle between them (81). Tesar felt this gulf to represent a serious division in society. Loos, Kraus, and the Secession had seen a similar gulf and perceived the need to bring art and society into meaningful contact with one another as part of their respective missions in the world. Indeed, a general sense of discontinuity within society was shared by all three. In Kokoschka, however, this feeling is lacking.

In his memoirs, Kokoschka never talks of himself as hav-
ing shared in the cultural anxieties of his patrons. For him,
art nouveau was merely a transitional period in which art
tried to beautify life in reaction to the evils of the machine
and progress (82). Even this observation, however, has the
ring of a retrospective judgment for, at the time, his only
concern with the style was that it was too ornamental (83).
Politics before 1914 didn't concern him either, though his
willingness to enlist at the outbreak of the war and his
subsequent condemnation of the empire's dissolution (84)
show that he accepted the Habsburg state. By his own ac-
count, however, even though he and his friends knew that
the political situation in Austria meant that their world was
moving to its end, they refused to go "into the streets" to
do anything about it (85). Instead, they called society "the
adults" (86), and went about their own youthful business.
In Kokoschka's case that meant pursuing his art and his love
affair with Alma Mahler. Those who encouraged him might
be concerned about the role of art in solving society's prob-
lems, but Kokoschka was not.

Kokoschka reflected this unconcern for the external world
in his work. Though firmly anchored in a belief in the valid-
ity of depicting the human form, the manner in which he
depicted that form was based on his individual and intuitive
perception of whomever he was painting. Some of his works
have a searing quality that seems to lay bare the very nerve
endings of his subjects as in his drawings of Loos and Kraus
(1909). Others have a dream-like haziness as in the portrait
of Ernst Reinhold, the director of "Murder, Hope of
Women," which Kokoschka painted in 1908. The later
paintings of himself and Alma Mahler seem to have an
almost prophetic quality, suggesting future depressions and
miseries as in the tortured, prostrate body of Kokoschka in
"The Bride of the Wind" (1914) (Figure 44), which appears
to presage death or the physical agony of his war wounds
and the emotional ambivalence of his affair with Alma. His

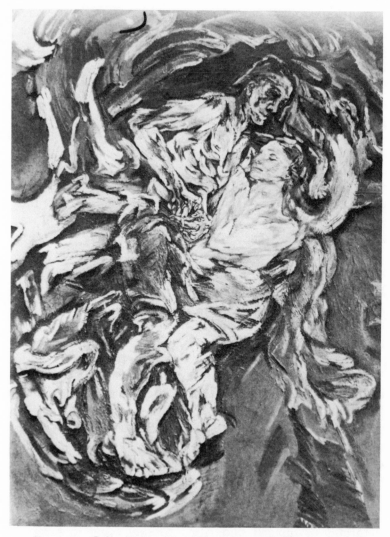

Figure 44 Oskar Kokoschka, "The Bride of the Wind" (1914).

use of bold and primary colors further heightened the eccentricity of his work and marked it even more as an expression of his own unique vision.

In his expressionist style, there was no effort nor even a sense of need on Kokoschka's part to reconcile his individual

vision of the world with that of the artists who had preceded him. The desire to affirm a sense of continuity was not one of his concerns. When he visited Berlin in 1910, he felt he was in a 20th-century city with the hustle and bustle of the mass industrial age, while in contrast to this he saw Vienna and Austria generally as having so far been spared the impact of this modern world (87). Yet, Kokoschka makes this comment as a matter of fact observation, with perhaps a slight bit of regret for what lays ahead of Austria, but with a great enthusiasm for what he had found already extant in Berlin. The change happening around him does not cause him any significant anxiety; he accepts it with basic equanimity. Compared to the sense of mission found in Loos, Kraus, and the Secession, Kokoschka represents the autonomous artist whose lack of ostensible commitment to his society and extreme individuality of perception make him as much a creator of art for art's sake as any aesthete who had preceded him. Indeed, in the expressionism of Kokoschka and to a lesser extent in that of his contemporary, Egon Schiele (Figure 45), the effort at creating an engaged art undertaken by the Secession found its negation.

As the two most important painters of the new avant-garde in prewar Austria, both Kokoschka and Schiele were distinctively individual in their approaches to art, and in some ways Schiele was even more iconoclastic in his depiction of the human form than Kokoschka. Yet, it was Schiele who remained outside the Loos-Kraus circle while maintaining links with the Secession movement through his close ties with Klimt. As an art student, Schiele felt a strong admiration for Klimt and in his own work attempted to follow the style of the older artist. In the period 1907–1909 both Kokoschka and Schiele made their debuts under the aegis of the Secessionist *Klimtgruppe,* but in Schiele's case no encouragement was forthcoming from either Loos or Kraus. His principal patron at the time was Gustav Klimt, and for the rest of his life a main source of his artistic support remained the aging founder of the Secession.

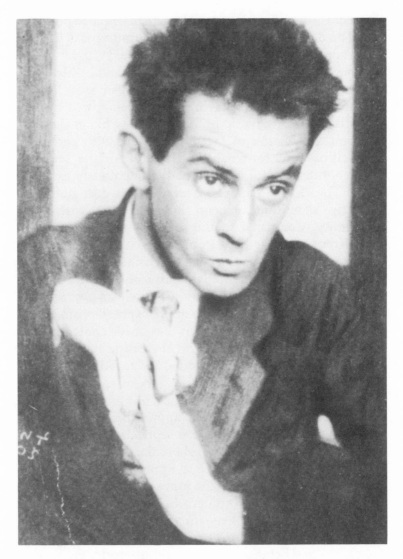

Figure 45 Photograph of Egon Schiele in 1914.

Unlike Kokoschka, Schiele initiated direct contact with Klimt well before his participation in the *Kunstschau*. In 1907 he went directly to Klimt's studio, showed the master some drawings, asked if he had talent, and, receiving a very affir-

mative reply, began his long association with Klimt (88). Schiele became Klimt's close protégé with a kind of father-son relationship developing between them (89). In 1909 Klimt secured him a job at the *Wiener Werkstätte* (90) where Schiele did much the same kind of work as Kokoschka. That same year, at Klimt's personal invitation, Schiele exhibited three portraits at the second *Kunstschau* (91).

Schiele's appearance that year gained him exposure without, however, causing any notoriety. There was no repetition of the minor scandal caused by Kokoschka. Schiele's portraits of his sister and two artist friends were well within the accepted "modern" style of the Secession. The strong influence of Klimt upon the style of these portraits is evident in the use of line and decorative elements. They were so reminiscent of the master's style that there could hardly be anything objectionable about them. At the time, Schiele even styled himself the "silver Klimt" (92). Only in the modeling of the faces and the hands is there a suggestion of the later and more tortured depiction of the human form that would become a hallmark of his portrait style.

In addition to giving Schiele a large audience for his work, the *Kunstschau* gave him a chance to see the latest trends in modern art outside of Austria. The international emphasis of the second *Kunstschau* carried out the old didactic theme of Secession exhibitions as educators of public taste. The inclusion of such artists as Van Gogh, Munch, Toorop, and Minne not only stirred the interest of the viewing public, but also of the young artists who were themselves exhibiting at the *Kunstschau*. Schiele and Kokoschka were not the only aspiring artists at the exhibition. The presence of Paris von Gütersloh and Max Oppenheimer (93) testified to the *Klimtgruppe*'s commitment to helping talented artists of the younger generation even if their work was not necessarily in the idiom of the Secession. Indeed, for all his admiration of Klimt, Schiele had no particular admiration for the applied arts, which were so integral a part of the Secession philosophy, and in 1910 he even called for a new *Kunstschau*

to be dedicated to the fine arts alone (94). Moreover, as Alessandra Comini has pointed out, Schiele's exposure to foreign artists at the *Kunstschau* served primarily as an influence away from his Secession-oriented imitation of Klimt and helped pave the way for his own more radical style of painting.

The year 1909 was significant for Schiele's development in other ways as well. Again in action parallel to Kokoschka's, Schiele left the constricting atmosphere of the Academy of Art to strike out on his own (95). He also acquired a patron outside the Secession movement in the person of Arthur Roessler, the art critic of the *Arbeiter Zeitung,* who saw an exhibition of Schiele's work at the Pisko Gallery at the end of 1909 (96). Finally, in his departure from the academy, he was accompanied by other young artists who with Schiele as their titular leader founded a loose association among themselves known as the *Neukunstgruppe* (New Art Group) (97). Close on the heels of these events Schiele's style underwent rapid change.

Schiele's exhibitions at the *Kunstschau* had given him the necessary confidence to leave the academy. Being among other artists, such as Anton Faistauer and Anton Peschka, who were also painting in an expressionist mode, must have given further support to Schiele's own developing style, while the critical encouragement of Roessler was now added to that of Klimt. The effect of these altered circumstances was that by late 1909 and early 1910 Schiele had largely shed the decorative influence of Klimt and was producing portraits and self-portraits in the distended, angular style that came to typify so much of his work. By the time of his December showing at the Pisko Gallery in 1909, his work was being cited as "ugly" and "morbid," with "outrageous gesticulations and completely unnatural use of color" (98). He was now definitely in the footsteps of the avant-garde. The "silver Klimt" was gone.

The type of portraits Schiele began producing had a psychological quality to them that was reflected in the transfor-

mation of the sitter's face from an objective to what Comini
terms "a subjective realism" (99). Schiele's subjects often
found themselves revealed on the canvas in a form dictated
by Schiele's personal and inner perception of them. This was
true in a portrait commissioned by Otto Wagner (1910) in
which Schiele showed him as being older than he really was.
As a result Wagner, though he paid Schiele a commission
anyway, stopped sitting for him. The psychological quality
of his work, however, is best reflected in the numerous
self-portraits (Figure 46) that Schiele produced from 1910
on. In them his body has the ravaged appearance of a con-
centration camp victim, the harsh brush-strokes and color-
ing give his flesh a tortured appearance, and his often
grimacing face accompanied by ungainly gestures present an
image of disturbed narcissism. Also present in these works,
as well as in his female nudes and paintings of himself with
women, is a strong sexual theme, which because of the raw-
ness of his style was considered by some to be pornographic.
In 1912 he was actually arrested on a charge of immorality
and seduction in the village of Neulengbach because of his
sexual liaisons, invitations to children to sit for him, and his
erotic sketches. He spent 24 days in jail for this and was
forced to watch a judge in St. Polten burn one of his draw-
ings as pornographic while pronouncing public censure
upon him (100).

 With the passage of time Schiele's art developed a less
searing side to it. There was still evidence of a strong erotic
quality, but this had persisted even in Klimt's less contro-
versial style. His preoccupation with depicting himself also
remained, however, in his late portraiture, while the line still
plays a key role in delineating the figure, the form of the
figure is fuller with more attention being given to physical
detail accompanied by less distortion. This resulted in a less
starkly subjective perception of the subject. In the 1916
"Portrait of Johann Harms" there is still a strong drawing
quality with the paint acting as filler between rather harsh
lines. In 1918, the year of his death, the "Portrait of Guido

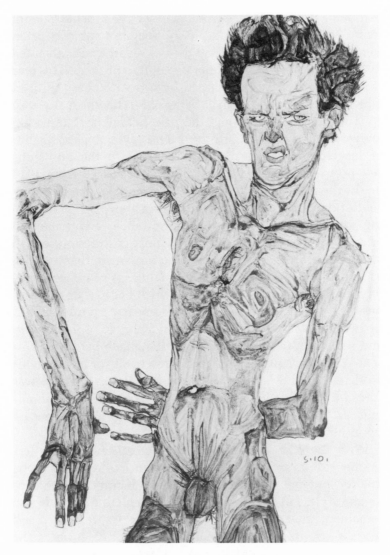

Figure 46 Egon Schiele, "Self-Portrait" (1910).

Arnot" and the "Portrait of Dr. Hugo Koller" (Figure 47)
reveal a Schiele who has abandoned the use of an undefined
background in favor of depicting the personal surroundings
of his subjects, and the subjects themselves, though well

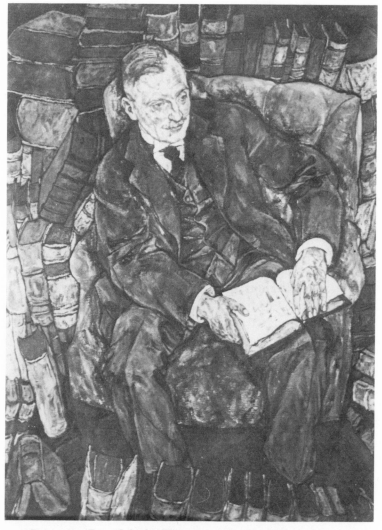

Figure 47 Egon Schiele, "Portrait of Dr. Hugo Koller" (1918).

defined by line in their general form, produce a softer, more objective image by depicting detail and subtleties of coloring.

Although Schiele also painted landscapes where line and the bold use of color are in evidence, it is in his portraits that

his expressionism finds its most compelling outlet. Even in his later "softer" portraits the subjectivity of perception resulting in a highly individual style is in evidence. The portrait is there to capture the artist's personal view of the sitter detached from any formal stylistic or philosophical framework. The reduced harshness in the expression of that view toward the end of Schiele's life may have been due to his more stable love life, as well as the onset of critical recognition and the material success that it brought.[3] It nevertheless stood out from the mixture of mannered subjectivity, complex ornamentation, and elegant realism that was so common in Secession art. In this sense, Schiele easily ranks with Kokoschka as a representative of the expressionism that became the new modern art of Austria between 1907 and 1918, but unlike Kokoschka, he retained certain links with the earlier avant-garde.

The most obvious of these links is Schiele's long-term relationship with Klimt. Unlike Kokoschka, he continued to be in contact with the older artist after 1909. Klimt helped find him patrons, such as the Lederer family (101), and at his passing, Schiele sketched him on his deathbed. Nevertheless, he did break with Klimt's style and by 1912 in a painting entitled "The Hermits" a young Schiele seems to be leading a blind Klimt symbolizing the unconscious recognition by the younger artist that the art of his generation has replaced that of Klimt's and is now the new modern art (102). For all that, however, the long attachment between the two men represents a recognition by Schiele of a debt to the older generation of the avant-garde that Kokoschka did not feel. In concrete stylistic terms, Schiele's nudes, though far less elegant, are suggestive of Klimt's own preoccupation with the female body and, as Kokoschka himself noted,

[3]The symbol of this success was a one-man show of Schiele's works at the Secession. This indicates how much a part of the recognized establishment the post-1905 *Vereinigung* had become by 1918.

Schiele's use of line was considered to have come from Klimt (103). Moreover, Schiele never expressed a distaste for the Secession-*Werkstätte* style that had been his first source of inspiration.

In addition to the above aspects of Schiele's connection with the Secession, there is also an interesting parallel between himself and the artists of that movement that is present in their shared preference for some kind of organizational connection. Though never a member of the formal Secession or the *Klimtgruppe,* Schiele belonged to and helped found two other artists' associations.

In 1909 he founded the *Neukunstgruppe* as an association of young artists dissatisfied with the conservative artistic attitudes of the academy. Again in 1917, he was one of the founders and chief instigators of a project known as the *Kunsthalle* (Art Hall). Among those associated with it were Klimt, Josef Hoffmann, and the composer, Arnold Schönberg. Its main purpose was to protect and preserve Austria's cultural heritage from the expected turmoil of the postwar period and to develop plans to assist the youth of Austria in reconstructing that heritage free of any damage from the past (104). Its organization, though loose, was to be strong enough to provide a variety of services to help young artists, and among these services was included a permanent gallery for their exhibitions (105). Plans had gone so far by March of that year that a location near the *Stadtpark* was contemplated as a site for the *Kunsthalle's* building, and a capital of 30,000–40,000 Kronen pledged for the first half-year's operating expenses (106). The project was never realized, but Schiele's undoubted enthusiasm for it indicates that he had no fear of an institutional influence in contemporary art. Indeed, the idealism of the project, its emphasis on a free atmosphere for the development of new art, its concern for Austrian culture, and its desire to have a permanent structure to house its activities in a conspicuous public place is very reminiscent of the Secession itself.

Schiele once maintained that a "new epoch" in art was only brought about by an exceptional "artistic individuality" (*Künstler individualität*) embodied in the person of what he called the "new artist" (*Neukünstler*) who, breaking with the past, was able to create something new (107). Schiele assumed that he was such a "new artist," yet his willingness to maintain strong contacts with leading elements of the Secession, the absence of any repudiation of its art, and his own institutionalizing tendencies all indicate that despite his radical style he had no unequivocal desire to break with a recent artistic past out of which he himself had sprung. A statement he once made that "there is no 'modern art,' that there is only art and it is everlasting (*immerwährend*)" (108), when taken with everything else, suggests that Schiele sought his own new artistic expression, but was not willing to see it as an exclusive vision. In contrast to Schiele, Kokoschka stands out as a loner supported only by other cultural and intellectual loners, such as Loos and Kraus. Of all those developing a new artistic modernity, Schiele, despite his iconoclastic style, was the least radical among them.

Although Schiele may have been the least radical of Austria's new avant-garde, this question of his radicalism is basically a relative one. When compared as he has been to his principal counterpart of the time, Oskar Kokoschka, he does certainly appear less radical in his attitudes toward the Secession and the issue of his own artistic modernity. He offers little or no criticism of the culture and society in which he lives, which is in sharp contrast to Loos and Kraus. Indeed, such questions, except when they forcibly intruded themselves upon him as in his arrest and trial and later involvement in the war and its effects as a soldier and artist, were basically alien to him. His ties with the Secession and rather favorable attitudes toward the artistic past also stand out as moderate features in his character. Yet, if one looks simply at Schiele's art, he is easily as radical as Kokoschka, for, whether nurtured by the Secession or not, he is painting

in a stylistic idiom far more individual and detached from his surroundings than the Secession had ever attempted. Both Schiele and Kokoschka are essentially subjective and autonomous in their approach to art.

It was mentioned earlier that in the expressionism of Kokoschka and Schiele the engaged art aimed at by the Secession found its negation. Such a negation came about because of the highly individualistic nature of the new art. The Secession had come into being because a group of artists felt themselves stifled by the atmosphere of the *Künstlergenossenschaft* and set off to create a freer environment for themselves and their art. They chose to do so as a group, but their act of secession and emphasis on artistic freedom created an atmosphere conducive to greater artistic experimentation and individuation that, in turn, formed a context in which artists like Kokoschka and Schiele could feel encouraged to follow their own subjective vision of art. Moreover, in addition to creating this general situation, the Secession movement through the *Klimtgruppe* gave specific assistance to the younger artists by giving them work at the *Werkstätte* and exhibiting space at the *Kunstschau.* The exhibition of 1909 included not only Kokoschka and Schiele, but Gütersloh and Oppenheimer as well. Though helped by the Secession movement, these young artists did not become a part of it. They absorbed nothing of the *Gesamtkunstwerk* idea, saw no idealistic role for art in solving society's problems, and with the partial exception of Schiele, were suspicious of the institutional tendencies of art, which, in their personal secessions from academies and schools, they were trying to leave behind them. The type of involvement they knew was that of themselves with their own subjective perceptions of life and the need to express those perceptions on canvas.

The style of the expressionists has been described as a reliance upon "emotive formulations in place of visual descriptions for communicating their individual, subjective reality . . . representation of external phenomena was com-

pletely subordinated to visual statement of inner feeling"
(109). In the art of Kokoschka and Schiele, the distorted
depiction of the human body and the unusual use of color
was the visual expression of these traits. In contrast, the art
of the Secession movement for all the sensuous forms of
Klimt, the decorative fantasies and even impressionistic im-
ages created by its artists, was primarily interested in soften-
ing and enhancing reality and not in ignoring it. At the other
end of the spectrum, Kraus and Loos were almost entirely
absorbed with reality. They devoted themselves to exposing
what they considered to be its unsavory and corrupt side
within their respective cultural spheres while championing
a purer, cleaner version free of the errors into which art and
literature had fallen. Kokoschka was only superficially
touched by this attitude, and Schiele not at all.

It is rather ironic that Kokoschka and Schiele actually had
less in common with the two opposing cultural camps that
supported them than those two camps had with each other.
Although Kraus and Loos differed from the Secession move-
ment and *Jung Wien* in how literature and the fine arts
should conduct their relationship with society, they never-
theless agreed that a positive relationship did exist and that
art in all its forms had a responsibility to act in a constructive
manner for the good of society. This is not to minimize the
very real gap between these two camps in their respective
attitudes toward modernity, but it does illustrate how far
the new art, which they had helped to nurture, was moving
from its *fin-de-siècle* background and in the course of that
movement developing its own artistic response to moder-
nity.

In the case of the Secession movement, the approach to
modernity was a mixture of enthusiasm and caution. It was
enthusiastic to the extent that it wholeheartedly sought to
create a new art for a new age, an age that was technologi-
cally and socially different from those from which the his-
toricist style had derived its inspiration, and distinct as well,
in its outlook, from the immediate past, which had patron-

ized the efforts of historicism. It was also cautious, however, in its sense of uneasiness about the divisions within society that were specifically present in quite palpable forms in Austria and as part of the modern world generally.

This uneasiness found expression in an emphasis on unity in art as a means of restoring it in society. Hence, the concern with acknowledging the artistic past and its contributions to contemporary culture. Modernity in this approach meant a combination of past and present in the elements of continuity and change. By acknowledging change in their art, they were also acknowledging the importance of change in contemporary life, but by emphasizing continuity they were seeking a stabilizing factor in that life. In essence, it was an effort at having the best of both worlds by striking a balance between these key elements in art. Such an attitude was basically optimistic and idealistic in its hopes for the future and solution of existing problems. Had its approach succeeded to its fullest potential for reconciling Austria's internal conflicts, presumably the events of 1914 that resulted from those conflicts would not have occurred and the Habsburg state would have remained intact; that it contributed nothing to preventing these events indicates its unrealistic dimension.

In contrast, its opponents, Kraus and Loos, felt themselves to be more realistic in their outlook on modernity and its needs. Each took a hard look at modern society and found it lacking. For Kraus, there was no real optimism or faith concerning the salutary effects of change. Modern society was heading for disaster because it had changed technologically and socially, which, in turn, had corrupted its moral foundations and could only be saved by a return to, and not by a simple amalgam with, the past. The material changes that had been wrought so far would presumably be left intact, but the moral underpinnings of society, which culture provided, would have to be renewed by a return to the eternal verities found in the world of the *Vormärz*. Modernity for Kraus was, in fact, pernicious, and the compromise

vision of the best of both worlds basically illusory. Men such as Klimt and Bahr only clouded men's vision with their art and sustained an illusion, which, because it obscured reality with false images, was dangerous to man's well-being and art's higher purpose.

Loos, on the other hand, though he shared Kraus's moral outrage over what he saw as sham, and misuse of society's resources in the modern world, nevertheless saw technological advancement and social change as positive because it led to a rationalization of life that was for him the essence of modernity. This rationalization process was manifested in the breakdown of tradition through the standardization of habits and outlook for those living in the country and city alike according to the example of America. This standardization and, therefore, modernization, could be helped along by art, at least in its architectural form, by the elimination of useless ornament in favor of functional and highly geometric forms. Loos' view of architecture also included the *Gesamtkunstwerk* concept, but without its arts and crafts side or philosophical implications. In later life Loos went so far in the direction of standardization in his art as to become an early proponent of economical prefabricated housing. To such a man the element of functionalism in Secession architecture could only be halfway and obscured by its penchant for ornament.

The environment produced by Loos' type of architecture would be unencumbered by the extraneous and false ornamental elements of the designs produced by his opponents. This cleaner and more honest style, honest because of its use of unadorned materials, reflected a version of reality that in its moral tone was, at least artistically, to be less illusory and more straightforward. Moreover, it was a reality that, like Loos' buildings themselves, would express the concrete needs of life. This was the modern world Loos was working toward, and it was one that, except for the classical past, found little need to include elements of previous periods.

Continuity was less important to Loos than the acceptance of change, although in propounding his own ideas on architecture and encouraging their standardization along with other aspects of human society, a stabilizing process would ultimately have come about and modernity as Loos saw it would be established.

In general, when compared to the Secession movement, the attitudes of Kraus and Loos towards modernity are those of extreme advocates of the past and future, respectively, with their opposite numbers standing for a compromise between the two. Nevertheless, all three shared a sense of definite purpose in art's relationship to society that transcends the individual work of art itself. Kokoschka and Schiele, however, notwithstanding their occasional concern with nonartistic problems, display an attitude toward modernity that is artistically and personally autarchic. For them, the contemporary world simply exists and they react to it as they see fit, creating their art as autonomous individuals. In pre-1914 Austria such an attitude is ominous when set against the increasing feeling of separateness among the empire's nationalities and the undercurrent of social antagonism between its classes. If the expressionist approach to the modern world was the main alternative to that of the Secession or of Kraus and Loos that presented itself to the artistically active generation of Austria just before the war, then the older artistic generation had not only failed to preserve its notion of an engaged art, but had even assisted through their support of men like Kokoschka and Schiele in hastening its demise and encouraging the trend of atomization and indifference that they all feared.

Chapter Notes

1. The letter to von Hartel carried the signatures of the following artists: Josef Auchintaller, Wilhelm Bernatzik, Adolf Böhm, Adolf

Hözel, Josef Hoffmann, Franz W. Jäger, Gustav Klimt, Max Kurz-
weil, Wilhelm List, Richard Luksch, Franz Metzner, Carl Moll, Emil
Orlik, Alfred Roller, and Otto Wagner. All of these men became part
of what was known as the *Klimtgruppe,* and to theirs may also be
added the names of Koloman Moser, Felician Freiherr von Myrbach,
and Hans Schwaiger. In 1906 the group adopted the formal title of
"Österreichischer Künstlerbund," and in 1912 changed it to *"Bund
Österreichischer Künstler"* with Klimt as president and Wagner as
vice-president. Besides the *Kunstschau,* the group also exhibited in
Rome in 1914 and at the Berlin Secession in 1916. (See Christian M.
Nebehay, *Gustav Klimt, Dokumentation* [Wien: Verlag der Galerie
Christian M. Nebehay, 1969], pp. 126, 345–47.)

2. *Ibid.,* p. 348.
3. Otto Stoessl, "Kunstschau," in *Die Fackel,* Nr. 259–260 (13 Juli
 1908), pp. 24–30.
4. *Die Fackel,* Nr. 29 (Mitte Jänner 1900), pp. 16–20.
5. *Die Fackel,* Nr. 30 (Ende Jänner 1900), pp. 9–17.
6. *Die Fackel,* Nr. 36 (Ende März 1900), p. 17.
7. *Ibid.*
8. Karl Hauer, "Staatliche Kunstpflege," in *Die Fackel,* Nr. 250 (14 April
 1908), pp. 11–15. (Though not by Kraus himself, it had Kraus's
 editorial approval and in general reflected his attitudes on the sub-
 ject.)
9. *Die Fackel,* Nr. 41 (Mitte Mai 1900), p. 18.
10. *Die Fackel,* Nr. 44 (Mitte Juni 1900), pp. 15–18.
11. *Die Fackel,* Nr. 73 (Anfang April 1901), p. 13.
12. *Die Fackel,* Nr. 147 (21 November 1903), pp. 10–12.
13. *Die Fackel,* Nr. 59 (Mitte November 1900), pp. 19–20. The question
 of the Secession's "Jewishness" is fundamentally spurious. As Wais-
 senberger has pointed out, the movement did receive significant
 support from the Jewish middle class, but so did most cultural activi-
 ties in Vienna whether conservative or avant-garde. Moreover, the
 members of the Secession itself seem to have been overwhelmingly
 gentile. That the movement attracted Jews among its supporters is
 only to be expected from its cosmopolitan outlook, particularly in
 a city with one of the largest, best educated, and wealthiest Jewish
 populations in Europe.
14. *Ibid.,* p. 19.
15. *Die Fackel,* Nr. 36 (Ende März 1900), p. 20.
16. Karl Kraus, "Apokalypse" (Oct. 1908) in *Untergang der Welt durch
 Schwarze Magie* (München: Kosel-Verlag zu München, 1960). p. 11.
17. *Ibid.*

18. *Ibid.*
19. See Wilma Iggers, *Karl Kraus, A Viennese Critic of the Twentieth Century* (The Hague: Martinus Nijhoff, 1967).
20. *Ibid.,* p. 225.
21. *Ibid.,* p. 211.
22. *Ibid.,* p. 227.
23. *Ibid.,* p. 203. See also Frank Field, *The Last Days of Mankind, Karl Kraus and His Vienna* (London and N.Y.: Macmillan and St. Martin's Press, 1967), p. 23. Here the author points out Nietzsche's influence upon Kraus particularly as a moralist and critic of the modern world.
24. *Ibid.,* p. 29.
25. See "Die demolirte Literatur," in *Wiener Rundschau* (Rundschau: Verlag der Wiener, 1897), Band I, No. 1–12 (Kraus Reprint, 1970).
26. The phenomenon of *"der jüdische Selbsthass"* was described by Theodor Lessing in a book of the same name published in 1930. It deals with several outstanding young Jews who became antisemitic, among whom the author includes Karl Kraus. As a phenomenon it may have been caused by the pressures of assimilation placed on Jews in Central Europe where, in order to be accepted, one needed to be as gentile and German as possible. For many, to do so and still be a Jew was not possible. The demand of their host culture proved too strong, and to justify their membership in it they attacked their own heritage. This probably served as a means of emphasizing their non-Jewish character while also expressing their hatred for the thing that stigmatized them as undesirable. Yet their heritage was psychologically inescapable, and hatred of that heritage was hatred of themselves. For a further discussion of this problem with respect to Kraus, see Iggers, pp. 171–91; also, Field, p. 23; and Harry Zohn, *Karl Kraus* (N.Y.: Twayne Publishers, Inc., 1971), pp. 38–41.
27. *Ibid.,* p. 214.
28. *Ibid.,* p. 90.
29. *Ibid.,* p. 92.
30. *Ibid.*
31. *Ibid.,* p. 98.
32. Karl Kraus, "Bahr Feier" (Sept. 1913), in *Literatur und Lüge* (München: Im Kosel-Verlag zu München, 1958), p. 303.
33. Between 1890 and 1894 Bahr wrote four major collections of essays dealing with literary criticism in which, among other topics, he discussed the nature of the *Jung Wien* movement. They are: *Zur Kritik der Moderne* (1890), *Die Überwindung des Naturalismus* (1891), *Die Neue Stil* (1893), and *Studien zur Kritik der Moderne* (1894).
34. Claus Pack, "Adolf Loos (1870–1933)," in *Neue Österreichische Bio-*

graphie, Band XVIII (Wien: Amalthea-Verlag, 1972), p. 133 (hereafter referred to as N.Ö.B.).

35. Ludwig Münz and Gustav Künstler, *Adolf Loos, Pioneer of Modern Architecture* (New York and Washington: Frederick A. Praeger, 1966), p. 20.

36. *Ibid.,* p. 17.

37. *Ibid.,* p. 20.

38. *Ibid.,* see pp. 223–24.

39. *Ibid.,* pp. 30–31.

40. *Ibid.,* p. 31.

41. Adolf Loos, *Das Andere, Ein Blatt zur Einführung Abendlaendischer Kultur in Österreich* (Wien, Oktober 15, 1903), No. 2, 1. Jahr; pp. 1–2.

42. Adolf Loos, "Ornament and Crime," in Münz and Künstler, *Adolf Loos . . . ,* p. 229.

43. *Ibid.,* p. 228.

44. *Ibid.,* pp. 228–29.

45. Münz and Künstler, pp. 30–31.

46. *Ibid.,* p. 31.

47. *Ibid.,* p. 17.

48. *N.Ö.B.,* p. 134.

49. Robert Waissenberger, *Wien und die Kunst* (Wien: Jugend und Volk Verlag, 1965), p. 38.

50. *N.Ö.B.,* p. 135.

51. See Robert Scheu, "Adolf Loos," in *Die Fackel,* Nr. 283-84 (26 Juni 1909), pp. 25–37, and Otto Stoessl, "Das Haus auf dem Michaelerplatz," *Die Fackel* (28 Februar 1911), Nr. 317–318, pp. 13–18.

52. Ludwig Hevesi, *Altkunst-Neukunst 1894–1908* (Wien: Konegan, 1909), pp. 284–88.

53. Loos had a great respect for the principles of classical architecture. Like Wagner, he saw Greece and Rome as valuable sources of architectural knowledge. Classical motifs were even present in his own style as in the case of the Goldman building on the Michaelerplatz. In the 1920s, Loos even went so far as to propose a skyscraper in the form of a doric column as his entry in the competition for the *Chicago Tribune's* new building. Even in some of the avowed modern features of his style, such as flat roofs and plain marble or stucco surfaces, there is an echo of the ancient Mediterranean style of domestic architecture.

54. *Das Andere,* p. 1.

55. Oskar Kokoschka, *My Life* (translated by David Britt) (New York: Macmillan Publishing Co., Inc., 1974), p. 42.

56. Münz and Künstler, p. 31.

57. "Ornament and Crime," pp. 230–31.

58. Ludwig Goldscheider and Oskar Kokoschka, *Kokoschka* (London: Phaidon Publishers, Inc., 1963), p. 10.
59. *Ibid.*
60. *Ibid.*
61. Kokoschka, *My Life,* p. 20.
62. *Ibid.,* p. 19.
63. Goldscheider and Kokoschka, p. 9.
64. *Ibid.*
65. Oskar Kokoschka, *Die Träumenden Knaben* (Wien und München: Facsimile by Jugend und Volk Verlag, 1968), see dedication page.
66. Kokoschka, *My Life,* p. 20.
67. *Ibid.,* p. 21.
68. *Ibid.*
69. *Ibid.*
70. *Ibid.*
71. *Ibid.,* p. 72.
72. Nicholas Powell, *The Sacred Spring, the Arts in Vienna 1898–1918* (New York: New York Graphic Society, 1973), p. 119.
73. Kokoschka, *My Life,* p. 21.
74. *Ibid.*
75. *N.F.P.,* 5 July 1909, p. 8. In his memoirs Kokoschka also claimed that in a commentary that appeared the following day in the *Neue Freie Presse* he was called a "bourgeois-baiter," "corrupter of youth," "degenerate artist," and a "common criminal" (Kokoschka, *My Life,* p. 31). Peter Vergo, however, has pointed out that no such commentary exists for July 5th (Peter Vergo, *Art in Vienna 1898–1918, Klimt, Kokoschka, Schiele and Their Contemporaries* (London: Phaidon Press, Ltd., 1975), pp. 248–49, n. 16) and my own examination of the *Presse* from July 1 through 10 failed to uncover anything even vaguely like what Kokoschka says appeared. A check of Georg von Schönerer's Pan-German *Alldeutsche Zeitung* for the same period also reveals no news of a sensational riot at the *Kunst-schau,* though his paper would certainly not have been above such reportage. Yet, the most telling evidence against the artist's recollection is that Kraus, a putative eyewitness and friend, says not a word about that day and, in fact, doesn't even publish anything about Kokoschka in *Die Fackel* until March 1910 (an interview). For all of the above, however, a definitive solution to this scholarly mystery will probably have to await an examination of Viennese police records for July 4, 1909, something which my own belated awareness of the discrepancy and my being on this side of the Atlantic has prevented me from doing.
76. Kokoschka, *My Life,* p. 21.
77. Goldscheider and Kokoschka, p. 10.

78. Powell, p. 173.

79. *Ibid.*, p. 169.

80. See L. E. Tesar, "Oskar Kokoschka (Ein Gespräch)" in *Die Fackel,* Nr. 298–299 (21 März 1910), pp. 34–44; also Franz Gruner, "Oskar Kokoschka," in *Die Fackel,* Nr. 317–318 (28 Februar 1911), pp. 18–23; and L. E. Tesar, "Der Fall Oskar Kokoschka und die Gesellschaft" in *Die Fackel,* Nr. 219–320 (1 April 1911), pp. 31–39.

81. Tesar, "Der Fall Oskar Kokoschka und die Gesellschaft," pp. 32–39.

82. Kokoschka, *My Life,* p. 18.

83. *Ibid.*, p. 24.

84. *Ibid.*, p. 17.

85. *Ibid.*, p. 23.

86. *Ibid.*, p. 25.

87. *Ibid.*, p. 65.

88. Allessandra Comini, *Egon Schiele's Portraits* (Berkeley: University of California Press, 1974), p. 20.

89. Fritz Karpfen, *Das Egon Schiele Buch* (Wien: Verlag der Wiener-Graphischen Werkstätte, 1921), p. 85.

90. Comini, p. 21.

91. *Ibid.*, p. 26.

92. *Ibid.*, p. 34.

93. *Ibid.*

94. *Ibid.*, p. 38.

95. *Ibid.*, p. 30.

96. *Ibid.*, p. 66.

97. *Ibid.*, p. 30.

98. *Ibid.*, p. 48.

99. *Ibid.*, pp. 70–72.

100. *Ibid.*, p. 100.

101. *Ibid.*, p. 113.

102. *Ibid.*, pp. 95–98.

103. Goldscheider and Kokoschka, p. 9.

104. Arthur Roessler, *Briefe und Prosa von Egon Schiele* (Wien, 1921), p. 119. For the text of the letter from Schiele to Anton Peschka in which he describes the *Kunsthalle* project see also Christian M. Nebehay, *Egon Schiele 1890–1918. Leben, Briefe, Gedichte* (Salzburg, Wien: Residenz Verlag, 1979), pp. 417–18.

105. *Ibid.*, p. 121.

106. *Ibid.*, p. 122.

107. *Ibid.*, pp. 17–18.

108. Karpfen; unnumbered biographical page.

109. *Encyclopedia of World Art,* vol. V (New York: McGraw-Hill Book Company, Inc., 1961), p. 311.

Chapter 5
Conclusion: The Ideal and the Real

The years between 1905 and 1914 witnessed the decline of the Secession movement. Within the formal Secession, the *Klimtgruppe* and the *Werkstätte* creative activity remained steady, but less exciting. Some notable achievements, such as the Palais Stoclet and the *Kunstschau* exhibitions were still being carried out in this period, but, in general, the artists of the Secession, particularly those still housed in the Friedrichstrasse, had ceased to constitute a controversial avant-garde. The primary accomplishment of the movement in these years was represented by the efforts of Klimt and his followers to provide an encouraging atmosphere for new talent, which resulted in Kokoschka and Schiele getting their first significant public exposure. In bringing these two artists and their new style into the foreground the Secession exchanged the role of artistic deity for that of a muse.

With the outbreak of World War I the *fin-de-siècle* phase of the Secession came to an end. In the war years that followed, the movement's remaining vitality continued to ebb and in 1918 three of its most important figures, Klimt, Wagner, and Koloman Moser, died. The original Secession from which they had seceded in 1905 survived, but the social and

political structure that had formed the context of their activities did not. What remained was a Rump Secession in a truncated Austria.

The final disaster that overtook both Austria and the Secession at the end of the world war had as its most basic cause an inability to accommodate change in a constructive manner. The decision to attack Serbia in 1914 was prompted, in large part, by the fear that the internal dissension, which threatened the dissolution of the empire, could only be arrested by a successful war against an external enemy in which the danger from without would induce unity within. Such a solution ignored the real factors of change and made the destruction of what it sought to save all the more likely.

The very month in which the Secession was founded, April of 1897, saw a conspicuous failure to institute constructive change in the fall of Count Casimir Badeni as prime minister over the issue of his language ordinances to put Czech and German on an equal footing in the Bohemian bureaucracy. The aftermath of the disturbances that followed left Austria with a rapid succession of weak administrations until 1900, after which time their number decreased, but their ability to provide solutions to problems was no greater. On the eve of the war the central issue remained how to reconcile the demands for change in status by the non-German nationalities, especially the Czechs, but in virtually all other significant issues as well, the fear of or desire for basic change in the status quo was crucial. For the liberals it meant decline in popular politics, for the Christian Socialists the disappearance of "the little man," and for the Social Democrats the total transformation of society. Class conflict, party disagreement, and nationalism seemed to be working against any kind of change that might lead to a restoration of unity and harmony. It was in such a context that the Secession's approach to change in the medium of art attempted to influence that taken by society as a whole.

As an art movement per se, the Secession had an undoubted impact not only in Austria, but in Europe generally. That both Loos and Kraus, among others, were moved to attack it attests to the Secession's importance in the cultural life of the Habsburg state, while the affair of the *Fakultät-bilder* illustrates its ability to challenge if not to actually change the self-perceptions of Austrian society. The Secession, as did art nouveau, stood for a stylistically innovative and socially engaged art. To be a representative of modern art carried obligations of confronting man's problems outside the studio. The Secession movement recognized its duty to integrate art and life, but the question is how well it succeeded.

If examined in terms of its programs and activities, the Secession's record of intervening in what it considered significant social issues involving the fine and applied arts is impressive. The open didacticism of *Ver Sacrum* the Secession's exhibition policy, the participation of its members in the official *Kunstrat,* their support for the Modern Gallery and public causes in the arts of all kinds indicate an engaged movement. Yet, for all its spirited activity, the Secession could influence the direction of Austrian life primarily by example only. Nowhere is this clearer than in its philosophy and approach to modern art.

In its desire to create an art of its times, the Secession sought to be different without being *déraciné* and to allow for variety while maintaining a basic harmony. What was of inspirational or historical value such as the art of Greece and Rome or Austria's own artistic heritage, was honored by the new art. The stylistic modernity of the Secession responded to what were perceived as the unique needs of the present, yet built upon the achievements of the past, thus neatly encompassing the theme of change with continuity. To this notion of a continuum were added additional elements of harmony in the concepts of the *Künstlerschaft* and the *Gesamtkunstwerk.* In the former, the artist and public were

united by the personal, almost mystical bond of reciprocal aesthetic feeling, while in the latter the creation of a unitary form from different elements provided a single physical environment for daily life.

By themselves these elements could be taken as examples of harmony in time, sentiment, and space, a harmony that had been achieved despite what many considered a radical change in the world of art. Their value as idealistic influences upon an artistically receptive public was potentially more cogent since they were analogous and complementary to important ideological elements in the Habsburg state. Traditionally, the stability of that state was helped by the inertial force of its long temporal continuity, the personal bond between dynast and subject, and the fact that from disparate parts a unified whole had been created and maintained. Formalized versions of these ideas were taught in school, propagandized by the government, and cited by reformers as Austrian strengths. Right up to the collapse of the empire the themes of a great and continuous past, imperial paternalism, and international mission were rhetorically healthy if constitutionally ill.

How conscious a replication of these elements those in the Secession were is open to debate, but as an institution the Secession certainly tended to be *Habsburgtreu*. [1] While all in its ranks may not so unequivocally have expressed themselves to be supporters of the monarchy as did Otto Wagner (1), the Secession was consciously Austrian at a time when Austria and the Habsburg dynasty were synonymous. Its association with political movements like liberalism and Christian socialism was largely accidental. However, the dedication of the Secession to the multi-national character of the monarchy was reflected in its membership, policies, and championing of a cause like the Mehoffer case. Considering also the turbulent period in which the Secession flour-

[1]Habsburg-true (loyal to the Habsburg dynasty).

ished, it is interesting that factors that were supposed to make for a sense of unity and harmony in society were so neatly complemented by those directed toward the same end in art.

Yet, even with the weight of the Habsburg state behind them, ideas of continuity, symbolic bonds, and historic unity did not suffice to stop the disintegrative process of change in Austrian society. Similar ideas promoted by the Secession on its own could hardly have had any greater success, and, accordingly, the active intervention of the movement into society at large never went beyond its forays into public artistic questions. Specific major social and political issues were simply not addressed. Had the Habsburg body politic, however, shown more vitality in dealing with social complaints and nationality conflicts, the art of the Secession might have served to glorify and reinforce it as earlier the art of the Baroque had done for a revitalized monarchy through palaces, churches, and monuments. As it was, such vitality was lacking and despite some significant commissions like the Imperial and Royal Postal Savings Bank, the unheeded call made by Klimt at the opening of the first *Kunstschau* for more public commissions and the numerous unrealized projects by Wagner testify to the lack of interest on the part of government circles in making the style of the Secession an official one. Without that recognition, the connection between the principles of the Secession and those of the monarchy could have appeared vague at best. In such circumstances the movement's independence was a form of isolation, which outside the sphere of art condemned its ideas to being only passive examples of how things might be.

In a final assessment it must be said that the Secession succeeded to only a limited degree in becoming the representative of an engaged art. Though actively involved in various public issues, the movement failed to affect concretely any that were crucial to the course of prewar Aus-

trian society. The progress of disruptive change continued along its path to 1914. What had been attempted by art in Austria, however, fared no better in the rest of Europe.

In the preface to this study, it was remarked that the central question posed by *fin-de-siècle* art concerned the nature of culture and its relationship to contemporary life. Beyond affirming the necessity of art's involvement at all levels of that life neither the Secession nor art nouveau as a whole were able to provide a definitive answer. Since 1918 the support of a political ideology such as fascism or communism has become usual for any art movement that aspires to such a broad influence in society. Before the war, the Secession assumed that art could have a more independent impact upon its surroundings; unfortunately, the ideal of one could not overcome the reality of the other.

Chapter Note

1. Berta Zuckerkandl, *Österreich Intim, Erinnerungen 1892–1942* (Berlin, Wien, Frankfurt: Verlag Ullstein, 1970), p. 32.

Appendix:
Note on Austrian Monetary Units

The sums of money quoted in this study appear in units of Florins, Gulden, or Kronen. In order for the reader to have some idea of the value of these units in what was then contemporary American money, the following scale of equivalency may be used:

$$
\begin{array}{llll}
\text{1 Florin} & = \$0.414 & (\text{approx.})[1] \\
\text{1 Gulden} & = \$0.414 & (\text{approx.}) \\
\text{1 Krone} & = \$0.21 & (\text{approx.}) \\
& \text{or} \\
\text{2.40 Florins} & = \text{One Dollar} \\
\text{2.40 Gulden} & = \text{One Dollar} \\
\text{4.80 Kronen} & = \text{One Dollar}
\end{array}
$$

The Gulden and Florin are the same coin, but the term "Florin" is the older designation and is derived from the Florentine coin that was accepted all over Europe during the Middle Ages and the Renaissance. By a law of 1892, the Austro-Hungarian government changed its coinage and currency from Gulden to Kronen effective January 1, 1900, with 2 Kronen = 1 Gulden. The new Krone was equal to 100 Heller.[2]

[1] Author's figures.
[2] See New York Times, Jan. 1, 1900, "Annual Review and Quotation Supplement," p. 28.

Reproduction Credits

The following individuals, institutions, and publishers have kindly provided permission for the use of those illustrations listed below.

Cover and Frontispiece: Courtesy of Barbara Leibowitz Graphics Ltd., New York, NY.
Figures 1, 12, 13, 15, 23: Historisches Museum der Stadt Wien.
Figures 2–4, 30, 31, 32, 47: Österreichische Galerie.
Figures 5–7, 11, 35, 36: Bildarchiv der Österreichischen Nationalbibliothek.
Figures 8, 33, 34: Franz Steiner Verlag, Wiesbaden.
Figures 16, 43, 47, 48: Graphische Sammlung Albertina and for the Schiele reproductions Ing. Norbert Gradisch, Vienna
Figure 22: Residenz Verlag, Salzburg.
Figures 24–29: Galerie Welz, Salzburg.
Figure 37: Courtesy of Olda Kokoschka
Figure 44: Kunstmuseum Basel.

Bibliography

Books

Bahr, Hermann. *Der Antisemitismus.* Berlin: S. Fischer Verlag, 1894.

――――. *Studien zur Kritik der Moderne.* Frankfurt: Literarische Anstalt Ruethen & Loening, 1898.

――――. *Secession.* Wien: Wiener Verlag, 1900.

――――. *Rede Über Klimt.* Wien: Wiener Verlag, 1901.

――――. *Gegen Klimt.* Wien, 1903.

――――. *Dialog vom Tragischen.* Berlin: S. Fischer Verlag, 1904.

――――. *Schwarzgelb.* Berlin: S. Fischer Verlag, 1917.

Barea, Ilsa. *Vienna.* New York: Alfred A. Knopf, 1967.

Barilli, Renato. *Art Nouveau.* London: Paul Hamlyn, 1969.

Bisanz-Prakken, Marian. *Gustav Klimt, Der Beethovenfries; Geschichte, Funktion und Bedeutung.* Wien: Residenz Verlag, 1977.

Comini, Alessandra. *Egon Schiele's Portraits.* Berkeley: University of California Press, 1974.

――――. *Gustav Klimt.* New York: George Braziller, 1975.

――――. *Schiele in Prison* (Greenwich: New York Graphic Society, 1973).

Fenz, Werner, *Kolo Moser: internationale Jugendstil und Wiener Secession,* Salzburg: Residenz Verlag, 1976.

Field, Frank. *The Last Days of Mankind, Karl Kraus and His Vienna.* London & New York: Macmillan and St. Martin's Press, 1967.

Freud, Sigmund. *An Outline of Psychoanalysis.* New York: W. W. Norton & Co., Inc., 1969.

Fuchs, Albert. *Geistige Strömungen in Österreich 1867–1918.* Wien: Globus Verlag, 1949.

Geretseger, Hans, and Peintner, Max. *Otto Wagner 1841–1914, The Expanding City, The Beginning of Modern Architecture.* London: Pall Mall Press, 1970.

Goldscheider, Ludwig, and Kokoschka, Oskar. *Kokoschka.* London: Phaidon Publishers, Inc., 1963.

Graf, Otto Antonia. *Die Vergessene Wagnerschule.* Wien: Verlag Jugend und Volk, 1969.

Gropius, Wlater. *The Scope of Total Architecture.* New York: Collier Books, 1974.

———. *The New Architecture and the Bauhaus.* Cambridge, Mass.: M.I.T. Press, 1974.

Solomon R. Guggenheim Museum. *Gustav Klimt & Egon Schiele.* New York: Published by the Museum, 1965.

Hamann, Richard, and Jost, Hermand. *Stilkunst um 1900.* Berlin (D.D.R.): Akademie Verlag, 1967.

Hauser, Arnold. *The Social History of Art.* Vol. II. London: Routledge & Kegan Paul, 1951.

Hevesi, Ludwig. *Acht Jahre Secession (März 1897–Juni 1905) Kritik - Polemik - Chronick.* Wien: Verlagsbuchhandlung Carl Konegan, 1906.

———. *Altkunst - Neukunst 1894–1908.* Wien: Verlagsbuchhandlung Carl Konegan, 1909.

Hitchcock, Henry-Russel, and Johnson, Philip. *The International Style.* New York: W. W. Norton & Co., Inc., 1966.

Hofmann, Werner. *Gustav Klimt.* Greenwich, Conn.: New York Graphic Society, Ltd., 1971.

Hughes, H. Stuart. *Consciousness and Society.* New York: Vintage, 1958.

———. *The Sea Change.* New York: Harper & Row, 1975.

Iggers, Wilma. *Karl Kraus, A Viennese Critic of the Twentieth Century.* The Hague: Martinus Nijhoff, 1967.

Janik, Allan, and Toulmin, Stephen. *Wittgenstein's Vienna.* New York: Simon & Schuster, 1973.

Johnston, William M. *The Austrian Mind, An Intellectual and Social History.* Berkeley: University of California Press, 1972.

Jullian, Phillipe. *Dreamers of Decadence.* New York: Praeger Publishers, Inc., 1971.

Kapner, Gerhrdt. *Ringstrassendenkmäler, Zur Geschichte der Ringstrassendenkmäler.* Vol. IX of *Die Wiener Ringstrasse - Bild einer Epoche, Die Erweiterung der Inneren Stadt Wien unter Kaiser Franz Joseph.* Edited by Renate Wagner-Rieger. Wiesbaden: Franz Steiner Verlag GMBH, 1973.

Karpfen, Fritz (Editor). *Das Egon Schiele Buch.* Wien: Verlag der Wiener Graphischen Werkstätte, 1921.

Kindermann, Heinz (Editor). *Essays von Hermann Bahr.* Wien: H. Bauer Verlag, 1962.

———. (Editor). *Kulturprofil der Jahrhundertwende, Essays von Hermann Bahr.* Wien: H. Bauer Verlag, 1962.

Kokoschka, Oskar. *Schriften 1907–1955.* München: Albert Langen & Georg Müller, 1956.

———. *Die Träumenden Knaben.* Facsimile of the original edition by Jugend und Volk Verlag. Wien, 1968.

———. *My Life.* Translated by David Britt. New York: Macmillan Publishing Co., Inc., 1974.

Kraus, Karl. *Literatur und Lüge.* Vol VI of the collected works. Kosel-Verlag zu München, 1958.

———. *Untergang der Welt durch Schwarze Magie.* Vol. VIII of the collected works. Kosel-Verlag zu München, 1960.

Lenning, Henry David. *The Art Nouveau.* The Hague: Martinus Nijhoff, 1951.

Lichtenberger, Elisabeth. *Wirtschaftsfunktion und Sozialstruktur der Wiener Ringstrasse.* Vol. VI of *Die Wiener Ringstrasse—Bild einer Epoche, Die Erweiterung der Inneren Stadt Wien unter Kaiser Franz Joseph.* Edited by Renate Wagner-Rieger. Wien: Verlag Hermann Böhlhaus Nachf., 1970.

Lux, Josef August. *Joseph M. Olbrich, Eine Monographie.* Berlin: Verlag Ernst Wasmuth, 1919.

———. *Otto Wagner, Eine Monographie.* München: Delphin-Verlag, 1914.

May, Arthur J. *Vienna in the Age of Franz Joseph.* Norman: University of Oklahoma Press, 1966.

McGrath, William J. *Dionysian Art and Populist Politics in Austria.* New Haven: Yale University Press, 1974.

Mucha, Jiri. *The Master of Art Nouveau, Alphonse Mucha.* England: Hamlyn Publishing Group, Ltd., 1967.

Münz, Ludwig, and Kunstler, Gustav. *Adolf Loos, Pioneer of Modern Architecture.* New York and Washington: Frederick C. Praeger, 1966.

Naylor, Gillian. *The Arts and Crafts Movement.* London: Studio Vista, 1971.

———. *The Bauhaus.* London: Studio Vista/Dutton, 1973.

Nebehay, Christina M. *Gustav Klimt Dokumentation.* Wien: Verlag der Galerie Christian M. Nebehay, 1969.

———. *Ver Sacrum 1898–1903.* New York: Rizzoli, 1975.

———. *Gustav Klimt. Sein Leben nach zeitgenössischen Berichten und Quellen.* München: Deutscher Taschenbuch Verlag, 1976.

———. *Egon Schiele 1890–1918, Leben, Briefe, Gedichte.* Salzburg & Wien: Residenz Verlag, 1979.

Novotny, Fritz, and Dobai, Johannes. *Gustav Klimt.* London: Thames & Hudson, 1967.

Olbrich, Josef. *Ideen von Olbrich.* Wien: Gerlach von Schenk, 1899.

Österreichische Bürgerkunde. Handbuch der Staats- und Rechtskunde in ihren Beziehungen zum öffentlichen Leben. Vol. II. Verfasst unter teilweisen

Mitwirkung der Behörden von Fachmännern der einzelnen Ressorts. Wien: Verlag der Patriotischen Volksbuchhandlung, 1909(?).

Powell, Nicolas. *The Sacred Spring, The Arts in Vienna, 1898–1918.* Greenwich, Conn.: New York Graphic Society, 1974.

Ramberg, Gerhard. *Die moderne Kunstbewegung, Zweck und die Secession.* Wien: Verlag S. Kende, 1898.

———. *Öffentliche Kunstpflege—ein Stückchen Sozialpolitik.* Wien, 1904.

Reade, Brian. *Art Nouveau and Alphonse Mucha.* London: Her Majesty's Stationery Office, 1967.

Rhiem, Maurice. *The Age of Art Nouveau.* London: Thames & Hudson, 1966.

Roessler, Arthur (Editor). *Briefe und Prosa von Egon Schiele.* Wien, 1921.

Santifaller, Leo, and Obermayer-Marnach, Evo *Österreichisches Biographisches Lexikon 1815–1950.* Vol. I. Graz-Köln: Verlag Hermann Böhlaus Nachf., 1957.

Schmidt, Rudolf, *Das Wiener Künstlerhaus Eine Chronik 1861–1951,* Wien: Gesellschaft bildender Künstler Wiens, Künstlerhaus, 1951.

Schmutzler, Robert. *Art Nouveau.* London: Thames & Hudson, 1964.

Schnitzler, Arthur. *My Youth in Vienna.* New York/Chicago/San Francisco: Holt, Rinehart and Winston, Inc., 1970.

Schorske, Carl E. *Fin-de-Siècle Vienna, Politics and Culture.* New York: Alfred A. Knopf, 1980.

Seligmann, A. F. *Kunst und Künstler von Gestern und Heute.* Wien, 1910.

Selz, Peter (Editor). *Art Nouveau, Art and Design at the Turn of the Century.* New York: Museum of Modern Art, 1959.

Sotriffer, Kristian. *Modern Austrian Art.* New York: Frederick A. Praeger, 1965.

Spencer, Robin. *The Aesthetic Movement.* London: Studio Vista, 1972.

Stanford, Derek (Editor). *Pre-Raphaelite Writings, An Anthology.* Totowa, N.J.: Rowman & Littlefield, 1973.

Wagner, Otto. *Moderne Architektur.* Wien: A. Schroll & Co., 1896.

———. *Die Baukunst Unserer Ziet. Dem Baukunstjüngen ein Führer auf diesem Kunstgebiete* (a modestly expanded 4th edition [1914] of *Moderne Architektur*). Wien: Locker Verlag, 1979.

———, *Einige Skizzen, Projekte, und ausgeführte Bauwerke,* 4 Bände. Wien: Kunstverlag Anton Schroll und Comp., Bände I & II 1905, Band III 1906, Band IV 1915.

Wagner, Walter. *Die Geschichte der Akademie der bildenden Künste in Wien.* Printed under the auspices of the Akademie der bildenden Künste in Wien, 1967.

Waissenberger, Robert. *Wien und Die Kunst in unserem Jahrhundert.* Wien: Verlag Jugend und Volk, 1965.

————. *Die Wiener Secession, Eine Dokumentation.* Wien: Verlag Jugend und Volk, 1971.

Watkinson, Raymond. *Pre-Raphaelite Art and Design.* Greenwich, Conn.: New York Graphic Society, 1970.

Wunberg, Gotthard (Editor). *Zur Überwindung des Naturalismus* (Essays by Hermann Bahr). Stuttgart: W. Kohlhammer Verlag, 1968.

Wurzbach, Dr. Constant von. *Biographisches Lexikon des Kaiserthums Österreich, enthaltend die Lebensskizzen der denkwürdigen Personen welch seit 1750 in den Österreichischen Kronländern geboren wurden oder darin gelebt und gewirkt haben.* 66 vols. (In 1856 published by Verlag der Universitäts—Buchdrückerei von L. C. Zamarski; from 1857–1859 by Druck und Verlag der typogr.-literar.-artist. Anstalt, and from 1860 by Druck und Verlag der K. K. Hof-und Staatsdruckerei, Wien; 1859–1891.)

Zohn, Harry. *Karl Kraus.* New York: Twayne Publishers, Inc., 1971.

Zuckerkandl, Berta. *Zeitkunst Wien 1901–1902.* Wien & Leipzig: Hugo Heller & Cie, 1908.

————. *Österreich Intim, Erinnerungen 1892–1942.* Frankfurt, Berlin, Wien: Verlag Ullstein, 1970.

Zweig, Stefan. *The World of Yesterday.* New York: The Viking Press, 1943.

Catalogs

Kulturamt der Stadt Wien, *Wien um 1900.* Wien, 1964.

Mrazek, Wilhelm. *Die Wiener Werkstätte, Modernes Kunsthandwerk von 1903–1932.* Wien: Österreichisches Museum für Angewandte Kunst, 1967.

Österreichisches Museum für angewandte Kunst. *Finnland 1900, Finnischer Jugendstil.* Wien, 1973.

All catalogues of Secession exhibitions from 1898 to 1918.

Pamphlets

Der Arbeitschuss der Vereinigung bildender Künstlers Österreich (Secession). "Der Wiener Secession und Seine Excellenz Freiherr von Helfert." Wien: Ostern, 1902.

Articles

Anonymous. "Weshalb Wir Eine Zeitschrift Herausgeben." *Ver Sacrum,* Vol. I (Januar 1898), pp. 5–7.

———. "Die Moderne Galerie." *Ver Sacrum,* Vol. V (15 Oktober 1902), pp. 341–49.

Ankwicz-Kleehoven, Hans. "Josef Hoffmann 1890–1956." *Neue Österreichische Biographie,* Vol. X. Wien: Amalthea Verlag, 1957, pp. 171–79.

Bahr, Hermann. "An die Secession, Ein Brief." *Ver Sacrum,* Vol. I (Mai–Juni 1898), p. 5.

———. "Der Englische Stil." *Ver Sacrum,* Vol. I (Juli 1898), no page numbers.

———. "Zur Ausstellung." *Ver Sacrum,* Vol. IV (15 Februar 1901), pp. 71–85.

———. "Ein Brief an die Secession." *Ver Sacrum,* Vol. IV (15 July 1901), pp. 71–85.

Breicha, Otto, "Gustav Klimt und die neue Wiener Malerei seiner Zeit". *Alte und Moderne Kunst.* 9. Jahrgang (Mai/Juni 1964), pp. 6–10.

Burckhard, Max. "Ver Sacrum." *Ver Sacrum,* Vol. I (Januar 1898), pp. 1–3.

Clark, Robert Judson. "J. M. Olbrich 1867–1908." *Architectural Design,* Vol. XXXVII, London (December 1967), pp. 565–72.

Dreger, Mortiz. "Die Neue Bauschule." *Ver Sacrum,* Vol. III (August 1899), pp. 17–24.

———. "Ehrlichkeit in der Kunst." *Ver Sacrum,* Vol. III (1 März 1900), pp. 71–77.

Günther, Dr. Georg. "Karl Wittgenstein und seine Bedeutung für den Aufbau und die Entwicklung der österreichischen Volkswirtschaft." *Neue Österreichische Biographie,* Vol. II. Wien: Amalthea Verlag, 1927, pp. 156–63.

Hauer, Karl. "Staatliche Kunstpflege." *Die Fackel,* Nr. 250 (14 April 1908), pp. 11–15.

Hevesi, Ludwig. "Zwei Jahre Secession." *Ver Sacrum,* Vol. II (Juli 1899), pp. 3–12.

———. "Der Bildende Kunst in Österreich." *Die Pflege der Kunst in Österreich 1848–1898.* Publication of the Franz Joseph Jubiläum. Wien, 1900, pp. 3–22.

Kindermann, Heinz. "Hermann Bahr." *Neue Österreichische Biographie ab 1815,* Vol. X. Wien: Amalthea Verlag, 1957, pp. 138–48.

Kleehoven, Hans Ankwicz von. "Die Anfänge der Wiener Secession". *Alte und Moderne Kunst.* 5. Jahrgang (Juni/Juli 1960), pp. 6–10.

Klimt, Gustav. "Über der Deckengemälde 'Die Medicin.' " *Ver Sacrum,* Vol. IV (1 Mai 1900), pp. 158–64.

Kossatz, Horst-Herbert. "Wiener Juwel in Brüssel." *Arbeiter Zeitung Journal,* Samstag (23 Juni 1973), pp. 12–13.

Kraus, Karl. "Die demolirte Literatur." *Wiener Rundschau,* Vol. I, No. 1–12. Wien: Verlag der Wiener Rundschau, 1897 (Kraus Reprint).

Lilienkron, Detlev von. "Ich und die Rose Warten." *Ver Sacrum,* Vol. V (1 Juli 1902), unnumbered.

Loos, Adolf. "Die Potemkin'sche Stadt." *Ver Sacrum,* Vol. I (Juli 1898), pp. 15–17.

———. "Unseren Jungen Architekten." *Ver Sacrum,* Vol. I (Juli 1898), pp. 19–21.

Lux, Josef August. "Wiener Werkstätte." Deutsche Kunst und Dekoration, Vol. XV (Oktober 1904–März 1905), pp. 1–44.

Matulla, Oskar. "Die Theodor von Hörmannsstiftung." Xeroxed typescript copy of an article written in 1962 for catalogue of an exhibition held in St. Pölten; 4 pages.

———. "Die soziale Seite der bildenden Kunst 1900–1945." *Kultur Berichte aus Niederösterreich,* VI (1966), pp. 41–43.

———. "Problem Heimatkunst Bestände in Niederösterreich." *Mitteilungen der Gesellschaft für Vergleichende Kunstforschung in Wien* (April 1973), pp. 31–34.

Mehoffer, Josef. "Glossen über die Kunst, Antwort auf den Brief des Grafen Lanckoronski in Angelegenhiet der Restaurierung der Kathedrale auf dem Wawel." *Ver Sacrum,* Vol. VI (Juli 1903),pp. 245–61.

Michalski, Ernst. "Die Entwicklungsgeschichtliche Bedeutung des Jugendstils." *Reportorium für Kunstwissenschaft,* Vol. 46, Heft 1 (1925), pp. 133–49.

Mrazek, Wilhelm, "Die Wiedergeburt des Kunsthandwerks und die Wiener Werkstatte". *Alte und Moderne Kunst,* 9. Jahrgang (Mai/Juni 1964), pp. 38–48.

Neumann-Spollart, Gottfried. "Alfred Roller." *Neue Österreichische Biographie ab 1815.* Wien: Amalthea Verlag, 1956, pp. 149–59.

Neuwirth, Walther Maria, "Die sieben heroischen Jahre der Wiener Moderne". *Alte und Moderne Kunst,* 9. Jahrgang (Mai/Juni 1964), pp. 28–31.

Pack, Claus. "Adolf Loos 1870–1933." *Neue Österreichische Biographie,* Vol. XVIII. Wien: Amalthea Verlag, 1972, pp. 132–38.

Rilke, Rainer, Maria. "Ueber Kunst." *Ver Sacrum,* Vol. II (Januar 1899), pp. 10–12.

Roller, Alfred. "Unsere VIII Ausstellung." *Ver Sacrum,* Vol. III, (15 November 1900), pp. 343–45.

———. "Letter to Unterrichtsminister von Hartel" (no title). *Ver Sacrum,* Vol. V (1 Februar 1902), pp. 49–56.

Schaeffer, Wilhelm. "Kunstenthusiasmus." *Ver Sacrum,* Vol. II (Januar 1899), pp. 15–18.

Scheu, Robert. "Adolf Loos." *Die Fackel,* Nr. 283–284 (26 Juni 1909), pp. 25–37.

Schmied, Wieland. "Egon Schiele 1890–1918." *Neue Österreichische Biographie ab 1815,* Vol. XVIII. Wien: Amalthea Verlag, 1972, pp. 123–31.

Schnitzler, Henry. "Gay Vienna—Myth and Reality." *Journal of the History of Ideas,* Vol. XV, No. 1 (January 1954), pp. 94–118.

Schorske, Carl. "Politics and Psyche in fin de siècle Vienna: Schnitzler and Hofmannsthal." *The American Historical Review,* Vol. 66, No. 4 (July 1961), pp. 930–46.

————. "The Transformation of the Garden: Ideal and Society in Austrian Literature." *The American Historical Review,* Vol. 72, No. 4 (July 1967), pp. 1283–1320.

Segantini, Giovanni. "Betrachtungen über die Kunst." *Ver Sacrum,* Vol. II (Mai 1899), pp. 3–6.

Servaes, Franz. "Ein Streifzug durch die Wiener Malerei." *Kunst und Künstler,* Vol. 8 (1909–1910), pp. 587–98.

Stoessl, Otto. "Kunstschau." *Die Fackel,* Nr. 259–260 (13 Juli 1908), pp. 24–30.

Stöhr, Ernst. "Die Malerei Unserer Zeit." *Ver Sacrum,* Vol. IV (1 Mai 1900), pp. 157–58.

————. "Kunstakademien." *Ver Sacrum,* Vol. V (1 August 1902), pp. 228–29.

Strobl, Alice. "Zu den Fakultätbildern von Gustav Klimt." *Albertina Studien,* Vol. II, 1964, pp. 138–69.

V.S. [*Ver Sacrum*]. "D. [das] Haus D. [der] Secession." *Ver Sacrum,* Vol. II (Januar 1899), pp. 6–7.

————. "Der Hofpavillon Der Wiener Stadtbahn." *Ver Sacrum,* Vol. II (August 1899), pp. 3–13.

————. "Die Reformierte Akademie, Gedanken Beim Schlusse Der Schulausstellung." *Ver Sacrum,* Vol. II (August 1899), pp. 26–30.

————. "Mittheilungen Über Die Organisation Der Österreichischen Kunstabteilung Auf Der Pariser Weltausstellung 1900." *Ver Sacrum,* Vol. III (15 Februar 1900), pp. 55–65.

————. " 'Die Philosophie' von Klimt und der Protest der Professoren." *Ver Sacrum,* Vol. III (15 Mai 1900), pp. 151–66.

————. "Die K. und K. Hofgartendirection auf der Pariser Ausstellung." *Ver Sacrum,* Vol. III (15 Juni 1900), pp. 189–95.

————. Untitled Statement on Reasons for Ending V.S. *Ver Sacrum,* Vol. VI (15 Dezember 1903), pp. 399–401.

Der Arbeitausschuss der Vereinigung bildender Künstler Österreichs Secession (V.S.). "Die Wiener Secession in die Ausstellung in St. Louis." *Ver Sacrum,* Vo. VI (Februar 1904), pp. 5–14.

Tesar, L. E. "Oskar Kokoschka (Ein Gespröch)." *Die Fackel,* Nr. 298–299 (2 März 1910), pp. 34–44.

Wagner, Ott. "Die Kunst im Gewerbe." *Ver Sacrum,* Vol. III (Januar 1900), pp. 21–23.

———. "The Development of a Great City." *Architectural Record.* Vol. 3 (May 1912), pp. 485–500.

Wandruszka, Adam. "Die 'Zweite Gesellschaft' der Donaumonarchie." *Adel in Österreich,* edited by Henry Siegert. Wien: Verlag Kremayr und Scheriau, 1971, pp. 56–67.

Dissertations

Kowalski, Helene. "Die Stellung der Wiener Werkstätte in der Entwicklung des Kunstgewerbes seit 1900." Dissertation manuscript for the Ph.D. degree in the philosophische Fakultät der Universität Wien, 1951.

Wagner, Gertrude. "Die Einflüsse der Wiener Secession auf das Zeitgenössische Schriftum und die sich daraus ergebenden Wechselwirkungen." Ph.D. dissertation in the Philosophische Fakultät der Universität Wien, 1939.

Newspapers and Journals

Arbeiter Zietung, 1897–1918.
Die Neue Freie Presse, 1897–1918.
Neues Wiener Tagblatt, 1897–1918.
Reichspost, 1897–1918.
Die Fackel, 1899–1918.
Das Andere: Ein Blatt zur Einführung Abendlaendischer Kultur in Österreich, Oktober 15, 1903, Nr. 2, 1. Jahr (one of only two issues).
Secession Jahresberichte, 1899, 1903, 1908.
Ver Sacrum, 1898–1903; official organ of the Secession.

Interview

Matulla, Oskar. Conversation with author concerning the Secession in late May of 1973.

Stenographic Records

Stenographische Protokolle über die Sitzungen des Hauses der Abgeordneten des österreichischen Reichsrates in Jahre 1901.

Protokolle der öffentliche Sitzungen des Gemeinderates der k. k. Reichshaupt- und Residenzstadt Wien, 1897.

Index

OTHER PUBLICATIONS FROM SPOSS, INC.

Modern Austria

Editor: Prof. Kurt Steiner. Co-Editors: Prof. Fritz Fellner and Dr. Hubert Feichtlbauer. Editorial Committee: Prof. Eduard März and Prof. Gottfried Scholz.

Well-known Austrian authorities from public and academic life have contributed twenty-six chapters that present a comprehensive treatise on contemporary Austria's geography and demography, economy, government and politics, public policies, international position, and culture.

Published June 1981, 527 pp., hard cover, illustrations, index ISBN 0-930664-03-5; $26.00 in USA, $28.00 elsewhere per copy

Modern Switzerland

Editor: Prof. J. Murray Luck. Co-Editors: Dr. Lukas F. Burckhardt and Prof. Hans Haug. Editorial Committee: Profs. Joseph von Ah, Hugo Aebi, and Erich Gruner.

Modern Switzerland provides a comprehensive cross-sectional view of many aspects of Switzerland, of her people, and their institutions. Some twenty-seven Swiss scholars, gifted with expert knowledge in their special fields of interest, have cooperated in this unusual effort to describe Switzerland in the 1970's.

Published 1978, 531 pp., hard cover, illustrations, index ISBN 0-930664-01-9; $22.00 in USA, $23.00 elsewhere per copy

"Each contributing author writes with authority and perception and frequently supplies minute details on such matters as the education system or leisure-time activities . . . Whether the reader seeks some general information about Switzerland or whether he seeks technical details, this book will be of great assistance and it is therefore highly recommended for every library, no matter whether public or college."

Choice, Oct. 1978

"Its aim is to describe present-day Switzerland to the English-speaking world, and in this it succeeds admirably."

Peninsula Living, June 3, 1978

". . . unequalled in English, and possibly any other language, as a survey of an exemplary country."

World Affairs Report 8, No. 4, 1978

"*Modern Switzerland* does an outstanding job of providing a comprehensive cross-sectional view of many aspects of Swiss life."

Bulletin Credit Suisse, Vol. 84, Summer 1978

(continued next page)

Population Pressures: Emigration and Government in Late Nineteenth-Century Britain

By Prof. Howard L. Malchow, Dept. of History, Tufts Univ., Medford, Mass.

This book is a study of the politics of emigration, and specifically of those organizations lobbying to persuade the government to assist emigration. The focus is on the National Emigration League in the period 1869–1871 and on the National Association for Promoting State-directed Emigration and Colonization 1883–1891.

Published 1979, 323 pp., hard cover, illustrations, index
ISBN 0-930664-02-7; $18.00 in USA, $19.00 elsewhere per copy

"This is a most useful book. The research is extensive, with the author bringing together in a relatively short compass the activities of men and organizations supporting emigration during the latter part of the Victorian period . . . it will be consulted by anyone working in the field of emigration or in the related fields of charity, the role of the state, the relation between labor and emigration, and intra-imperial relations . . . it is a useful case study of lobbying tactics and strategies, and the discussion of J. H. Boyd and Lord Brabazon (later Earl of Meath) is most illuminating."

Albion, Vol. 12, No. 1

"Malchow admirably succeeds in identifying the reasons advanced by those favoring state-assisted emigration . . . Both the author and his publishers have produced a book . . . the plates from the *Illustrated London News* do much to add life to the subject. Malchow should be complimented, not only for his thorough use of a wide variety of sources but also for his excellent grasp of peripheral issues."

The American Historical Review, Oct. 1980

"An addition to the growing literature on Victorian pressure groups. Malchow describes the attempts to pressure government into initiating state-aided emigration to relieve social distress in England and to help build colonies in the empire. His focus is on the large but unsuccessful National Association for Promoting State Colonization of the 1880's . . . We now know what happened to large-scale emigration schemes after Edward Gibbon Wakefield. Recommended for university libraries."

Choice, July/Aug. 1980

Tradition and Innovation in Contemporary Austria

Editor: Prof. Kurt Steiner, Dept. of Political Science, Stanford Univ., Stanford, Calif.

This volume is based on a symposium on the occasion of the twenty-fifth anniversary of the Austrian State Treaty, 1955, held at Stanford University.

To be published fall 1982, about 250 pp., hard cover, index

Orders may be placed through booksellers or directly from
SPOSS, Inc., 4139 El Camino Way, Palo Alto, CA 94306 USA
(California residents please add applicable sales tax)